The Importance of Elsewhere
Philip Larkin's Photographs

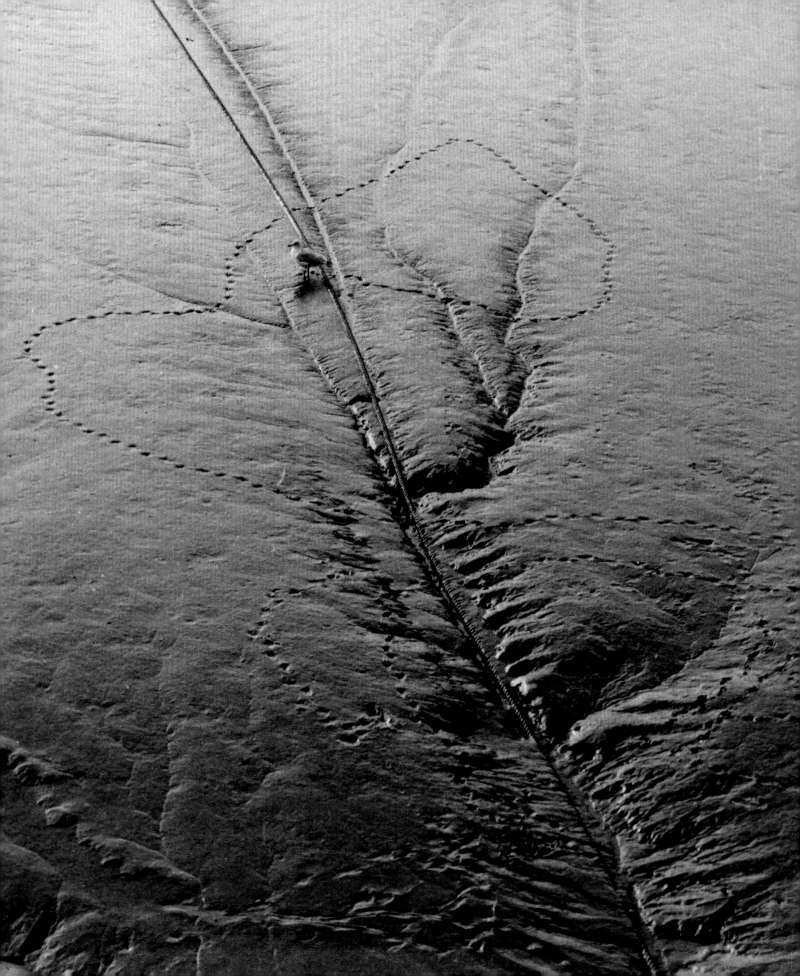

The Importance of Elsewhere
Philip Larkin's Photographs

Richard Bradford

F

FRANCES LINCOLN LIMITED

For Ames

Frances Lincoln Ltd
74–77 White Lion Street
London N1 9PF
www.franceslincoln.com

A catalogue record for this book is available from the British Library
ISBN 978 0 7112 3631 8
Printed and bound in China

2 4 6 8 9 7 5 3 1

Contents

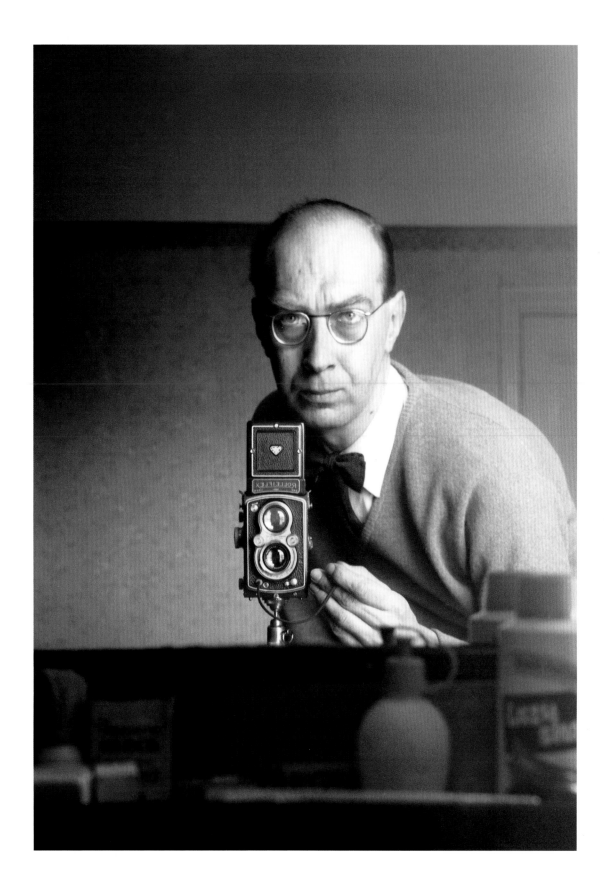

Foreword by Mark Hayworth-Booth

It is a great pleasure to be invited to write the foreword to this first book of photographs by the great poet Philip Larkin. I became one of his legion of admirers after reading *The Whitsun Weddings* soon after its publication in 1964. In 1974 I was so outraged by a shamefully negative review of *High Windows*, Larkin's final volume, that I sent the reviewer (at a national newspaper) the rudest letter I could conceive – including an Anglo-Saxon word that the poet had used to great effect in the book. I posted a copy to Larkin, c/o the Brynmor Jones Library at Hull University. His brief reply began 'Many thanks for your inspiriting letter' and that beautifully chosen word has inspirited me ever since.[1] Another connection is that I began photographing in the early 1970s, as a would-be 'serious amateur', with very similar equipment to Larkin. However, whereas Larkin owned a classy Rolleiflex, mine was one of its imitators (a Zeiss Ikoflex). I like to think I learned something about photography from the inside before putting the tripod, etc., away and concentrating on my new position as curator of photographs at the Victoria and Albert Museum (1977–2004). In preparation for writing this foreword, it was thrilling to immerse myself in the collection of some 5,000 Larkin prints and negatives so well looked after in the handsome new facilities of the Hull History Centre – an institution of which Larkin, the professional librarian, would surely have approved.[2]

Larkin defined himself as a photographer with the self-portrait reproduced on the cover of this book and opposite this page. He had all the accoutrements of the serious amateur: a Rolleiflex Automat twin lens reflex camera, mounted on a tripod, with a cable release to make relatively long exposures in poor light and avoid camera shake – I don't think he ever used flash. The self-portrait was taken in Larkin's bathroom mirror, then cropped. (The final artistic flourish was, of course, the bow tie.) As the Rolleiflex had no built-in light meter, Larkin would have used his

With this self-portrait Larkin defined himself as a serious amateur, in command of a camera used by great professionals like Brassai and Bill Brandt. The photograph was taken in his bathroom, using a tripod, cable release and light meter. A shelf of shaving requisites, etc. was cropped out of the final image.

Weston Master IV light meter (professional quality kit) to calculate the exposure of the self-portrait. The Rolleiflex was at the opposite end of the spectrum from the Baby Brownie being used by Larkin's father Sydney in the photograph on page 16.[3] Perhaps the frustrating inadequacies of the simple lenses on popular cameras like the Baby Brownie are behind the phrase 'All's kodak-distant' in Larkin's early poem 'Whatever Happened?'.[4] By contrast, the German-made 'Rollei', first introduced in 1929, was used by, for example, Brassai in the 1930s for his famous photographs of Paris by night, by Bill Brandt for much of his illustrious career in England, and by Lee Miller for her Surrealist photographs in Paris and her wartime reportage. The camera was held at chest height or used on a tripod. The image seen on the ground glass was laterally reversed but large and clear. It was often used for portraiture, buildings and landscape but quick enough to use for street scenes too. It was a gem of precision engineering and optics. Thus, this self-portrait is no casual selfie. It was probably taken by Larkin to test his new equipment.

In order to try to work out which cameras Larkin used and when, I was granted special access to his negatives. Larkin used local photo labs, at home or on holiday, to process his film and print from the negatives, or mailed his film to Will R. Rose Ltd in Chester. (These prints are stamped ROSE MAGNA PRINT on the back.) The labs did their work well: virtually all Larkin's prints have escaped process-staining. Colour film was sent for processing by Kodak Ltd in London and many prints, but by no means all, have suffered the usual fading. Larkin was adept at marking up contact prints for enlargement by these professional labs. A wallet of negatives in the archive (U DLV/3/44) indicates that Larkin took his first Rollei negatives in 1957. Possibly he acquired the camera to photograph libraries in preparation for planning the superb new one he oversaw at Hull. However, he also used his new camera for personal image-making. It had a self-timer, allowing Larkin to take delayed action photographs of himself with friends and many solo self-portraits. The Rollei negative was square and, at 6 × 6 cm, relatively large compared to cameras such as the classic Leica. Its size gave great latitude for cropping, at which Larkin excelled – as we can see from his cropping of the famous self-portrait with the England sign (page 13) which briskly straightens and concentrates the image.

Before 1957, Larkin used a British-made Purma Special, introduced in 1937, which also had a square negative (but smaller at 3.1 cm). Several aspects of the Purma Special were innovative. By holding the camera in different ways, the operator could choose from three shutter speeds – Slow: 1/25, Medium: 1/150, Fast: 1/450. The camera had a lightweight casing of Bakelite plus a fixed lens. Anything ten feet or more from the camera would be in focus. The photographs of the Leicester University Rag Day (pages 58–9) were taken with the Purma. There was also a range of accessories such as colour filters, close-up lenses and a lens hood, all of which Larkin owned. It seems likely that the Purma was the camera to which Larkin referred in a letter quoted on page 75 of the fascinating text by Richard Bradford that follows. Larkin wrote on

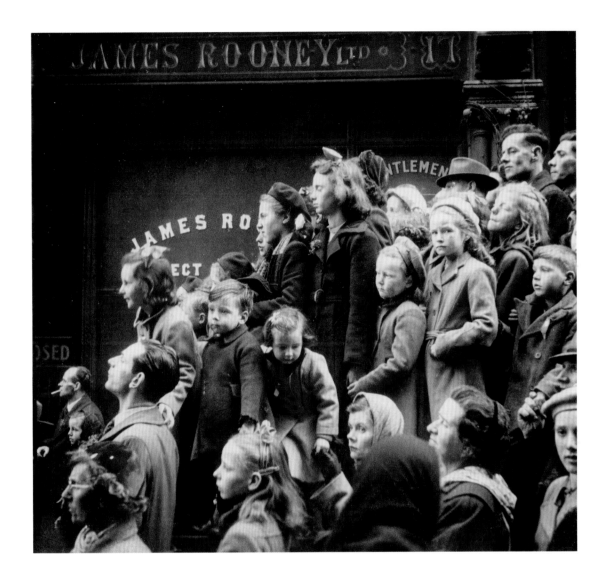

This is one of Larkin's most animated street scenes, a gallery of vivid individual portraits.
He was able to take the picture unobtrusively as all the people in the group were absorbed
in a spectacle – perhaps the funeral portrayed in his late poem 'Dublinesque'.

28 October 1947 to his painter friend Jim Sutton of his 'act of madness' in laying out £7 (over a week's salary) on a camera. It is worth quoting the rest of the paragraph, written soon after Larkin's arrival in Leicester to work at the university library: 'I am so far awaiting my first roll of results: if they are bad I shall feel I have been rather a fool. It is a "fast" camera, that is, best suited to swift scenes in bright sun. Now I like poor light the best & I don't think it will do any good in that line. But I'll show you any worthy results. There are dozens of worthy compositions knocking around: it's a question of realising what is good even in black and white.'[5]

The word 'compositions' – rather than 'subjects' – suggests that Larkin was looking to compose photographic images with his new camera. Several prints were inscribed by Larkin with technical data and record experiments from his earlier years with the camera. For example, a print of 'To the Match' (illustrated on page 50) gives the film type (Kodak Verichrome), the exposure (1/150 of a second) and possibly the time and month: '2.15 Oct.' A photograph of the Leicester Rowing Club boathouse, a static subject, had an exposure of 1/25. A portrait of Monica Jones on a bed, dated 1948 and inscribed 'Miss Jones', was annotated '1/25': an interior shot required the 'Slow' exposure.[6]

Larkin must have learned a great deal from the camera bought in 1947. However, as Richard Bradford tells us (page 75), there was another camera before the Purma. Larkin's first camera, given him by his father, was a Houghton-Butcher Ensign Carbine no. 5. This was a good quality starter camera for amateurs – a folding, bellows model which yielded 'landscape' or 'portrait' format negatives of 6 × 9 cm. Larkin used it, for example, for his Oxford photographs and regularly after he acquired the Purma. The Ensign Carbine and the Purma, but not the Rollei, are preserved in the Hull History Centre.

On 20 November 1941 Larkin wrote to his painter friend Jim Sutton about a wonderful evening spent listening to Dylan Thomas performing at the Oxford English Club. He added, 'If you see this week's Lilliput you will find a very good photo of Dylan T . . .'[7] He was referring to a portrait of 'Dylan Thomas at the Salisbury' by Bill Brandt. It is one of Brandt's very best and was published in a feature on eight 'Young Poets of Democracy' in the issue for December 1941. If he saw Lilliput regularly, Larkin would have received an education in brilliant photography by Brandt and others. In addition, it seems likely that Larkin regularly saw Picture Post, which also championed the art of photography. As librarian at the University of Hull, Larkin bought a complete run of Picture Post (1938–57).[8] Larkin was creatively engaged with the popular arts of his time to an unusual degree, as Dr John Osborne has emphasised.[9] However, the official art world held photography at arm's length. Kenneth Clark, director of the National Gallery, remarked in a lecture in 1953 that 'it is the opinion held by many educated people that photography has nothing to do with art at all'. That prevalent view was overturned a generation later.[10]

Larkin used his camera, like most of us, to record his family, friends and holidays – but there was much more to his photography than that. As this book

shows, Larkin used photography to sharpen his connection with the broader social landscape towards which he was simultaneously reaching in his poems – that 'fuller and more sensitive response to life as it appears from day to day'.[11] He made poignant photographs of other lives, such as the 'Hull shop front' from 1956 (page 129), and he achieved marvels like the splendid photograph, full of vivid portraits, of a crowd outside James Rooney's jewellers in Dublin (page 9): perhaps this was the event that later triggered the dream that became the poem 'Dublinesque' with its 'stucco sidestreets, / Where light is pewter'. Larkin photographed another ritual, this time in colour, at the Bellingham Country Show (page 221). Larkin's marvellous photograph of the wrestlers is, however, outdone by his even more photographic account of the same event in verse (page 220).

A thread runs through Philip Larkin's life, intertwining his profession as a librarian, his vocation as a poet and his avocation as a photographer. As a librarian he was primarily concerned with the printed word and printing is 'the art preservative of all the arts'. As a poet, Larkin aimed, in his famous definition, 'to construct a verbal device that would preserve an experience indefinitely by reproducing it in whoever read the poem'.[12] As a photographer, Larkin managed the same act of preservation of family, friends, places, moments.[13]

Notes

1. See Mark Haworth-Booth, 'The bad review of *High Windows*', *About Larkin*, *Journal of the Philip Larkin Society*, No. 39, 2015, p. 5.

2. The History Centre has ambitious plans to revisit the current catalogue of Larkin's photographs through selective digitisation and updated descriptions. This will greatly enhance our understanding of this aspect of Larkin's oeuvre. The collection includes Larkin's Houghton-Butcher and Purma cameras (with colour filters and lens hood), plus a Polaroid Automatic 104 Land camera.

3. Sydney Larkin's camera, and Larkin's Rolleiflex – an Automat – were kindly identified for me by Michael Pritchard, author of *The History of Photography in 50 Cameras*, London: Bloomsbury, 2014, which includes sections on both the Baby Brownie and the Rolleiflex.

4. Ed. Anthony Thwaite, Philip Larkin, *Collected Poems*, London: Faber and Faber, 1988, p. 74.

5. Hull History Centre, U DP/1742/168.

6. These annotated prints are in wallet U DVL3/1-15.

7. Ed. Anthony Thwaite, *Selected Letters of Philip Larkin 1940-85*, London: Faber and Faber, 1992, p. 28.

8. Andrew Motion, *Philip Larkin: A Writer's Life*, London: Faber and Faber, 1993, p. 301.

9. John Osborne, 'Larkin and the Visual Arts', *About Larkin*, No. 36, 2013.

10. Mark Haworth-Booth, *Photography: An Independent Art*, London: Victoria & Albert Museum 1997, tells the story. Clark's comment is on p. 134.

11. Motion, *op. cit.*, p. 265 (Larkin writing to Robert Conquest, 28 May 1955).

12. Philip Larkin, *Required Writing. Miscellaneous Pieces 1955-1982*, London: Faber and Faber, 1983, p. 83.

13. I gratefully acknowledge the kind help of James Booth, Richard Bradford, Dennis Low, Alan Marshall, Dr John Osborne, Dr Michael Pritchard, Anthony Thwaite and, above all, Simon Wilson, University Archivist, and his colleagues at the Hull History Centre.

This is the most interesting of all Larkin's cropped photographs. It seems likely that he planned the crop while making the exposure. He was able to photograph the scene at some distance and without pointing his lens directly (and obtrusively) at the people relaxing under the trees – knowing that he could bring the scene he wanted closer by enlargement at the printing stage.

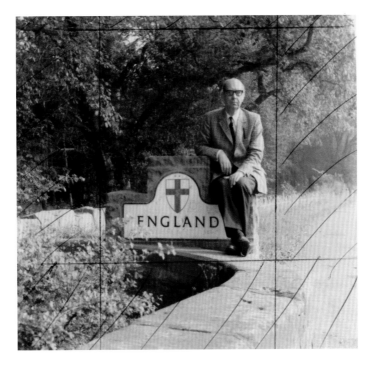

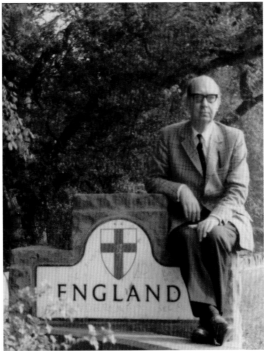

Larkin photographed Monica Jones at the same spot and presumably she
made this exposure. However, Larkin made many photographs of village
name signs and the idea was no doubt his – as was the cropping. This self-
portrait contributed to Larkin's image as an insular English patriot.

Before Hull

In January 1954 I wrote a poem called 'I Remember, I Remember' . . . after stopping unexpectedly in a train at Coventry, the town where I was born and lived for the first eighteen years of my life. The poem listed, rather satirically, a lot of things that hadn't happened during the time, and ended

'You look as if you wished the place in Hell,'
My friend said, 'judging from your face.' 'Oh well,
I suppose it's not the place's fault,' I said.

'Nothing, like something, happens anywhere.'

From 'Not the Place's Fault', 1959

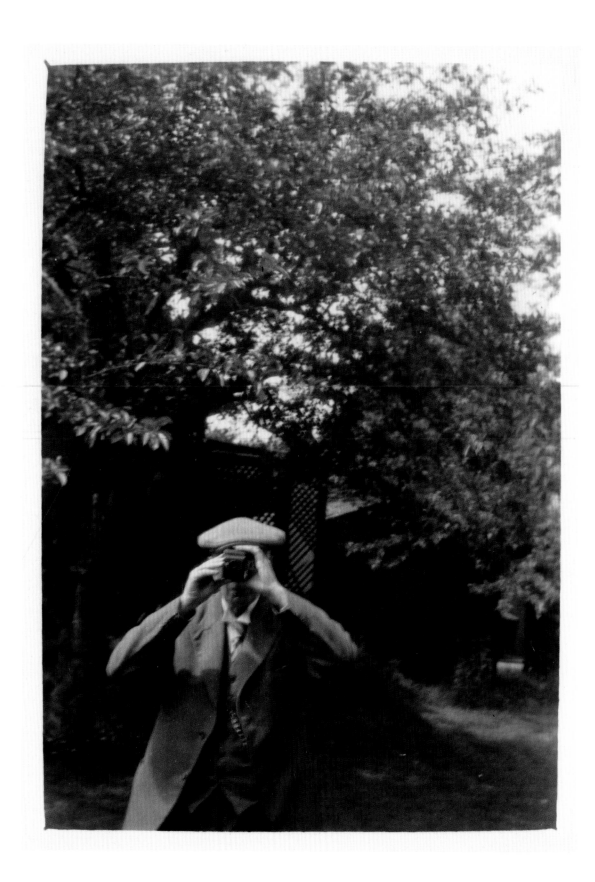

Chapter 1
Family

In an untitled poem that remained unpublished until twenty years after his death Philip Larkin comes close to offering an autobiography in verse. He begins with the day 'we broke up', when he left King Henry VIII School, Coventry. Passing through the 'Hall' he encounters 'long sheets of manuscript', nailed to the wall, which tell a story 'written in capitals / Upon some lavatory paper'. It begins with him at 'eight' when 'I came to school with large and curious eyes', and we are led through his teens via lessons in Latin, French, Maths, Geography, Chemistry to when he becomes engaged with a subject that goes beyond the curriculum.

> And I have read the poets
> Yes, every bloody one:
> From Langland up to Shelley
> And from Auden back to Donne . . .

He would not have come across Auden at school. His father Sydney had introduced him to the so-called 'Pylon Poets', along with the work of T.S. Eliot, Ezra Pound and Joyce's *Ulysses*.

School long past, he ponders the encroachments of age.

> O yes my hair is wavy
> But it comes out by the roots
> And falls in golden strands about
> My neatly-polished boots . . .

His eyes, he tells, us, are 'gentle' and yet his mind is 'quicker'.

Sydney Larkin at the rear of 1 Manor Road, Coventry, photographed by his son Philip, then aged eleven.

> For I read eleven hours a day
> And my specs are getting thicker

There is a wonderful rhyming segue where the focus shifts from physical decay to something more intangible.

> And though my smile is kindly
> My teeth are rotting in my head
> And though my thoughts are up aloft
> My lower half is dead.

'What' he asks a little later 'am I becoming'? He knows the answer. He has 'become' a state of mind.

> O I wish I wish I wish I were
> Anyone but myself:

If you are remotely familiar with Larkin the letter-writer or indeed Larkin the gloomily introspective poet you will not find this poem at all extraordinary; he is at his self-denigrating, misanthropic best. What is surprising, even unsettling, is that he began it when he was seventeen and completed it two weeks after his eighteenth birthday in August 1940. The stanzas covering his teens are based on recollections of his recent past but the rest of the piece might have been written by Larkin aged sixty. Few if any teenagers are blessed with such an abundance of weary prescience. Larkin would never be visited by disappointment; he always assumed the worst.

He was born on 9 August 1922 into a family that seemed to epitomise provincial, lower-middle-class ordinariness. His father Sydney was descended from four generations of artisans – tailors, coach makers, cobblers and finally shopkeepers – and after completing part-time courses in accountancy at Birmingham University he did well as a civil servant in the conurbation of the West Midlands. Shortly before Philip's birth he was appointed Treasurer of Coventry City Council, a position he would occupy until his death in 1948.

Sydney Larkin was a man of bizarre contrasts. His notebooks, many of which were retained by his son, reflect on obsession with ruthless efficiency. At one point he celebrates the creation at Coventry of a template for 'financial legislation . . . for many years the best in the country'. This was the 1930s and for inspiration he looked abroad, specifically to Nazi Germany. He corresponded regularly with Hjalmar Schacht, the German Economics Minister who is credited with rescuing the German economy from the cycle of depression and inflation caused by the 1929 slump. Sydney was determined to create in Coventry a microcosm of the German revival. His office in the City corporation was decorated with Nazi regalia, including a 12-inch statue

of the Führer which, when a button was pressed, would do a passable imitation of a Nazi salute. No one is certain whether Sydney found anything preposterous in this miniaturised version of fanaticism but there is circumstantial evidence that Larkin saw it as such. Even when receiving eminent dignitaries to his office at the University of Hull where he was Chief Librarian he insisted that his own statue of Guy the Gorilla maintained a prominent position on his desk.

Before we dismiss Sydney Larkin as a faintly bizarre version of Arnold Bennett's Clayhanger we should note that he was an immensely well-read, astute connoisseur of avant-garde literature. As a youth he cultivated a taste for Hardy, Wilde, Butler and Shaw but by the time Philip was born he had shifted his attention to the Modernists, not a widespread interest among local authority figures in the West Midlands. He read Joyce, from *Dubliners* to *Ulysses*, and the year before his son was about to leave school he acquired a copy of *Finnegans Wake*. He was an avid follower of Woolf, Eliot, Pound and Katherine Mansfield but his favourite was D.H. Lawrence, principally because Lawrence was concerned as much with ideas as art. In *Aaron's Rod*, for example, Lilly argues for the introduction of 'a proper and healthy and energetic slavery', plus a programme of extermination for the worst of the lower orders and for the rest an instilling of respect for a natural aristocracy. Lilly was a prototype fascist and there are parallels between Lawrence's model of social and ethnic cleansing and Sydney's routine in the family home.

He met Eva Day in the summer of 1906 when both were on holiday in Rhyl. She was a junior school teacher and for Sydney she was a manageable version of the new independent woman: educated, moderately cultured but not overambitious. During the five years between their first meeting and their marriage in 1911 Sydney would have no idea that his fiancée was in truth a nervous jittery individual who craved support, and Eva had no reason to foresee a life with a monomaniac who would interpret her needs as evidence of weakness and failure.

Larkin's only detailed public account of his childhood is 'Not the Place's Fault' (1959), a rather wistful recollection of provincial city life, including his hobbies and early schooldays. It is honest enough, in that he tells no outright lies, but compare it with a semi-autobiographical notebook (preserved in Hull) and an impression forms of a man well suited to the routines of librarianism. He rigorously categorised his life and made certain that parts of it would remain scrupulously separate from others. In 'Not the Place's Fault' his parents and his only sibling, his elder sister Kitty, are hardly mentioned at all and in the unpublished notebook we discover why. Sydney treated her, Kitty, as 'little better than a mental defective' and he reports that on one occasion Eva sprang up without warning 'announcing her intention to commit suicide'. Larkin concludes that 'the marriage left me with two convictions: that human beings should not live together, and that children should be taken from their parents at an early age.

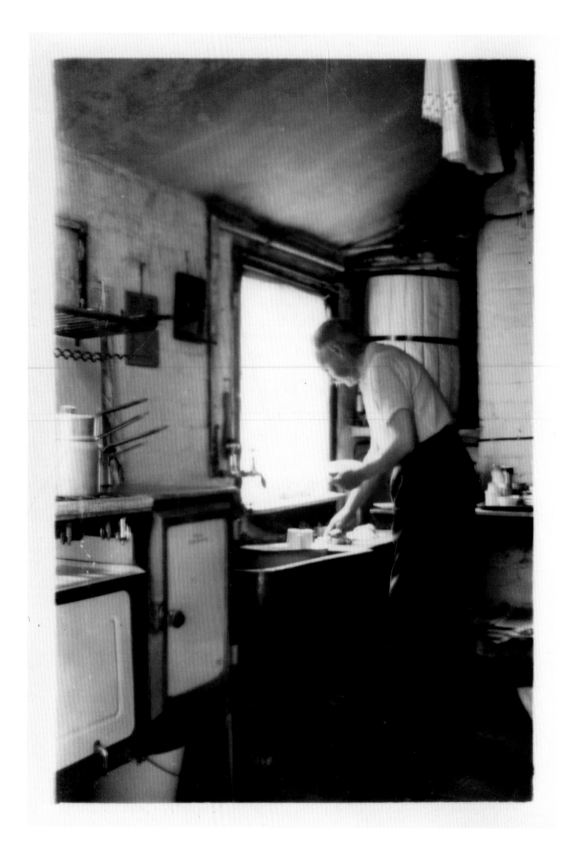

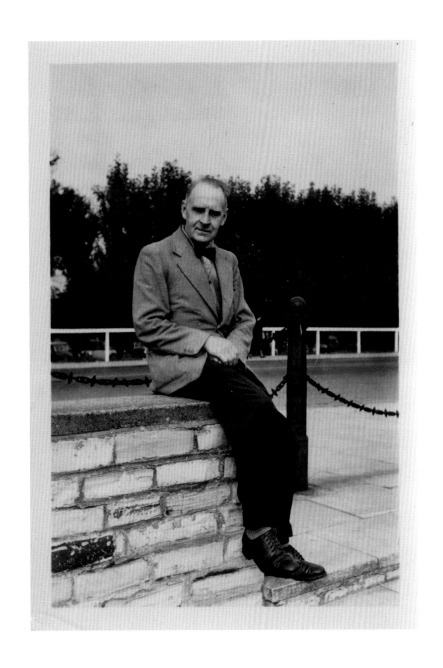

OPPOSITE Sydney in the scullery of 1 Manor Road, *c*.1937.

ABOVE Sydney in Coventry, 1939.

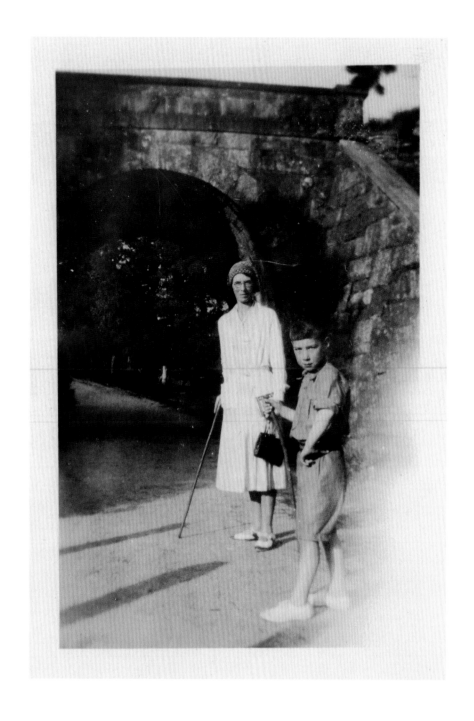

ABOVE Larkin with his mother, Eva, 1929.

OPPOSITE TOP Larkin and Kitty during the 1936 trip to Germany.

OPPOSITE BOTTOM Larkin and Eva during a family holiday in Folkestone, 1936.

Chapter 2
Friends

The notebook seems despairingly candid, yet it leaves out a great deal. Sydney treated Larkin as his beloved alter ego. He saw in his son a version of himself, but one who would benefit fully from his self-evident cleverness. He insisted that Larkin should attend King Henry VIII School because it was extraordinarily eclectic, even liberal, in terms of its curriculum. It gave special emphasis to the modern sciences, alongside Latin and Greek, yet beyond the fifth form pupils were encouraged to read modern literature. The headmaster who had instituted this unusual regime, A.A.C. Burton, had been appointed in 1931 shortly before Larkin's arrival. Burton's adventurous notions of pedagogy might seem to have anticipated the 1960s but in other respects he was solidly Victorian, subjecting slackers and miscreants to public beatings. Staff and pupils would be obliged to witness these and one of the former, E.J. Liddiard, reported that he felt 'sick all day . . . his beatings were cruel'. The eerie blend of bohemianism and lunacy that obtained in the Larkin household seemed to have followed Philip into his school life.

He sought relief mainly through his friendships with Colin Gunner and Jim Sutton. Gunner was a shiftless mischief-maker, seemingly impervious to authority – Burton's included: he left KHS at sixteen and joined the army. Sutton presented Larkin with the opposite of his world at home. His father, a self-employed builder, had designed and constructed the airy, spacious family home on the outskirts of Coventry where sometimes Larkin would observe a world he had previously only imagined. Friends of the family would gather and drink cocktails; in summer they would play tennis on courts in the garden and bathe in the swimming pool. Drinks would be offered to Philip and Jim.

Gunner offered Larkin an irresponsible counterbalance to some of the more disturbing aspects of Sydney's regime. In 1936, for example, the fourteen-year-old Larkin had accompanied his father and Kitty on one of his frequent visits to Nazi Germany. They spent most of the time in Wernigerode, in Saxony-Anhalt, a medieval city of half-timbered houses overlooked by a grand castle and flanked by the Harz mountains.

This idyllic reminder of Germany's fascinating history was not, however,

immune from the present day. Flags displaying the swastika were ubiquitous as were posters involving vivid representations of muscular militaristic Aryanism, along with grotesque caricatures of Jews as archetypes of greed and deception. Irrespective of what one thought of Nazism it was evident that some form of international conflict was imminent. No records of how Larkin felt about these visits survive, beyond a farcical story told later to Kingsley Amis of his failure to reply to a bus conductor in correct German. After a second visit in 1937 Larkin wrote in his notebook that 'My Father liked jolly singing in beer cellars, three–four times to accordions . . .', an observation so forcibly bland that the refusal to say anything else about what attracted his father to the place is almost tangible. A year later during the 1938 Munich Crisis Larkin and Gunner disguised themselves as newspaper sellers, ran alongside stationary trains in Coventry station yelling 'War Declared!' and sent commuters into various states of hysteria.

Sutton provided a more mature form of escape. They discovered jazz, graduating from the Anglicised conservatism of Billy Cotton and Teddy Foster to the dangerous exoticism of America, particularly the black America of Louis Armstrong and Sidney Bechet. They discussed poetry and fiction and found a shared sense of affinity with D.H. Lawrence as an artist rather than a demagogue. Sutton had already begun to paint and would eventually go to art school.

Just after war was declared for real in 1939 Larkin drew a cartoon for the amusement of Sutton. It shows the Larkin family at home, with father reading the newspaper and commenting, 'the British government has started this war . . . Hitler has done all he can for peace . . . well I hope that we all get smoked to Hades . . .' followed by some Nietzschean observations on the decline of civilisation.

Eva, knitting, answers, 'oh do you think so' and adds 'I wonder what we ought to have for lunch tomorrow . . . well I hope Hitler falls on a banana skin . . . by the way I only washed four shirts today', while Kitty mumbles something about George, a stormtrooper who had asked her to a dance – she had replaced Philip on Sydney's final trip to Germany the year before. Larkin sits staring darkly at a blank sheet of paper, his face drained of emotion, his pen poised but seemingly immobilised. It captures perfectly the weirdness of Larkin's family life; the commonplace features of provincial lower-middle-class existence are shot through with something abundantly peculiar. Within two weeks of sending Sutton the cartoon he wrote him a letter which might serve as a speech bubble for his silently brooding depiction of himself: 'half my days are spent in a black, surging, twitching, boiling HATE!!!' He does not go on to describe the target of his loathing and one might easily be forgiven for treating him as a man who would harbour a long-term contempt for his childhood and background and those who had been closest during his formative years. But it is not so simple. He loved his father deeply, and despite the self-evident ill-suitedness of Eva and Sydney he reserved an equal degree of genuine affection for his mother. In a letter to Monica

Jones reporting Sydney's premature death from cancer of the liver in 1948 the mood of sadness and despair is evident more in what is not stated than what is said. He tells her that 'my poor father grew steadily worse and died on Good Friday' and the rest of the lengthy report involves a rambling account of how he and Eva were 'looking at the stock in the house'. He spends an inordinate amount of space describing Kilner jars of bottled fruit and concludes, eventually: 'I don't know what will happen to it all – I don't like sweet things, you remember.' He is, in that very English way, talking pointlessly about anything that will numb a dreadful pain he would rather not admit to, let alone describe. After Sydney's death he wrote more frequently to Eva than to any other person, often sending her a letter every day, enquiring about her health and commonplace matters and trying to amuse her with his own seemingly trivial routines. Often he sounds like a man who has not quite grown up, or one who does not wish to. What cannot be doubted is his sincerity. She remained his rather hopeless but dearly loved 'Mamma' or 'Mop'.

Larkin's early life was most certainly unusual and many would have revolted against it or simply estranged themselves from it. He treated it as his due inheritance, something to be wearily endured, embraced with a mixture of affection and morbid enthusiasm. Aged twenty-nine he offered a starkly vivid portrait of these years in 'Best Society', one of his finest early poems.

> When I was a child, I thought,
> Casually, that solitude
> Never needed to be sought
> Something everybody had
> Like nakedness, it lay at hand
> Not specially right or specially wrong
> A plentiful and obvious thing
> Not at all hard to understand.

The 'solitude' he speaks of is not the meditative, solipsistic brand. It was an affliction he witnessed, something shared in varying degrees by Sydney, Eva and to a lesser extent Kitty, and in many ways he relished his role as participant and spectator in this dysfunctional assembly. It would enable him to gain control of what for Eva and Sydney was an obdurate affliction. He managed and choreographed various aspects of his solitariness, becoming different versions of himself for different people. He did not lie; rather he was selectively candid and virtuously dishonest and only rarely did this disparate presence come together – most notably in his poetry.

'Best Society' is an extraordinary poem in its own right, and it becomes all the more remarkable when we compare it with an unpublished notebook, written

around the same time, in which Larkin muses on his past. Creative osmosis is much speculated upon but when we read the notebook alongside the poem it is as though we are watching Larkin at work, distilling the enigmatic grace of the lines from the stark recollection of the prose.

What kind of home did they create . . . ? I should say it was dull, pot-bound and slightly mad . . . It was not a house where anyone called unexpectedly, as my father had no friends . . . I never left the house without a sense of walking into a cooler, cleaner, saner and pleasanter atmosphere, and, if I had not made friends outside, life would have been scarcely tolerable . . . Second child, myself, lived in a private world.

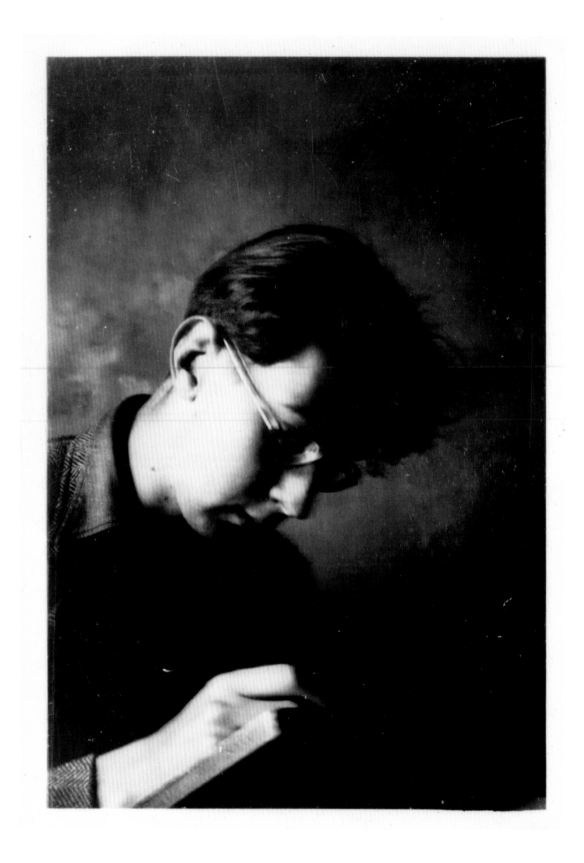

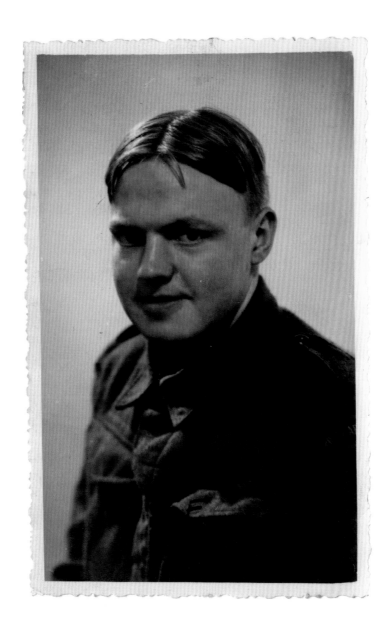

OPPOSITE Larkin, inspired by Sutton, had tried to paint, mostly watercolours and sketches. All that survive are pencil cartoons in letters but this photographic self-portrait is inscribed 'P.A.L. Painting.'

ABOVE Jim Sutton in battledress, 1941. Inscribed, 'To Philip from Jim'.

Jim Sutton photographed in Coventry by Larkin after his demobilisation in 1946. They would communicate infrequently after that and their correspondence would cease completely five years after these pictures were taken.

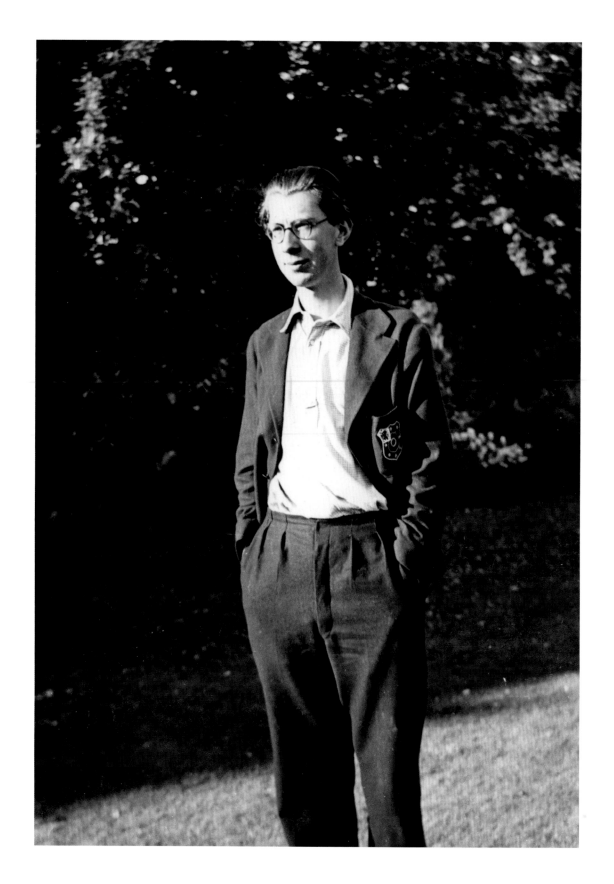

Chapter 3
Oxford

During his first year at St John's College, Oxford, Larkin tried desperately to reinvent himself as something other than the 'second child' in his 'private world'. He began with his wardrobe, sporting a collection of trousers that contrasted garishly with the standard greys and browns of his peers, notably some bright green cords and, he claimed, the only 'pair of cerise bags' in Oxford. To supplement these he would wear silk bow ties and waistcoats of equally loud hues, and despite his already receding hairline he let his black hair grow long at the front, allowing him to sweep aside what remained of his untidy fringe in true bohemian style. He entered self-consciously scurrilous remarks on life in general in the Junior Common Room 'Suggestions Book' and soon began to make a point of refusing to attend lectures. In letters to Sutton he berated Tolkien (Anglo-Saxon poetry), Neville Coghill (Chaucer), C.S. Lewis (Medieval and Renaissance Literature) and Charles Williams (Milton) as, variously, boring and incoherent. The course terminated with the writers of the 1820s and apart from finding himself thrown back to a canon that predated everything he had enjoyed in Coventry he was also dumbfounded by an apparent obsession with matters that seemed only marginally connected with poems and plays as art, such as how quarto versions of Shakespeare differed from their folio counterparts. The question of why they were not the same and if this caused one version to be superior to another was, he noted, never raised.

He seemed caught in a world of anachronisms, some of his own making. The younger dons had all been called up for wartime service and undergraduates were being regularly conscripted, deferring the remainder of their degrees until their return following the cessation of the conflict. But it was by no means certain that Britain would survive. Larkin had gone up three months after the Dunkirk evacuation

Larkin in St John's garden, 1941. Letter to Sutton, 23 June: '. . . stamped out of Playhouse and a shitty play. I seize a pad of blue bog paper and shamble out on to the sunlit lawns. Brilliant sun at 9.5 pm. Pigeons coo and generally gargle in the distance. Bird calls around me seem curiously distinct and artificial.'

and while Oxford was never bombed – Hitler, it was later revealed, wished to preserve it as one of the spoils of victory – the drone of bombers on their way to other cities was a regular feature of the blacked-out nights. The glamour and elitist self-confidence of the city appeared to have been absorbed by a fabric of ominous dreariness. Fire buckets and sandbags stood at the openings to staircases, and the ancient mullioned windows had tape on the glass and were hung with thick black-out curtains. Each undergraduate, Larkin included, had to do an all-night fire-watching stint every ten days. Larkin, with his flamboyantly bright bow ties and trousers, his slouch-brimmed hat and his well-rehearsed sardonic observations on the dons and the curriculum, seemed absurdly out of place.

In truth his self-cultivated image as an aloof eccentric was an attempt to secure himself against a fear of becoming ordinary and nondescript. This is his portrait of Sydney in a fragment written more than a decade later.

> . . . my father was intensely shy, inhibited not robust, devoid of careless sensual instincts (though not of humour) . . . [his] brain was dominating, active and keen . . . [but] his personality [incorporated] an ungenerous defeated pattern of life . . . I remember once saying to him that, after all, I supposed he had had a successful life. His humourless yap of laughter left no doubt as to what he thought on the subject.

As a eulogy it is charmless but its real topic is Larkin's recognition of himself as, temperamentally at least, a near facsimile of his father. He could not jettison his personality but what terrified him most of all was that it might condemn him to an existence like Sydney's. He knew what he wanted to do: he saw himself as a writer. Between 1937 and his first year in Oxford he produced almost 300,000 words of prose fiction – largely incomplete attempts at everything from realist novels to crime fiction – and a considerable number of poems. He burnt almost all of them. His problem was that, while he had considerable skills as a stylist, he could not locate a suitable subject. His first published poem, 'Ultimatum', appeared in *The Listener* six weeks after his arrival in Oxford, on 28 November 1940, but he had written it within months of Dunkirk earlier that year. It reeks of the self-indulgently distracted manner of Auden and the so-called 'Pylon Poets' – faintly ominous but resolutely unspecific.

> For on our island is no railway station,
> There are no tickets for the Vale of Peace,
> No docks where trading ships and seagulls pass.

We know that the lines are informed by the sense of fear that would have been felt by virtually everyone on an 'island' with no allies and from which there seemed no possible means of escape. But for Larkin to say anything in particular about June

1940 would probably have seemed vainglorious, even vulgar. This was, after all, a poem and not a newspaper report. Six months after 'Ultimatum' he wrote to Sutton:

> The enormous impact of war has given Oxford a fundamental shock, so that its axis has been shaken from the Radcliffe Camera to Carfax. Army lorries thunder down Cornmarket Street in an endless procession, past queuing shoppers and shops quickly altering their standards of judgement. Away in the depths . . . of university quadrangles, I gain the impression of being at the end of an epoch. Will the axis ever return to its normal position?

'Ultimatum' is a self-conscious performance, imaginative and uninvolved, while in the letter Larkin speaks candidly, marshalling his anxieties and perceptions as the engine of his writing.

It would take him a decade to discover how to combine his authentic voice – anxious, indecisive and pessimistic – with his unimprovable talent as a poet.

In the interim his attempts to find a role for himself as a writer were paralleled by his rather hopeless attempts to manage his life.

Larkin's performance as capricious aesthete was based on an image of Oxford that endured from Waugh's *Decline and Fall* (1928), where members of the Bollinger Club enjoy a carelessly hedonistic supremacy in undergraduate life. Waugh's Oxford was largely fantasy but within weeks of his arrival Larkin came upon a man who appeared to be a very grotesque leftover from it, his tutorial partner Norman Iles. Iles was contemptuous of all forms of discipline and regularity. He stole from the Buttery, voiced libellous and obscene comments on his peers and the dons that others would only enter as euphemisms in the JCR Suggestions Book and he drank regularly and illicitly in local pubs, seemingly immune from the attention of University Proctors. Iles did, however, introduce Larkin to a group of undergraduates that would eventually mutate into an informal jazz and literary society called 'The Seven'. Initially, this involved around a dozen men who would assemble in someone's rooms at night, if possible with bottles of beer and cigarettes, to talk about anything they had recently read, listened to or, less frequently, written. Early enthusiasts included Nick Russel, James Willcox, David Williams, Mervyn Russell, Philip Brown, Graham Parkes and Edward du Cann, all from St John's, plus Frank Dixon of Magdalen and Dick Kinder of Christ Church. In 1941 the group became smaller and more specifically focused on contemporary literature and its members' potential as writers. For Larkin, its most conspicuous new member was introduced to him by Iles; he was called Kingsley Amis.

Everyone in the group seemed to shy away from an enthusiasm for or commitment to anything in particular, be this an idea, an author or a clearly formed ambition. Few if any expected to complete their degrees, and as the Luftwaffe intensified its attacks on British cities the prospect of returning to the world they had known became all the more remote. Rarely did the number of undergraduates

at St John's rise above seventy; many completed a single term of their degree in uniform and university carried an atmosphere of hectic transience about it. It was Iles who encouraged Larkin to skip lectures that bored him and often Larkin found himself alone with their tutor Gavin Bone. Iles might in other circumstances have been sent down for refusing to attend tutorials but Bone was indulgent, and ill; he would die from cancer in 1942. Iles earned himself a reputation as a rebel and Larkin was magnetised by him. Larkin's relationship with Iles may be compared to that with his earlier wayward friend Gunner. But Gunner had no interest in books, music or art, while Iles presented himself as an intellectual egomaniac. Like Larkin he was a fan of D.H. Lawrence, but not an advocate of his ideas. Iles thought he could outrank him in terms of radical thinking regarding behaviour and art. This, Larkin stated, 'seriously frightens me', but Iles also bolstered his sense of self-esteem and helped ease his shyness. Larkin's letters to him during the Easter and Summer breaks of 1941 are reckless, confident and callow. Every paragraph is loaded with high-minded fatuities: 'If a man hasn't got his roots in a woman he'll have them in something else such as family code' (17 April 1941). Sometimes he aggrandises Iles, or to be more accurate both of them, as participants in a kind of Socratic one-to-one: 'Brown is my acquaintance, James [Sutton] is my comrade, you are my antagonist . . . We are both (you and I) "intellectuals". We depend upon language . . . James hasn't got the gist of expressing himself in words, and so naturally he doesn't seem so clever' (29 September 1941). To Sutton he presents Iles, with whom he was obliged to share rooms in October 1941, as a selfish bully, oblivious to the feelings of others. He would steal or misuse Larkin's possessions, clothes included: 'everything I possess is me: possibly it springs from a sense of inferiority, a desire to bolster up my personality with material things . . . but anyone that treats my things with the slightest carelessness earns my blackest loathing. Norman . . . treads on my toes ceaselessly' (10 November 1941). Certainly Sutton and Iles were his two closest friends during his first year at Oxford but during the same period he seemed constantly in need of others who would bolster his constantly wavering sense of self-regard, if necessary by taking the time to argue with or infuriate him. It was for this reason that he often comes across as a hypocrite, assuring Iles or Sutton that each alone was his true equal and confidant.

His reasons for this are straightforward. Oxford, his first opportunity to explore the world beyond the corrosive environment of his family home, seemed to him like a morbid version of a railway station. He had long enough, just, to speak with strangers in the waiting room but there was a collective preoccupation with a new timetable, and the clock. Life seemed supercharged, transient and frightening.

He composed a poem entitled 'Conscript' in October 1941. It reads like a strange combination of Auden and Tennyson and it laments Sutton's departure from Oxford to serve in the 14th Field Ambulance Corps.

Others were being called up and leaving just as frequently. He wrote to Sutton, two months after his conscription, of what had become something close to a ritual

performed in the beautiful gardens of St John's. 'We took photographs . . . Whiffen . . . refused to be taken . . . Norman looks like a Communist orator answering a question, Josh resembles a cheap film star of the 1920s, Buck looks as if someone has stuck a bayonet up his anus, Willcox looks deadly serious and intent, Brown looks like a happy young fox; and I look like a warmed up corpse' (23 June 1941). The frivolity is forced and it soon gives way to a blend of anxiety and resignation. 'There is also a group [portrait]. Very difficult to get enough prints done here. We want a set each, you see. God!' The photographs could well be the only enduring record of friendships that might never be renewed. After his medical examination in December 1941 Larkin was found unsuitable for active service. He had known, and in truth hoped for, the result since being asked to register for service in the summer: from his early teens he had been almost blind without his spectacles. He was one of the few in the College who would not be called up and he took on the role of visual elegist, roaming through St John's with a camera he had brought from Coventry, once his father's, and photographing friends and contemporaries, some of whom he hardly knew. He put together an album in a notebook of rough recycled wartime paper. On the left, facing each photograph, he inscribed the date and the full name of his subject in a manner formal enough to invite comparison with a 'lost in action' reference in despatches, or even a gravestone.

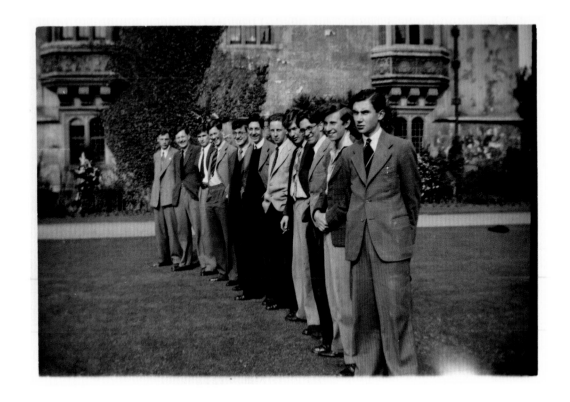

ABOVE Photograph by Larkin in St John's, Oxford. Accompanying note by Larkin: 'Formal Group. Right to left: Mervyn Brown, Philip Brown, Graham Parkes, Kingsley Amis, David Williams, Edward du Cann, Norman Iles, David West, Nick Russel, Walter Widdowson and MacNaughton Smith.'

OPPOSITE, CLOCKWISE FROM TOP LEFT Inscribed by Larkin: 'Summer, Oxford, 1943. N.C. Iles as 2nd Lieutenant', 'Hilary Joliffe Morris, 1941', 'David Glyn Williams, 1941', 'Nicol Russel, 1941'.

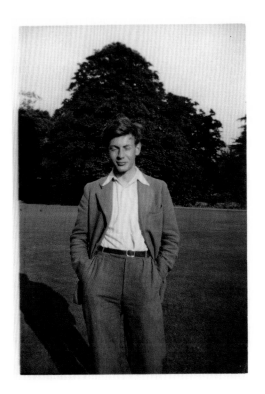
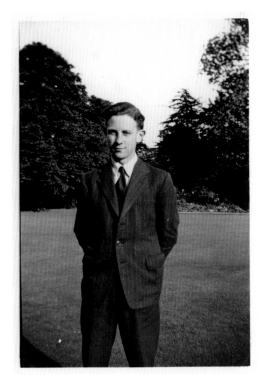
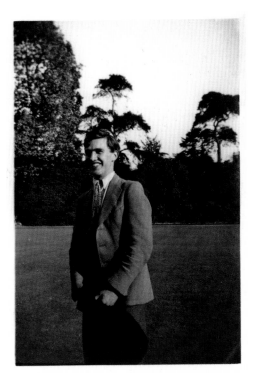

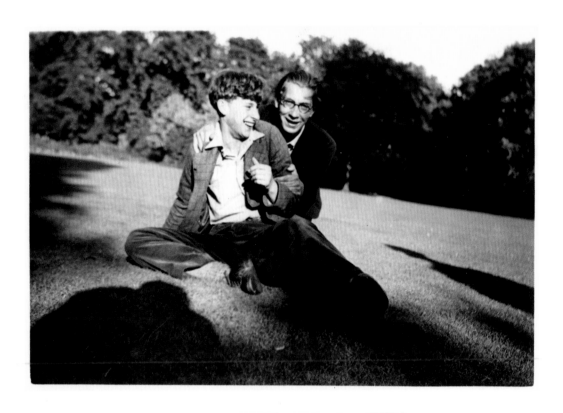

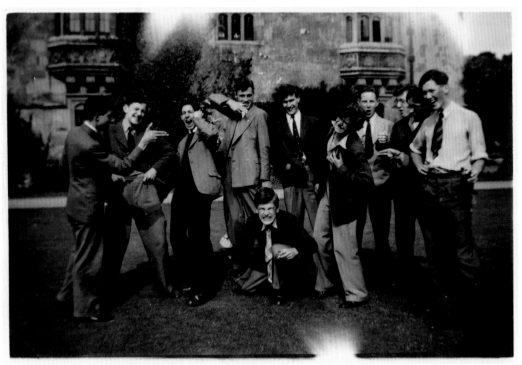

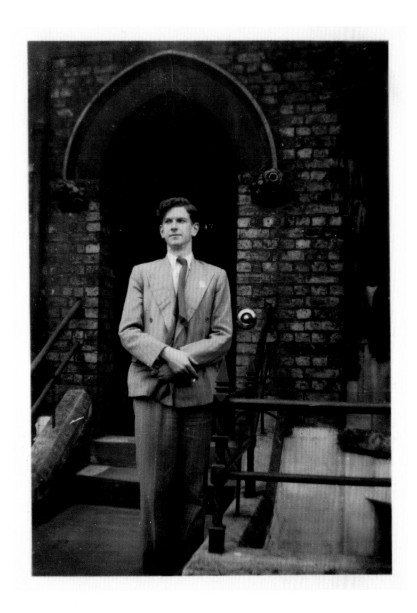

OPPOSITE TOP 'Philip S. Brown, P.A. Larkin.'

OPPOSITE BOTTOM Summer 1942. Group (left to right): Mervyn Brown ('Scarface'), J.B. Widdowson ('Russian Officer'), E.D.L. du Cann ('In the Rear of the Enemy'), MacNaughton Smith ('Scarface'), Kingsley W. Amis ('Japanese Soldier'), Nicol J.H. Russel ('Scarface'), P.S. Brown ('Scarface'), David Williams, N.C. Iles ('Firsttodai'), Graham Parkes ('Scarface'), David West ('Roumanian Officer').

ABOVE Bruce Montgomery outside his lodgings in Wellington Square, Oxford 1942.

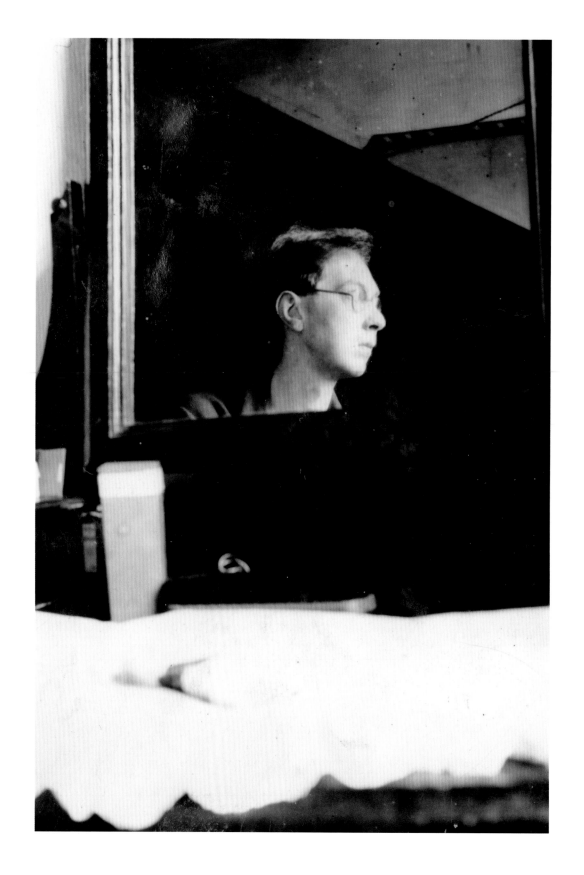

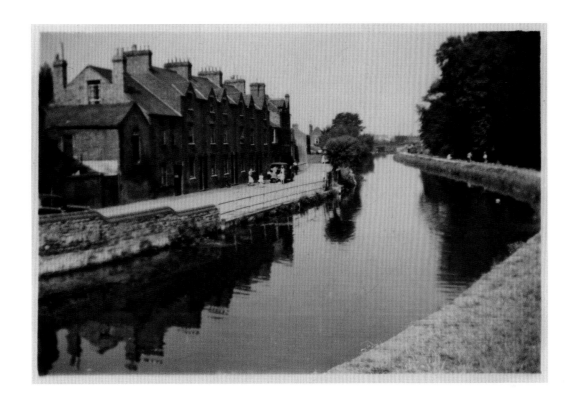

OPPOSITE One of Larkin's earliest self-portraits, taken in his room at St John's.

ABOVE Image of Oxford Canal. Walton Street, where he spent time in the Victoria Arms, led down to the canal. Bruce Montgomery had rooms near the street, as did Philip Brown.

Chapter 4
Kingsley

Something happened in May 1941 that would play a part in what Larkin did and felt for the rest of his life, though at the time its significance did not register. He and Iles were walking through the Porter's Lodge and the latter pointed out to him the name of a freshman he had met the previous year when both had tried, unsuccessfully, for Cambridge scholarships. Iles informed him, enigmatically, that he was 'a hell of a good man . . . who could shoot guns'. Later that day Iles pointed his finger, pistol style, at a young man emerging from a staircase in the front quad. After the stranger's passable imitation of being shot in the chest Iles introduced him to Larkin as Kingsley Amis, who then offered his own pistol-shot performance.

During the next few weeks he would follow this with imitations of a large number of their mutual acquaintances. Decades later Larkin wrote, 'For the first time I felt myself in the presence of a talent greater than my own.' (*Required Writing*, p.20) There is some facetiousness here but also a degree of polite modesty regarding their later double act. Between them Larkin and Amis would be more influential than any other writers in shaping the mood of British fiction and poetry in the two decades after the Second World War.

Their friendship flourished because for the first time Larkin had found someone who shared his flaws and idiosyncrasies and who was equally serious about writing as something other than a recreation.

Their fathers had much in common: not self-employed, but men who valued their self-made independence; both were politically conservative agnostics, a curious combination among the lower middle-classes of the thirties. For their sons, school was a valued alternative to households run by minor autocrats. Amis confessed to Larkin that his enthusiastic commitment to communism was in part a means of asserting his independence. He knew that it irritated his father, an arch-Tory, but that the latter could only fume impotently: his son, now an adult, was entitled to his opinions. How, wondered Larkin, might Sydney have reacted if he had declared his loyalty to Stalin? He would, he realised, probably have relished the challenge, and as a consequence stifled Philip's act of rebellion.

As they talked it seemed more and more that their lives too had followed almost parallel trajectories, been authored by the same omnipotent narrator determined to have fun by reframing Amis's as suburban farce and Larkin's as parochial grotesque. Both loved jazz but for Amis there was a further opportunity to infuriate his father, who regarded Duke Ellington records as evocative of 'dark skinned savages dancing round a pot of human remains'. Sydney encouraged Larkin's interest in such music, buying him a complete drum kit and paying for his annual subscription to *Down Beat*. William Amis treated much classical music, without the human voice, as a form of grandiose self-indulgence – he preferred Gilbert and Sullivan – while family attendance at classical concerts in Coventry was standard fare. Amis's parents enjoyed middle-market contemporary fiction and this too inspired Kingsley to rebel against anything his father espoused. His admiration for Auden, MacNeice and Eliot matched Larkin's but it had been acquired as a means of dissent from William's suburbanism. Sydney, by contrast, had energetically encouraged his son's interests in all aspects of avant-garde writing. The literary, cultural and political enthusiasms that Amis used as a means of announcing his impertinent singularity appeared for Larkin to have been anticipated and, rather eerily, endowed to him by Sydney. They were fascinated by each other and would spend long periods, usually in Amis's rooms, listening to jazz records, often prancing around in an attempt to mimic the improvisational rhythms of the piece. In the Victoria Arms on Walton Street Larkin could sometimes be persuaded to do a twelve-bar blues on the untuned piano, and 'if there were no outsiders present' Amis would join in with lyrics borrowed from record covers.

Larkin stated that his ultimate ambition was to write important fiction while Amis professed his commitment to poetry. During the first year of their friendship in Oxford neither made significant advances on their literary objectives. Instead they distracted themselves continually, each feeding the other's appetite for farce, satire and caricature. Amis would write obscene clerihews about college dons and during their private discussions of poems by other members of 'The Seven' they became weary of constructive comments and decided to have two rubber stamps made, reading 'What does this mean?' and 'Why do you think I care?'. By the summer of 1942 they had evolved a private ritualistic habit of speech which allowed them to comment as economically as possible on anything self-evidently boring, pretentious or ludicrous: 'Spencer bum, piss William Empson, Robert Browning shag.' The practice endured in their letters until Larkin's death, notably with 'bum' as a substitute for the second part of a deliberately tortuous closing sentence. Amis's copy of Keats's *Poems* contained a comment by Larkin on the moment of ethereal transcendence in 'The Eve of St Agnes': 'YOU MEAN HE FUCKED HER'. Gradually but insistently Amis was displacing both Sutton and Iles.

Astonishingly Larkin decided to say nothing at all to Amis even of Sutton's existence. During 1941–2 the latter was away, involved in various training exercises,

so Larkin knew Amis would not encounter him during a visit. But even after 1946 when both Sutton and Amis had been demobbed he treated each as if they existed in different universes. Neither in the *Collected Letters* nor in the unpublished correspondence still in archive can there be found any reference to Sutton in Larkin's letters to Amis or to Amis in his letters to Sutton. Amis first heard of Sutton, his close friend's other close friend, when Larkin's letters went into print, seven years after his death.

Larkin had reached a crossroads and these two young men represented ways in which he could contemplate alternative routes without committing himself fully to one or the other. Sutton, willingly enough, evolved into Larkin's subordinate muse. He was clever enough to respond appreciatively to Larkin's speculations on the directions of his writing and the inspiration he might draw from, variously, Homer Lane, Auden, Yeats, Lawrence and Freud but he was more a sympathetic listener than a fellow thinker, at least in Larkin's view. Larkin's letters to him, particularly after 1941 when he began wartime service, often carry the air of notebooks or diaries, prone to sudden changes in focus and discontinuities. It was as though Larkin was writing to himself but with the compensatory knowledge that he would receive a comforting and unthreatening reply.

Amis, by contrast, mirrored the rebellious, even argumentative element of his personality and was as likely to ridicule his enthusiasms as debate them seriously. On the one occasion that Larkin ventured his opinions on the psychological theories of John Layard and their creative counterparts in Lawrence, Amis replied that he should stop talking 'all that piss about liar's quinsy' and he did. Though he maintained a somewhat nostalgic affection for the work of Lawrence at least until the 1950s he avoided any mention of him in correspondence with Amis.

Larkin sat his finals in May 1943, a year after Amis, Sutton and Iles had departed for military service. To Iles he predicted he would be awarded 'a Second if I'm lucky', to Sutton, 'a Third, at most a Second' and to his parents 'a Third or lower'. In July he ascended the steps of the Sheldonian Theatre to find his name on the list of Firsts. He was genuinely, if briefly, elated and Eva and Sydney attended his graduation ceremony. Afterwards the three of them were joined for lunch in the Randolph Hotel by Bruce Montgomery, his only remaining friend in the city, and Diana Gollancz, for whom he entertained a tentative and completely hopeless infatuation.

Montgomery was only a year older than Larkin but had become something of a legend in Oxford: composer, painter, author of two novels and a radical survey of Romanticism (all unpublished but much advertised by Montgomery). He was the scion of a comfortably-off country family and cultivated the image of the lazy idiosyncratic sybarite, one of the few of that wartime generation who could indeed have walked out of a novel by Waugh. Amis too got to know him before his departure and both treated him with a blend of fascination, amusement and curiosity. All three would remain friends until Montgomery's death in 1978.

During the summer and autumn Larkin went through the obligatory ritual of applying for jobs. He had no interest whatsoever in a career or any other kind of conventional salaried activity – he wanted to be a writer – but wartime Britain did not allow for such self-serving activities. He failed his general interviews for the Civil Service in August after informing the panel that he would only offer them his considerable intellectual gifts part-time, in return for a livelihood sufficient for him to pursue his literary ambitions. Next, in September, the War Office looked him over as a candidate for training in counter-intelligence and again he was found unsuitable.

Amis and two friends, Oxford, 1941.

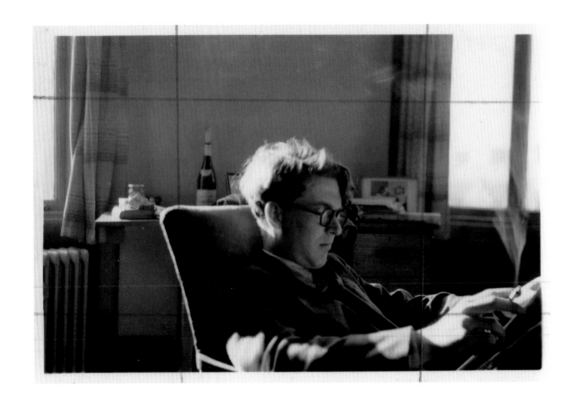

Amis in St John's, 1941.

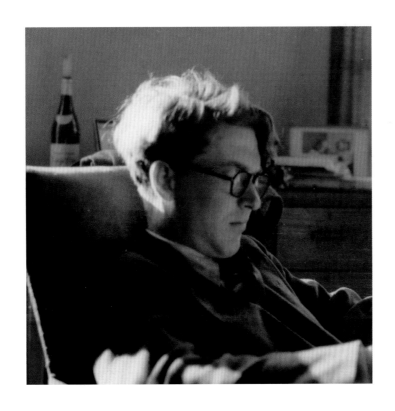

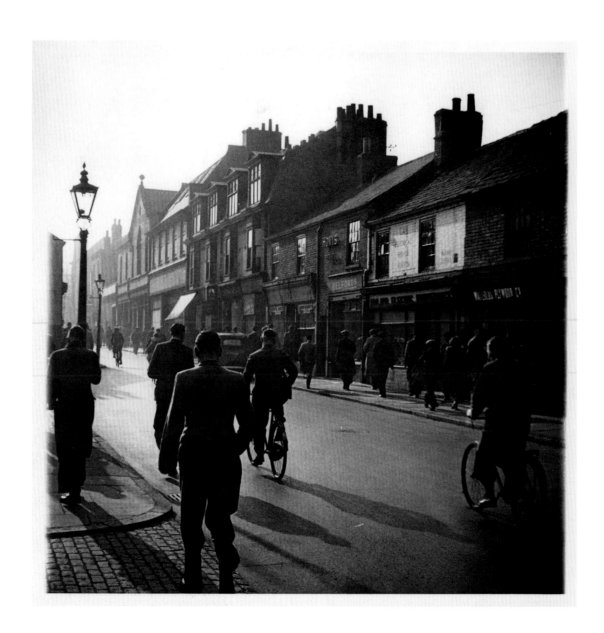

Chapter 5
Wellington and Leicester

In November Larkin was offered the post of Librarian in the public library in Wellington, Shropshire. He found a bedsitting room in a poorly heated Victorian house about a five-minute walk from his work. Miss Jones, his landlady, forbade the playing of phonographic records, jazz especially, and apart from being obliged to share the kitchen and bathroom with three other residents and, as he put it to Sutton, 'hand . . . tripey novels to morons' in the library, he ceased to have a social life. His only relief was provided by Montgomery, who had taken a temporary teaching post at Shrewsbury public school, roughly half an hour away by train. They would meet regularly at weekends and drink as much as possible. Larkin once passed out in the carriage on his return journey from Shrewsbury and awoke next morning in a siding at the next station. More famously they attended a meeting of the Shrewsbury School Literary Society after a pub crawl through the city. Montgomery spoke on Keats while Larkin found that his bladder was demanding more of his attention than his friend's somewhat wavering eloquence. Characteristically he did not wish to draw attention to himself or seem to insult Montgomery by leaving the hall so he decided to leave a pool under his chair instead.

On the face of things Larkin had entered a phase of feckless insouciance but in truth he was doing his best to earn a living wage while giving the rest of his, sober, time to a project he had begun almost immediately after graduation. It was his first serious attempt at a novel and would eventually be published in 1944 as *Jill*. When it was reissued in 1963 Larkin wrote that he hoped that it would 'still qualify for the indulgence traditionally extended to juvenilia'. There is some false modesty here but not much. The book, in its own right, takes us along a number of intriguing routes towards a portrait of youth and unfulfilment, while consistently failing to complete the journey. What it does do is shed some light on Larkin's conflicted states of literary aspiration and self-doubt. The story of its progress through 1943 and 1944

Inscribed 'To the Match', 1949. Fans of Leicester City were on their way to the club ground, Filbert Street.

is as intriguing as the novel itself. Its hero, John Kemp, evolved out of the rather pathetic young men who strove for some kind of sexual gratification in the various pseudo-pornographic pieces he had co-authored with Amis. In 1943 he wrote to Sutton and Amis (10 and 20 August respectively) of how, out of a batch of abandoned or half-completed stories, something more serious was emerging, confiding in Sutton that 'it could lengthen into an novel, if I could ever do it'. He also informs Sutton that the hero would be based on himself 'Oh yes, usual stuff . . . Young hero, intelligent, sensitive, bit of a poet. Cheap introspection. Patches of sheer beauty . . . Disappears into luminous future' (30 September). Weirdly he wrote to Amis on the same day and disclosed that he was trying desperately to distance anything faintly autobiographical from the story: 'I really and truly wish that it wasn't based in Oxford,' he writes, and adds that 'I am constantly conducting a defensive battle against these things [parallels between himself and Kemp] with one hand while carrying on with the story with the other.'

His most crude and elementary means of separating himself from Kemp was to turn the latter into a working-class youth from Huddlesford, Yorkshire, complete with accent and requisite social anxieties. Nonetheless Larkin could not help allowing aspects of himself to leak into his creation. As he wrote to Amis, 'John Kemp is getting rather clever, but it is because he is growing like me, a tendency I shall have to sternly redress in the third draft' (8 November, 1943). Ruthlessly Larkin cut out all indications in Kemp of literary ambition, which created something of an anomaly since much of the story involves Kemp's preoccupation with inventing a different persona for himself, including very authentic letters from his non-existent sister, the eponymous Jill. Self-evidently Kemp has an innate skill for creating imaginary worlds from language and it therefore seems preposterous that he would never consider making use of these talents as a writer. This was only one of a large number of problems that beset Larkin in his attempts to pretend that he was not the principal character in his first attempt at serious fiction. On 20 August 1943 he announced to Amis that he had found a new ally in his enterprise. 'Brunette, who wrote "Trouble at Willow Gables" is helping me.' During Amis's year at Oxford he had co-authored with Larkin a number of short stories involving, mostly, sexually precocious sixth formers in a girls' boarding school. Brunette Coleman, the female narrator of 'Trouble at Willow Gables', allowed Larkin to include a world made up exclusively of young females and for some reason she also made him feel a little less like a peeping Tom. Amis played a small part in her creation, his assistance acknowledged in her surname: his father William was a senior clerk at Colman's Mustard. Brunette gives off an air of moneyed flirtatiousness and bohemianism. She is part of the promiscuous world of the young London upper classes and in this respect Larkin based her on Diana Gollancz, daughter of the publisher Victor and an art student at the Slade, now relocated to Oxford. Amis would also have known that Diana, Brunette's real-life counterpart, was indeed helping out Larkin by reading and commenting on forged letters and diaries. To complicate matters further, Larkin brought Diana into *Jill* as

Elizabeth Dowling, who sees through Kemp's falsifications and rejects his somewhat timid advances. Gollancz, though remaining a close friend, had visited the same fate on Larkin, whose feelings of sexual inadequacy outdid even Kemp's.

Kemp sustains the narrative by systematically avoiding the facts about his life. He dissembles and fantasises relentlessly. In this regard he was an honest reflection of his creator, a man who was already fashioning different versions of himself for his two closest friends, Amis and Sutton, while pretending for each that the other did not exist. Worst of all Kemp is resigned to his fate: that he is and will remain a failure. Larkin shared his pessimism and rarely can a novel have been inspired by such a mood of introspective dreariness.

In 1946 he found a publisher, R.A. Caton, whose Fortune Press was turning out an impressive list of young often radical poets and novelists, which in truth was designed to add a sheen of respectability to its profitable line in pornography. When the book was published reviews were inoffensive if not particularly enthusiastic (Montgomery, using his newly acquired crime-writer pen-name of Edmund Crispin, was generous in *The Spectator*), but Larkin saw the book as an embarrassment. He knew, even if others did not, that it amounted to a fictionalised version of what we now call a misery memoir. Eventually, he would find a way in which to harness his melancholia to superb literary art – in poetry – but within months of the novel's completion he would find potential relief from one of his and Kemp's more elemental problems – the absence of sex.

In June 1946 Larkin was offered the post of Sub-Librarian at University College, Leicester. He had still not completed the correspondence course which would eventually qualify him as a member of the Library Association. And here one has to admire Wellington Council in appointing as chief of the Public Library a man who had obviously read a lot but who had no qualifications or apparent interest in the practicalities of Librarianship. It was not made a condition of the Wellington post that he remedy these formal shortcomings but over his two years there he acquired a genuine interest in the job. He did not expand the range of titles merely to offend local sensibilities. He attempted to stock the library with all of the most significant works in English – literary, philosophical and historical works included – along with their European counterparts in translation, and he succeeded in persuading the Urban District Council to raise the municipal rate by a penny in the pound to fund the improvement of library resources.

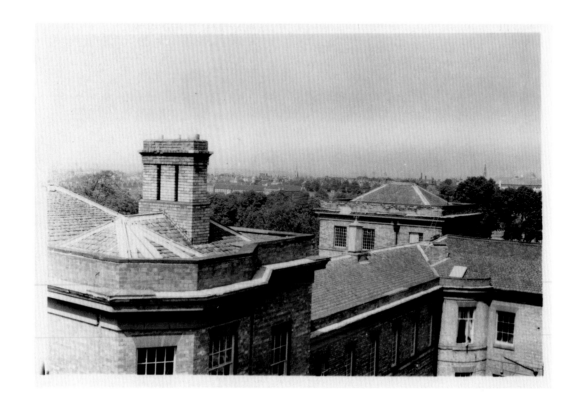

View across Leicester from the window of the Library, University College.
The Library was situated on the upper floor of the sprawling late Georgian
building that housed all of the institution's offices and lecture rooms.
This is now known as the Fielding Johnson Building and squats within
the neo-Brutalist high-rise architecture of the present-day university.
Larkin was amused to learn that Thomas Fielding Johnson had paid
for its construction in 1837, and had bequeathed it to the locality as the
'Leicestershire and Rutland Lunatic Asylum'.

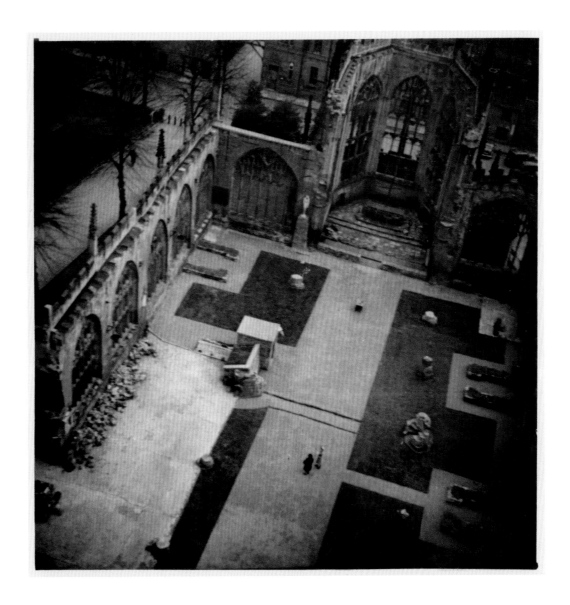

In late 1948 Larkin visited Coventry. It was the first time he had been
there since his parents had moved to Warwick and he wanted to see what
remained of the old city following the bombing raids of 1940 when he had
taken a train from Oxford in a desperate attempt to ensure that the family
home had been spared. The photograph is of the ruined cathedral, still
with fallen masonry piled against the walls. It is unclear how he gained
access to the unsafe tower but this is an early example of his taste for
scenes captured from a considerable height.

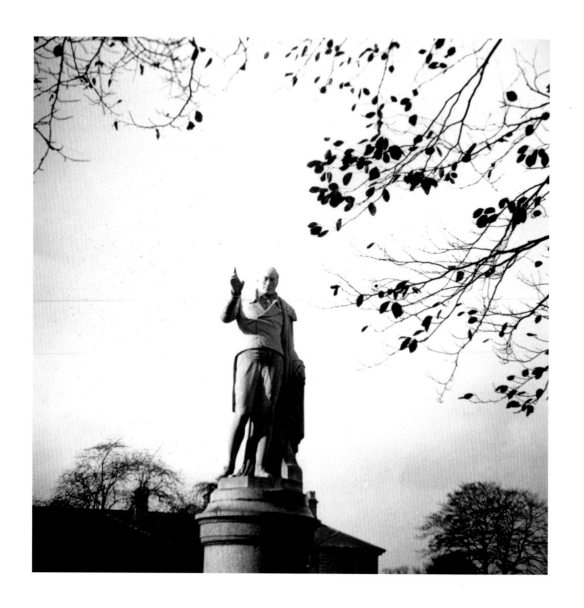

OPPOSITE Statue of Robert Hall (1764–1831), a dissenting Baptist preacher born in Leicester. The statue is on New Walk close to the University College. Larkin passed it each day during his first year as he went from his digs to work, and was moved to speculate that someone with a grim sense of humour had decided to place the memorial so close to the newly opened lunatic asylum during the same year, 1837, that the latter opened. Hall was plagued by bouts of mental derangement. The asylum building would eventually become University College.

ABOVE Bruce Montgomery, photographed by Larkin during one of their West Country excursions, 1945.

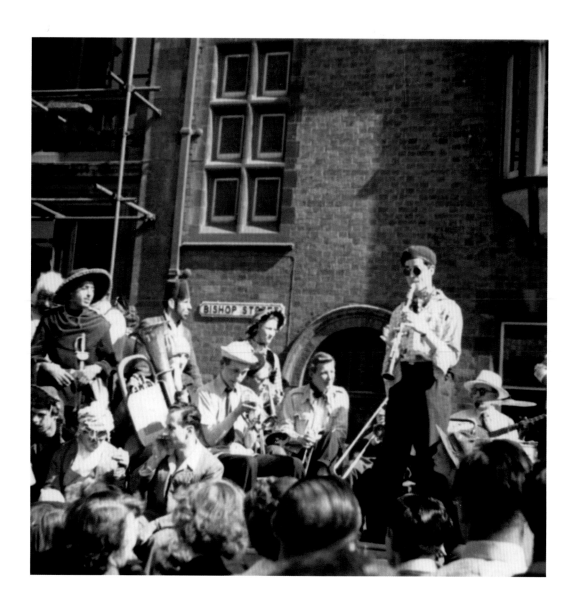

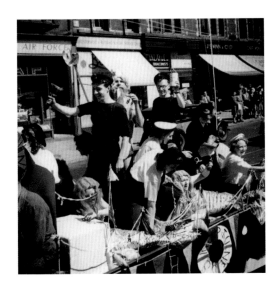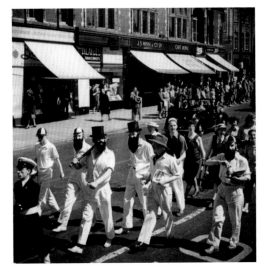

Undergraduate Rag Day Parades, Leicester, 1948.

Chapter 6

Ruth

Ruth Bowman was a regular borrower at the Wellington library and what exactly ignited her friendship with Larkin, which soon became a form of courtship, goes unrecorded. She was short, although not petite, wore spectacles and while not distractingly pretty, not unattractive either. Their difference in height made them a conspicuous couple, as did their habit of reciting poetry to each other in public during their walks around Wellington or picnics in the local park. Local gossips also commented on their age difference. Ruth was only sixteen.

It is tempting to see her as Larkin's attempt to improve on fiction. She was only a little older than the captivating, fifteen-year-old Gillian who had spurned Larkin's alter ego Kemp in the novel he had just brought to a rather cheerless conclusion. But if there was some connection between what he wrote and what he hoped for in real life it seemed again as if he was preparing himself for second-best. At first he played the part of informal tutor – she too had ambitions to read English and would eventually go to the University of London – and this reinforced his role as the dominant figure in their relationship. Hence she did not intimidate him, as Diana Gollancz and her fictional counterpart Elizabeth Dowling had done with their erotic sophistication. Moreover, Larkin no longer had to deal with Kemp's experience of an unwelcoming competitive context; this was dull provincial England and Ruth, of modest background, was certainly not part of the high-living set, up from London. Ruth's widowed mother dealt heroically with visits from her daughter's recently acquired 'boyfriend', who had an Oxford degree, had recently published a book of poems, *The North Ship*, and had caused a great deal of local unease by advertising the library's newly acquired authors, notably Lawrence, Huxley and Joyce, which most readers frowned upon as 'unsuitable'.

The academic environment at Leicester appealed to him, and the prospect of living in a city, albeit a modest one, seemed preferable to what amounted to a dull market town. Ruth wrote him a letter the day after he left, asking 'How can I battle

This is Larkin's earliest photograph of Ruth Bowman. Strangely, he inscribed it as 'Diana Gollancz, 16 St John's Street, 1943'.

my way through life . . . without you?' They had agreed that their relationship could continue despite the fact that she hoped to go to university the following year. Larkin had emphasised to her that they would rarely be more than two hours apart by train, and she seemed reassured, concluding that they 'mustn't let the mere fact that we do not live in the same town come between us irrevocably' (4 September 1946). They had started having sex and from their correspondence and Ruth's recollections after Larkin's death, it seems that both saw their relationship as a serious commitment.

In truth, however, Larkin was leading a double life. Less than a year after he met Ruth he embarked on an exercise in falsehood and disinformation which was prompted by Kingsley Amis. Amis was demobbed in July 1945 and returned to Oxford in September. What happened during the next five years can only be regarded as bizarre.

Amis first met Hilary Bardwell, Hilly, in a café in the High Street in January 1946, and he was fascinated. She was blonde, pretty and her life so far seemed enchantingly reckless. She had been expelled from Bedales after absconding on several occasions and following a period helping out at a dogs' home in Surrey run by two lesbians she had enrolled at the Ruskin School of Art. This too was not to her taste and she exchanged the study of art for a modest income modelling at Ruskin, sometimes in the nude. Amis thought that she was at least in her early twenties and was surprised to learn that she was seventeen, just. Amis announced this to Larkin with a mixture of shock and pride. He had, before meeting Hilly, visited Wellington twice and met Ruth: each of them, aged twenty-four, now had girlfriends only just beyond the age of consent. Less than a month after meeting Hilly, Amis sent Larkin a letter which included passages that could have come from one of the fantasy novels they had begun four years earlier, notably *I Would Do Anything For You* involving lesbianism and mature schoolgirls. Marsha, one of the heroines of the novel, was an art student at the Ruskin, and Amis could hardly believe that he had met her real-life counterpart. He offered Larkin an account of one of their conversations with his own dumbstruck comments, as if he had walked into a dream of his own making:

> 'I can't stand Ellington after about 1930.'
> 'After that I worked at some kennels with some dreadful women, two of
> them. They were lesbians.' (Me; 'Did they lezz with each other or with
> other people?' – Guess Who I meant eh you old Bugar I know my sort)
> 'With each other and with the dogs too. It was rather sordid.'
> 'Sex, sex, sex, nothing but sex all day long.'
> She is seventeen. I like that. (A to L, 25 February 1946)

Two weeks later Amis wrote that 'Hilly is coming on nicely. She does really like jazz. Her breasts are concave on top. And she likes me.' Like the rest of the letter this passage is double-edged. The phrase 'coming on nicely' does not refer entirely

to his strategy of seduction: he sees Hilly as both a real person and a fantasy he can shape and manipulate. 'She really does like jazz' would be understood clearly enough by Larkin: amazingly he had found a living version of their invented and sadly unobtainable jazz enthusiast Marsha.

At the end of the letter Amis stated that 'the quasi-Ruth implications of this business are coming out and I want to push them back again but can't quite see how I am going to do that, you see.'

The absence of a question mark is telling because Larkin did indeed 'see'. He had already told Amis that he felt that his relationship with Ruth was rather like something he observed from a distance albeit voyeuristically. In all of their letters Amis refers to her either as 'Misruth' or 'the school captain' because immediately after he had first met her in Wellington the two men had revived a version of *I Would Do Anything For You*. They were revisiting a disgraceful piece of fiction which was now, it seemed, drawing its energy from their actual experience. In the rewrite there are two principal characters, Marsha and Jennifer, who compete for the reader's attention as the more beguiling young girl, and the one more likely to deviate into heterosexuality. At the same time Larkin was amusing Amis with stories of Jane Exall, Ruth's school friend. She was the same age as Ruth, but prettier and with a more generous breast measurement. Typically he interrupts the report on library duties to report that 'Already I have wasted hours, and Jane came in and I wanted to lay her and SHAGG her. Yes I did, she looked that way and I felt that way but no . . .' He took Jane out only once for lunch in 1950 after his relationship with Ruth was over but over the previous five years she features in letters to Amis as the luscious stand-in for her rather ordinary friend. He was pretending that Jane was his opportunity to be unfaithful and his friend knew he was making it all up. For a while they would amuse themselves by pretending that fate had rewarded them equally. Later in 1946 they invented another figure for the novel, Mady, who struggles with Marsha in revealingly loose pyjamas. She was based on Isobel, another school friend of Ruth's who became the participant in imagined sexual foursomes involving Ruth, Jane and Larkin, reported to Amis by Larkin knowing his friend would see them for what they were – pure invention.

Larkin did this because during the same period Amis was enjoying, and disclosing, his own sequence of sexual adventures, almost all involving teenagers. But Amis's lurid reports were based on fact. By summer he was writing to Larkin of a fourteen-year-old, Norma: 'I removed a lot of her clothing in Xt [Christ Church] meadows, but I did not shag her because it would spoil things with Hilly.' He was not suffering an attack of conscience. What would have been spoiled was the prospect of a threesome 'with the Norma schoolgirl' which he had already mentioned to Hilly, who approved. This was the inspiration for Larkin's delusional foursome and there is evidence to suggest that Larkin was during these years undergoing something close to a minor nervous breakdown, at least regarding his relationships with women.

Amis had even taken to sending him his letters from Hilly, usually involving slightly coy references to sex: 'Billy darling [Hilly at this time called Amis by the familiar version of his middle name] . . . this bed of mine just aches for you . . . It absolutely gets upon its hind legs and eats me up'. Amis told Hilly he had sent Larkin her letter and she enjoyed becoming part of this new epistolary threesome, but in the letter accompanying Hilly's note he makes it clear that it would be unwise to move beyond fantasy. 'To put it bluntly, Hilly's an attractive girl, and you're rather a susceptible type. So – forgive me old boy don't let there be any nonsense, will you?' Larkin and Hilly got on well, flirted outrageously and within a few months of their first meeting she had begun to write to him. Typically: 'Now listen Mister, did you know that Albert Ammons plays the piano just like you . . . it quite breaks my heart to hear it . . . I'm looking forward very much to your coming down to Oxford.' Albert Ammons, with whom Hilly compares Larkin, was a black American jazz pianist.

At the same time as this Larkin began again to make brief entries in a diary he had kept in 1942–3 recording his dreams. Back then it was a Freudian experiment but four years later the material does not need to be analysed.

> I am a negro . . . I go to an American racecourse, where I go in the negroes'
> entrance . . . I then meet Hilly, and we walk arm in arm through a very
> gay scantily dressed beach crowd. I say, with a self pitying sob, that it is
> terrible to think I could be killed (ie lynched) for walking with her (I may
> have said sleeping with her).

Although Amis never threatened violence if he took his flirtations with Hilly any further he was clearly establishing territorial boundaries that must not be crossed.

Amis often acted as a bawdy Mephistopheles, exulting in his various conquests – some with Hilly's knowledge, others behind her back – while occasionally offering Larkin leftovers from his encounters with the female population of the locality. 'You ask about Marie,' he begins in one letter and goes on to describe her qualities and inclinations – apparently promiscuous and bisexual – much in the manner that a used car salesman would hypnotise a gullible customer.

Amis, with Hilly as his blameless accomplice, had effectively taken control of Larkin. He was like a character in a novel, seemingly autonomous but actually subject to the manipulative pressure of the narrator, in this instance Amis.

In June 1946 Amis wrote him a letter which sets out the founding precepts for their friendship, at least as far as he saw it.

> I enjoy talking to you more than anyone else because I never feel I am
> giving myself away and so can admit to shady, dishonest, crawling,
> cowardly, brutal, unjust, arrogant, snobbish, lecherous, perverted and
> generally shameful feelings that I don't want anyone else to know about;

but most of all because I am always on the verge of violent laughter when talking to you and because you are savagely uninterested in all the things I am interested in.

Amis was probably sincere in his presentation of the two of them as bound together in a fabric of shared secrets, but there was a degree of selfishness involved too. He was writing rather like the novelist he would later become; investing a character with a beguiling degree of independence while, in truth, turning him into one that suited his own predilections.

In late 1947 Hilly became pregnant and, after abandoning plans for a then illegal and dangerous abortion, they married in 1948. They settled in a rented cottage in Eynsham outside Oxford, and with children – their first-born Philip, named after Larkin, was followed less than a year later by Martin – debauched irresponsibility was replaced by a more conventional regime, or so at least Hilly hoped. In fact, Amis soon became a voracious predator for extra-marital sex and Larkin was his confidant, a man with whom he could share accounts of his misdemeanours in the secure knowledge that his friend would not betray him to his wife.

In 1948 Amis and Larkin had known each other for seven years, three of which Amis had spent in the army, but already Larkin was beginning to sense that he was and would always be the junior partner. It was not only that Amis was better looking, more attractive to women and a far more confident social animal. All of this Larkin could in his prematurely wearied mood of resignation come to accept. What he sensed was that his friend was both subordinating his sense of individuality and remodelling him as the figure Amis preferred him to be. And while they would remain on reasonably good terms for the rest of Larkin's life – with the exception of a peculiar period of silent enmity in the 1960s – there were already signs that Larkin was becoming unsettled by what amounted to Amis's possessive, almost exploitative manner.

Sydney Larkin died in March 1948 and there followed a series of events that again raise questions about Larkin's emotional state of mind. Apart from sincere feelings of loss and grievance Larkin faced numerous accounts from friends, family and obituaries in the local press that reminded him of the sort of man his father was. While politely disregarding his enthusiasm for Nazism all agreed that he was a commanding presence; he sought no assistance in his work or as a private individual and brooked no interference in the way he conducted himself. Larkin had always been in awe of him and now realised that in many ways he hoped to replicate his strengths, with the unwelcome, unavoidable proviso that he had also inherited a gallery of anxieties from Eva.

Next, Larkin had to deal with such practicalities as the sale of the family home in Coten End, Warwick; all agreed that Eva was incapable of running a spacious house on her own.

Larkin arranged the sale and the purchase of 12 Dixon Drive in Leicester, into which he would move with his mother, from his cramped but private bedsit. Suddenly, he realised that he had been sucked into the web of familial responsibilities that Sydney had discharged with gritty efficiency, and loathed. He had taken over from his father as his dithering mother's carer.

After the sale of Coten End was agreed and before the purchase of the Dixon Drive property he bought an engagement ring from a jeweller in Leicester, arranged a meeting with Ruth in London – she was by then a student – and proposed marriage. She accepted, with some subdued feelings of puzzlement. He had never before even indicated his intention to make their relationship permanent. He reported what he had done in a letter to Sutton in a manner that is almost comic. He begins: 'To tell the truth I have done something rather odd . . . got myself engaged to Ruth on Monday.'

Larkin goes on to explain who Ruth is, having been somewhat economical with details about her in previous correspondence, and continues rather in the manner of someone who has decided to purchase an entirely new wardrobe but is not sure if these curious and unfamiliar garments will suit him. 'I can't say I welcome the thought of marriage . . . No-one would imagine me to be madly in love, and indeed I'm more "madly out of love" than in love, so much that I suspect all my isolationist feelings as possibly harmful and certainly despicable.' He was trying to disengage himself from a nightmare of his own making, becoming the replacement for his perennially depressed father. In doing so, however, he had entered an arrangement that was rather like Sydney's and Eva's: later in the letter he admits that he loves Ruth only 'in a strangled way', so much so that he felt it his duty 'to help her take her finals which she was in a fair way to buggering up . . . I don't know how it will turn out!' He announced what he had done to Amis at the same time and although that letter no longer exists the reply is fascinating. It is a single sentence – 'Do you wish that I should congratulate you on its account?' Following this announcement the part salacious, part flippant references to 'Misruth' disappear from Amis's letters. He seemed to feel that Larkin had betrayed him, or in some way been disloyal to their confidential world of fantasies.

Ruth, shortly after their engagement in 1948.

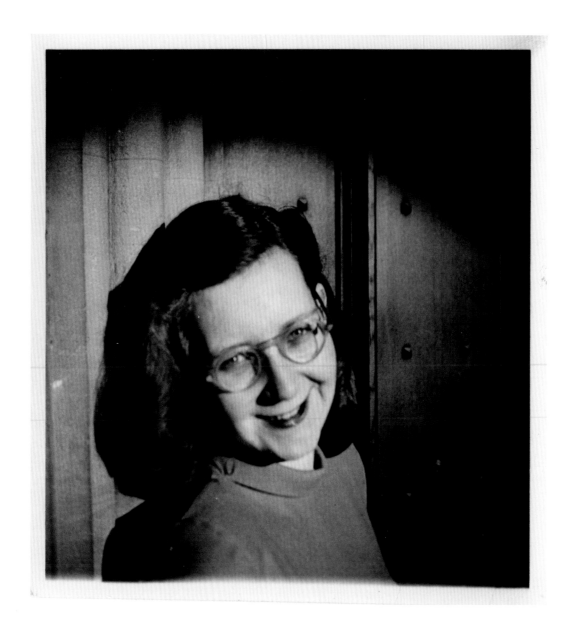

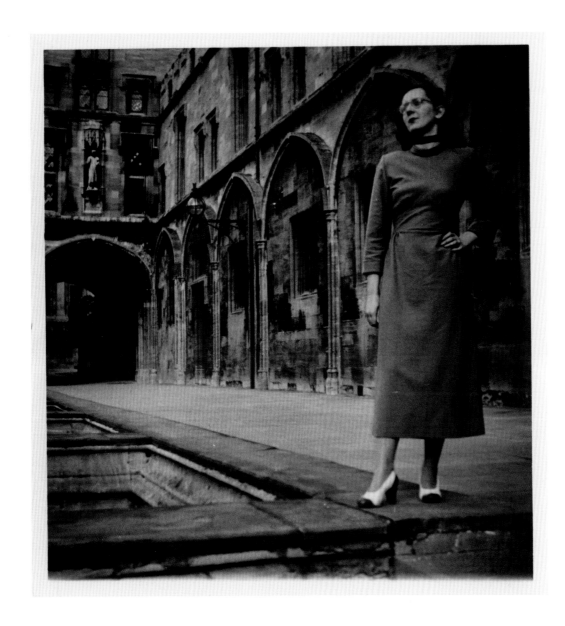

Ruth photographed in Tom Quad, Christ Church after he had introduced
her to Amis and Hilly in Oxford in 1947. The Gothic backdrop adds
a hint of the erotic and the furtive. She was still only sixteen.

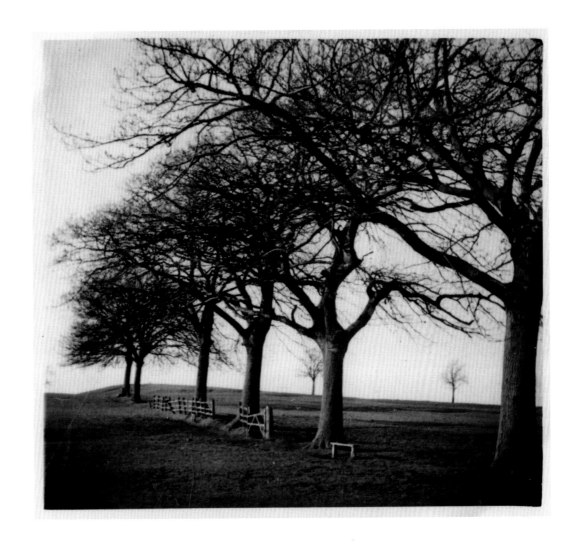

OPPOSITE Coten End, the Larkin family's handsome late Regency
house, shortly before it was sold in 1948.

ABOVE Inscribed 'Warwick Common'. The common, now built over, was
close to Coten End and Larkin took this slightly mournful photograph
shortly after completing the sale of the house.

Chapter 7
Monica

Soon after his arrival in Leicester, Larkin became friendly with Monica Jones. She had been his contemporary at Oxford, read English at St Hugh's and like him achieved a First, but they had not met at university. She had been employed for almost two years as a lecturer in English at Leicester and it was evident that she presented a serious alternative to Ruth. She was an attractive woman with blonde hair and striking blue eyes. There are pictures of her from the 1940s which disclose a natural beauty unimproved by Larkin's skill as a photographer. Her clothes, though unostentatious, might have featured in films of the period about Americans in Paris, and her jewellery seemed to be a statement against the drab parochialism of post-war Leicester. They both later recalled that during their first meetings each suspected that something more than friendship would follow, and although there is no reliable record of when they began a physical relationship it is worth noting that she is never mentioned in letters to Ruth. It is also clear that as a subject of photographic portraiture he found her far more fascinating than any woman he had met, Ruth certainly, and pictures he took during 1946–50 carry an air of enchantment on his part and flirtatiousness on hers.

Further evidence that there was more going on between them than friendship based on shared literary interests is provided in letters from Amis. He hated her. They met only twice before 1950, during visits by Amis to Leicester, but he took against her in a way that can only be seen as crazed. Every reference to her involved an insult: 'That postcard [actually a photograph by Larkin] was tardy. It carries to me a tide of unconventionality (or rather other peoples' conception of it)'; 'I think of her rimless geometrician's glasses and her voice contentedly forging ahead in shit, like a little flag-decked pinnac bravely steaming steaming with dung it carries below its polished deal decks.' In this last passage Amis finds it so difficult to contain his hatred for her that his prose almost collapses into an incoherent rant. It seemed that Larkin had consulted him on whether he should present himself as a serious

Monica, photographed by Larkin in her office in Leicester, 1947.

alternative to another man who Monica was seeing: 'If you aren't careful,' advises Amis, 'you'll find yourself back in the running. The relationship would doubtless go well into my Leicester novel, with a piss of fisticuffs.' Even Hilly was persuaded by her husband's tirades and she too wrote to Larkin begging him to have nothing more to do with her. Monica never said or did anything to Amis that could be treated as remotely offensive, but he was determined to prevent his friend from beginning a serious relationship with her.

From the dates of the correspondence in which Monica features it is clear that Larkin had only announced her existence, and eventually introduced her to Amis, shortly after the latter had expressed dismay at his engagement to Ruth. Was he presenting her as the clandestine alternative to his bride-to-be and showing himself to be just as adept at infidelity as his friend? If this was his plan then it backfired completely. It is evident from the astonishing level of malice in Amis's letters that he saw Monica as even more of a threat to the uniqueness of their friendship than Ruth.

Amis would later claim that his novel *Lucky Jim* was inspired by Leicester. He visited Larkin there several times before he was appointed lecturer at Swansea: it was his first encounter with the atmosphere of a non-Oxbridge provincial university. Larkin took him to the Senior Common Room and the strange combination of ennui and intellectual snobbishness prompted Amis to make early notes for his debut novel. Most of all he found that Leicester undergraduates seemed more uninhibited, less hidebound by institutional convention, than those in Oxford.

Larkin's second novel, *A Girl in Winter*, had appeared in 1947 and been well reviewed in the mainstream press. In 1948 he was at work on his third, provisionally entitled *No for an Answer*, which never got beyond the first five frequently revised chapters. Both pieces have much in common with his first, *Jill*, in that they are as much about Larkin's own dissatisfaction with who he was as attempts to create something that would be enjoyed and appreciated by a general audience.

During his struggle with *No for an Answer* he produced a horribly candid free verse poem in which he sums up his predicament.

> So must I live alone, do nothing,
> Give nothing except in writing? Oh people do harass me –
> . . . And when I look at that written down it rings like the saying of a shit
> Which I suppose is what I make myself out to be.
> I want to do both, write and be involved with people.
> Yet always I shy off when they come too close.

Without loathing any person in particular he resented the network of relationships and friendships that, daily, demanded some kind of emotional

accountability. This was his life, the only available raw material for his fiction, so it is hardly surprising that his attempts to become a novelist had entered a spiral of evasion and lacunae.

Two letters to Sutton in late summer 1947 are fascinating. In one he discloses that he is working on a novel about a visual artist and he asks his friend for advice: can a man teach himself to paint?; when you start a picture do you know what effects you will eventually achieve?

He goes as far as saying that he wishes to create an effect in his new novel that involves 'no words . . . only the pure vision', later conceding that to attempt this in a work comprised exclusively of words is 'pure bunkum'. The 'novel' got no further than 200–300 pages of notes and one can treat it as a further symptom of the malaise described so vividly in his unpublished poem: he wants to write yet he also wants to disappear from the activity of writing. Yet little more than a month later he wrote to Sutton again and this time his mood is far more upbeat. He rejoices in his 'act of madness' in purchasing a sophisticated camera for £7. Sydney had bought him one ten years earlier and he had become a keen photographer before then, in his early teens when he used Sydney's box camera. He dwelt on the 'madness' of the purchase because £7 amounted to more than a week of his net salary at Leicester. One does not require any knowledge of psychology to discern a link between Larkin's growing sense of inadequacy as a writer and his new investment. He would never take seriously any claim to being a photographic artist but, especially during these years of frustration as a novelist, he gained increasing satisfaction in capturing images from life without the assistance of words.

By 1950 Ruth had taken up a teaching job in Lincoln. During the previous two years their engagement had dwindled to the status of a token gesture, never fully revoked by him and regarded with patient scepticism by her. He visited her in mid-June and they went out to dinner. It seemed that he had something to announce and after taking resolve through drink he informed her that he had on 4 June been interviewed, successfully, for the post of sub-librarian at Queen's University of Belfast. Later, during the three months before departing for Northern Ireland, he suggested that she might consider accompanying him, much in the manner of someone who feels it his duty to make such an offer while regretting the obligation to do so. They met on several occasions and he constantly prevaricated on the specifics of what his proposal would amount to, should she choose to accept it. Eventually, she wrote to him shortly before he left and formally stated that there would be no further meetings, and that their relationship was over, which is what he had hoped for but not had the courage to declare himself.

Monica's room. On
the walls, reproductions
of Chirico & Picasso &
a self coloured map of
Oxford. On the table
the plays of Chapman
& her 3-vol. Rambler.
A tiny bit of a Campion
is also seen.

(13 · 7 · 50)

1950

2

OPPOSITE, CLOCKWISE FROM TOP LEFT Monica posed in Larkin's room in Belfast, *c.*1952; Monica, 1950; After one of Monica's tutorials, Leicester, 1950.

ABOVE Larkin's first recorded photograph of Monica, Leicester, 1947.

OPPOSITE Monica in the garden of her Leicester flat, taken by Larkin shortly before his departure for Belfast. 'I like it [her dress] very much . . . All I say is that it arouses the worst in me – which isn't very bad, of course, but still, it is the worst' (L to Monica, 16 January 1951).

ABOVE Monica and Eva on the university campus at Leicester, 1949. Before Ruth ended their engagement Larkin had already introduced his mother to Monica, and they got on well. He wrote to Monica in November 1952: 'Yes do ask mother to tea . . . she does like you.'

Chapter 8
Single to Belfast

Belfast, he found, suited him very well. The university could claim much more of a genuine academic heritage than Leicester. It was like a provincial version of Oxford but his peers were now junior academics rather than undergraduates. He no longer dwelt in the expectant, intimidating shadow of his late father, and Eva, still in Dixon Drive, Leicester, could rely on Kitty, married and settled ten miles away in Loughborough, for assistance. For the first time in his life he felt independent. He remained in close contact with his friends in Britain, through both visits and correspondence, but at the same time the grey sentry of the Irish Sea secured him against sudden intrusions into his private world.

One cannot overstate the effect that the move to Belfast had on his work – it wrought the transformation of Larkin from frustrated novelist to the finest English poet of the late twentieth century. His first letter from Belfast was to Monica and he dwells on the dreadfulness of his trip, telling of how his train 'dashed through the weeping quarries of Derbyshire' to the 'dusk-ridden ruinous vision of Manchester'. Tea and ham rolls sustained him during the journey to Liverpool where he walked through 'endless warehouses' to board the *Ulster Duke*, his ferry to Belfast. On reaching his room in Queens Chambers he documents the dreary interior with ill-disguised glee: '. . . this room is grossly under furnished, the lampshade is made of brown paper, the bulbs are too weak, the noise from the trams tiresome, the sixpenny meter for heat will prove expensive, the students ubiquitous . . .' Anyone familiar with 'Mr Bleaney' will by now be awaiting the three-word amalgam of triumph and weary resignation: 'I'll take it.' He would not begin that poem until his move to an equally grim lodging in Hull in 1956, but the 1950 letter to Monica reads as a rehearsal for it.

More significantly the still unpublished poem 'Single to Belfast' was begun after Larkin awoke in his cabin on the *Ulster Duke* and returned to when he settled into his rooms. It is a great pity that his letter to Monica of 1 October and the poem cannot be read as adjacent texts because there are few, if any, examples of such a dialogue between matter-of-fact writing and literary art. The poem (partly reprinted in Andrew Motion's biography of Larkin, but only available in complete form in the Hull archive) distils the sense of anticipation and masochistic glee of the letter into

something far less particular but in both we sense that he knows that his journey will be transformative.

> the present is really stiffening to past
> Right under my eyes,
>
> And my life committing itself to the long bend
> That swings me, this Saturday night, away from my midland
> Emollient valley, away from the lack of questions,
> Away from endearments.
>
> Through doors left swinging, stairs and spaces and faces

He was fascinated by how quickly similarities between Ulster and the world he knew were cut through with equally curious contrasts. 'Your doctor, your dentist, your minister, your solicitor would all be Queen's men, and would probably know each other. Queen's stood for something in the city and the province . . . It was accepted for what it was . . .' He knew that the university was fiercely meritocratic but it was not, like Oxford, class-riven and even those who weren't graduates treated it as a token of the compacted village-like nature of the six counties where, despite the religious divide, everyone seemed to know everyone else.

He wrote to Monica in 1951. 'I have almost given up the battle, and floating down the social tide feel my nationality and individuality and character submerging like empty cake boxes.' It was not that he seriously feared he might be absorbed by an almost alien culture. Rather he relished the tensions of being at once part of and different from this new environment, and this in turn provided a greater impulse to his output as a poet. He now felt more confident as an outsider, someone who could commit his impressions and imaginings to the words on the page without becoming their captive, as he had during his endeavours with fiction. On 12 July 1951 he sent Monica an account of his first 'Orange Day or whatever they call it'. It reads rather like the diary of an Edwardian anthropologist, who is at once dumbfounded and fascinated by tribal rituals previously unimaginable.

> The bands were various, too: fife and drum, pipe and drum, brass, & even accordion, all keeping a strong beat that slightly disagreed with the one behind & the one in front. As for the Lodges themselves . . . I said afterwards that it reminded me of a parade of the 70,000 Deadly Sins. Take a standard football crowd (soccer), cut a fringed orange anti-macassar in two and hang one round the neck of each man: give him large false orange cuffs & white gloves to emphasise the tawdry ugliness of his blue Sunday suit, & clap a bowler hat on his head – then you have a Lodger ready for marching.

Most of the anti-macassars were orange edged with purple, but some were purple edged with orange: certain members ('Sir Knights' or 'Provosts') carried shiny & curiously-repellent symbolic swords & axes – not real, but silver-plated. The dominant impression from the endless tramping file of faces was of really-depressing ugliness. Slack, sloppy, sly, drivelling, daft, narrow, knobby, vacant, vicious, vulpine, vulturous – every kind of ugliness was represented not once but tenfold – for you've no idea how *long* it was.

. . . bonfires at every street corner blazing up house-high. I strolled down about half past eleven (drizzle coming down as usual) & was fascinated by the cardboard arches across the streets, the thick waves of Guinness, War Horse tobacco, & vinegared chips, the dancing crowds, & the pairs & trios of gum-chewing young girls roaming about wearing paper hats stamped 'No surrender', 'Not an inch', & various Unionist catchwords. Police stood uneasily about in their raincapes . . .

A month after he arrived he sent Monica drafts of six poems, some of which he had begun earlier and abandoned, others composed in his first six weeks in Belfast. 'On the whole I think *Wind* [later published as 'Wedding Wind'] is the best. I wish I could write more like that, fuller richer in reference.' It is an unadorned account, told by the bride, of her wedding day, with more attention given to the weather and the countryside than to the emotional impact of the event.

Before this, he had shown some of his work to Monica, as he had to Amis, but now he began to trust her far more as someone who would talk with him about his verse, albeit often in correspondence, rather than tell him about it, as Amis generally did. Monica would remain his most trusted intimate, his valued consultant on work in progress, but there is a sense also that Belfast instilled something in his verse that would endure – something parochial, familiar yet rather bizarre.

The Less Deceived (1955) would alter his status from obscure, occasional novelist and versifier to one of the outstanding voices in the motley chorus of post-war English writing, and many of its best pieces benefited greatly from his relationship with Monica, by parts separated and intimate. Never before had he said so much about what a piece of writing meant to him, either to Sutton or Amis. On 'Next Please': 'I think it's just another example of the danger of looking forward to things . . . a sense that what we wait so long for and therefore seems so long in coming *shouldn't* take a proportionally long time to pass.'

The first of his great poems is 'Church Going'; imperfect but unimprovable. It tells us much about his sense of being elsewhere, not committed to a particular location nor alienated from it. He wrote in *Further Requirements* that 'One Sunday afternoon in Ireland when I had cycled out into the country I came across a ruined church, the first I had seen. It made a deep impression on me.' He had seen churches bombed but never one fallen into disuse, and it was the inspiration for the poem. But the ruined

church outside Belfast offered only a hint of what would evolve into the poem after his visit to England. On 6 March 1954 he wrote of his week in the Midlands spent mainly with his mother, on 'family graves' in Lichfield, notably Sydney's, followed by a 'queer mixture of hell and rest cure'; by this he meant a poorly attended service in Lichfield Cathedral. He sent a draft of the poem to Amis and reported to Monica that 'Church Going didn't interest him . . . Not a word about the poem as a whole.' He expected constructive criticism but what he received were heedless, dismissive projections of Amis's prejudices.

Monica shared Larkin's interest in churches, specifically those that in some way raised questions about their past and the individuals who had regarded them as an integral part of their lives. They would speculate on why and when the congregation had diminished and what kind of people had walked through the same lych gates and arched doors, some with their names on now overgrown gravestones; others unrecorded.

He discovered – or to be more accurate Monica helped him discover – a manner of writing verse that suited his temperament. He had as an undergraduate and during his career as a novelist attempted to make sense of the world by harnessing his innate talent as a stylist to all-consuming theories of art and existence. In Belfast he sharpened his focus, allowing what he saw and what he felt to determine the nuances and resonances of the words on the page. He did not exchange ideas for pure impressionism; instead he refused to allow either his intellect or visual faculty to take full command of the creative enterprise. He let them compete for prominence, albeit unobtrusively. It is no coincidence that during these same years he became more and more fascinated by photography.

His sister Kitty, now married to Walter Hewitt, with her daughter, Larkin's niece, Rosemary. After almost a year in Belfast he reported to Monica on a visit to his sister's house. 'The house situation gets much worse . . . have an uneasy inkling [it will involve] the transport of a certain party [Eva] to N. Ireland . . . As for my sister, a plague on her . . .' For the next two decades Larkin and Kitty would argue continuously over who should be more involved with the care of their mother. Typically, in 1955, he writes of his 'pure hatred for my bitch sister. She is an absolute mean spirited little swine of Hell'. Despite this, his photographs of Kitty and Rosemary seem to hint at affection.

Eva in Dixon Drive in the mid-1950s. The road was memorialised
by Amis in Jim Dixon, hero of his first novel.

Sometimes Larkin would almost confess to wishing Eva dead: 'I told myself "You must never come back . . . till she is dead and gone if you want a quiet life",' he wrote to Monica in December 1954, which suggests that some morbidly humorous intent went into his carefully posed photograph of Eva in a museum of wartime memorabilia near Loughborough.

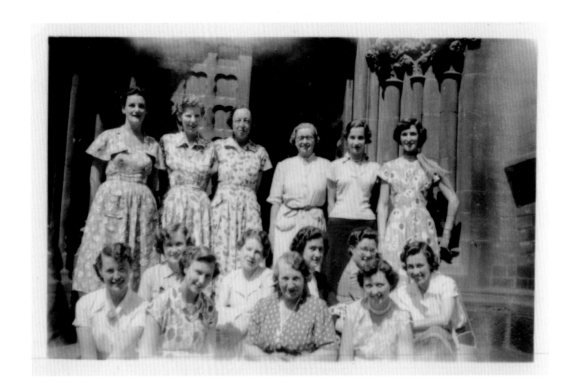

OPPOSITE TOP Larkin's (all-female) staff, outside Queen's, summer 1951.

OPPOSITE BOTTOM Larkin's photograph of degree ceremony, Queen's, 1951.

ABOVE Larkin's room in Belfast, 1950.

> I detest my room
> Its specially chosen junk,
> The good books, the good bed,
> And my life, in perfect order.
> ('Poetry of Departures')

The Walls of Derry, above, and, right, photographs taken in Belfast
on 12 July 1951, the same day that he reported on the marches in a
letter to Monica.

 The march interrupted the light afternoon.
 Cars stopped dead, children began to run,
 As out of the street-shadow into the sun
 Discipline strode, music bullying aside
 The credulous, prettily-coloured crowd . . .
 (From 'March Past')

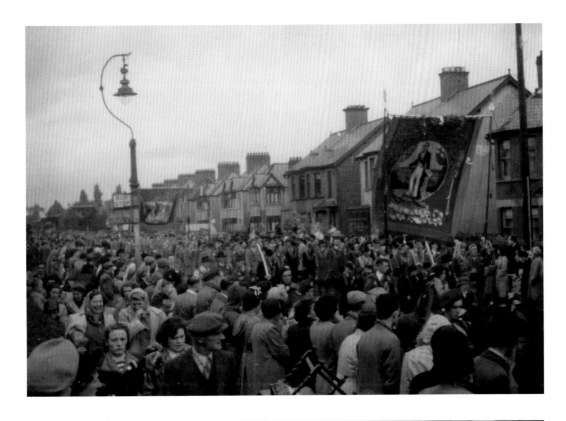

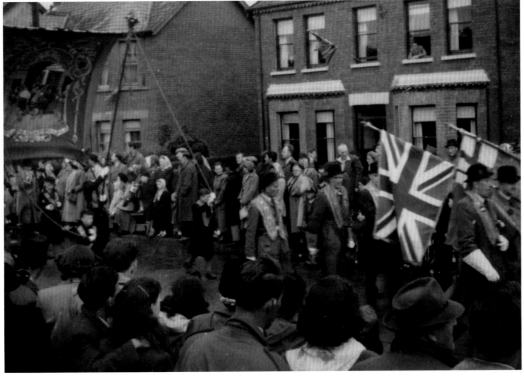

Two photographs of the library, Queen's University Belfast, taken by
Larkin in 1951. 'The library I came to in Queen's in 1950 was of course
the old library. The first part had been opened in 1865, and resembled
a large church with no transept . . . No one had much idea of what a
library ought to be like in those days . . . The light was dim and religious.
The lofty pitched roof of the reading room magnified the clack of rulers
and tapping of heels, but seemed to absorb conversation. The stack
was claustrophobic and even creepy. The galleries had a reputation
for romantic assignations.' ('The Library I Came To', *Gown*, Queen's
University Magazine, 1984)

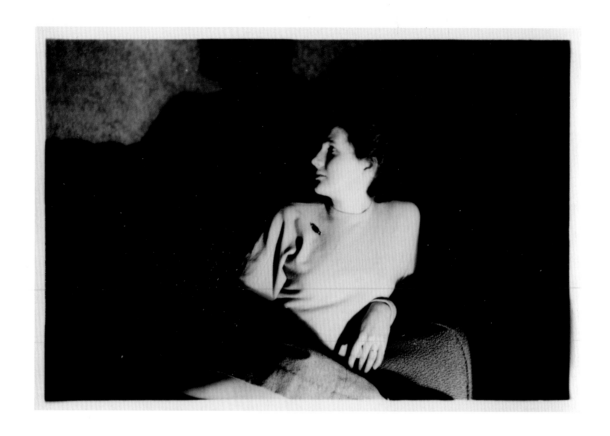

Chapter 9
Maiden Name

Soon after his arrival in Belfast Larkin came across Colin Strang, a near contemporary of his at St John's who had recently been appointed to a lectureship in philosophy at Queen's. In the intervening years Strang had met and married Patsy Avis, another Oxford graduate. Patsy had read medicine but had not gone on to train as a practitioner. She had literary ambitions and she and Larkin soon became friends. The Strangs' house in Kincotter Avenue, South Belfast, was within walking distance of Larkin's rooms. Their marriage was not exactly 'open' in the modern sense – 'ajar' would be a more accurate description – and it is likely that Colin suspected that his wife and Larkin evolved a mutual interest in matters other than poetry when they began their affair in 1951.

Patsy came from an immensely wealthy South African family – owners of diamond mines – and was the most overtly sexual woman Larkin would meet. Sometimes Patsy came to Larkin's rooms if he had time off during the day but on others they booked into guest houses in and around Belfast as Mr and Mrs Crane. The fact that they usually left the hotel without spending the night there would confirm to suspicious owners that their facilities had been used for acts of debauchery and Patsy would roar with laughter as they departed. The dour Presbyterian countenance of the city provided an ideal counterpart to their secret adventures.

Also during these years Larkin formed a close friendship with Judy Egerton which was not exactly asexual – she was strikingly pretty and he made it clear he was attracted to her – but came more and more to resemble that of brother and sister. Her husband Ansell was a lecturer in economics who would eventually leave academia to become City Editor of *The Times* and do extremely well as a merchant banker. All three would remain on good terms, with Larkin staying at their London home usually at the time of the Lords Test Match. Ansell nominated Larkin successfully for full membership of the MCC in 1973, backed by Harold Pinter.

Patsy in Larkin's room, 1952, posed in an almost identical manner to Monica who Larkin had photographed in the same place a few months earlier.

If Larkin and Judy had taken things further than this it is unlikely that Patsy would have objected – and she was certainly more amused than offended by his dalliance with Winifred Arnott. Winifred completed her degree in English at Queen's shortly before Larkin arrived and took up a part-time job in the library. She was seven years younger than Larkin and one is tempted to regard her as another version of Ruth Bowman, intelligent but slightly gullible and impressed by the witty, eccentric new arrival who had published novels and volumes of verse. But Larkin had changed. Ruth trapped him between conflicting states of sincerity and fear; he felt, as her lover, sentimentally accountable but wished he could in some way exempt himself from formal commitments. He tried, and failed, to persuade Winifred to have sex with him but more significantly he protected himself from any emotional side effects by turning her into the equivalent of his retainer. She already had a boyfriend, C.G. Bradshaw, who was conveniently based in London. Even after they announced their engagement in 1952 Larkin did not feel hampered in his pursuit of her. Quite the contrary; if she were to succumb only once or twice to his blandishments he would make sure that she didn't endanger her long-term commitment to Bradshaw. On one occasion he set her the task of reading a number of seventeenth-century amatory poems, chosen by him, while he was away in England. All involved the standard formula of the learned speaker addressing a generally innocent and gullible female, and the topic or subtext would be sexual persuasion. In the poems the woman remained silent but in Larkin's scenario he wanted Winifred to manufacture a response from her impressions of what was said by the centuries-old speakers. They would, promised Larkin, resurrect this dialogue when he returned. In the meantime he sent her letters of encouragement and instruction. 'How are you getting on with your holiday task? When you know it thoroughly you might go on to Herrick's to virgins, to make the most of time.' He ends, 'I rage, I pant, I burn for a letter from you . . .'

It might not have earned him her sexual favours but his exercise in quiet subordination inspired two of the most celebrated poems of *The Less Deceived*. 'Lines on a Young Lady's Photograph Album' is superbly double-edged. It could, at least for the sensitive and incorrupt reader, tell of moments recorded beautifully, timelessly, in photographic images, yet there is a lingering sense also of lewd masochism, as if the pictures are abrupt reminders of what cannot be had in the flesh:

> . . . too rich:
> I choke on such nutritious images.

Later he considers 'the theft' of 'this one of you bathing'. And throughout the piece he maintains an eerie sensation of having stopped time. He did not go so far as to steal her album but he had copies made of certain images of her that he felt captured the combination of eroticism and innocence that can be found in the seventeenth-century lyrics he instructed her to read. There is one moment when he celebrates

these photographs as things which simultaneously record the past while cleansing it of what were once attendant emotions.

> . . . in the end, surely, we cry
> Not only at exclusion, but because
> It leaves us free to cry. We know *what was*
> Won't call on us to justify
> Our grief, however here we yowl across
>
> The gap from eye to page.

'Maiden Name' does not refer specifically to photographs but shares the same theme of artefacts which preserve a presence from the past, in this case the 'now disused . . . five light sounds' of Winifred Arnott's maiden name. It was written shortly after Winifred's marriage to Bradshaw. Larkin sent her a copy but whether she showed it to her new husband remains a matter for speculation. It was certainly a curious wedding gift, drenched as it was in the language and slightly debauched manner of the seventeenth-century lyrics he had set her to read eighteen months before.

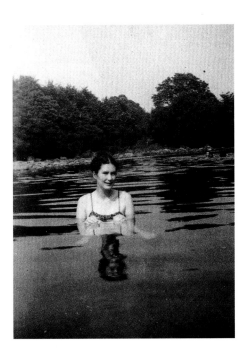

The photograph of Winifred Arnott that Larkin refers to in
'Lines on a Young Lady's Photograph Album'.

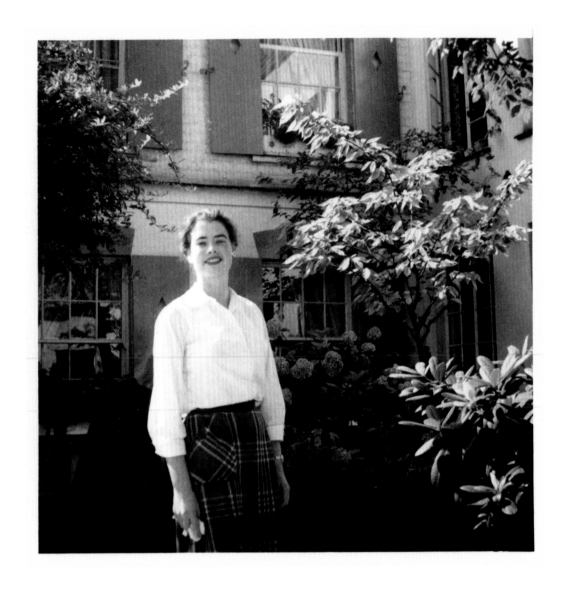

Patsy Strang during a trip with Larkin to England.

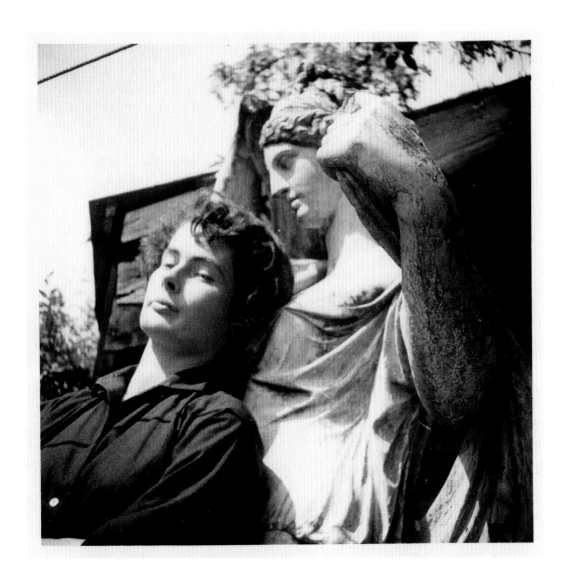

Patsy in Belfast.

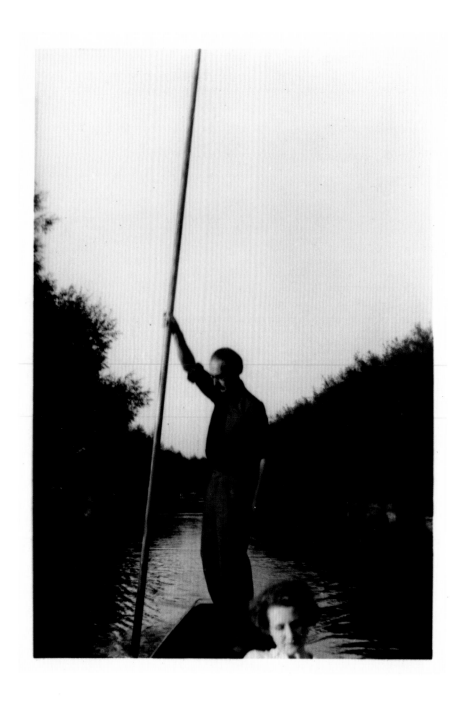

ABOVE Oxford, 1953. Larkin and Patsy punting on the Cherwell. They spent four days in the city during early summer that year.

OPPOSITE TOP Patsy and Colin Strang in their sitting room, with Larkin posed rather ominously in the background.

OPPOSITE BOTTOM Colin and Patsy Strang, photographed by Larkin in 1952.

ABOVE Judy Egerton, photographed by Larkin, 1952.

OPPOSITE One woman, still unidentified, posed for ten prints in his Belfast room, adopting postures and expressions remarkably similar to those of Monica and Patsy when they were photographed in the same spot.

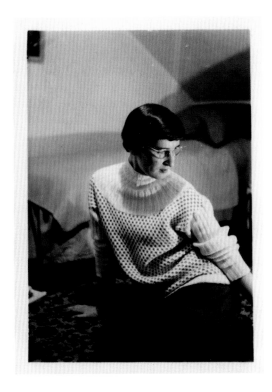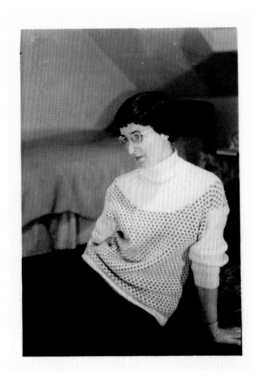
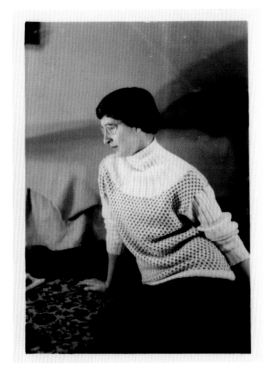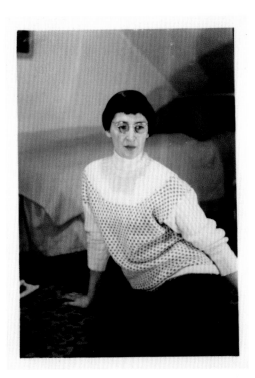

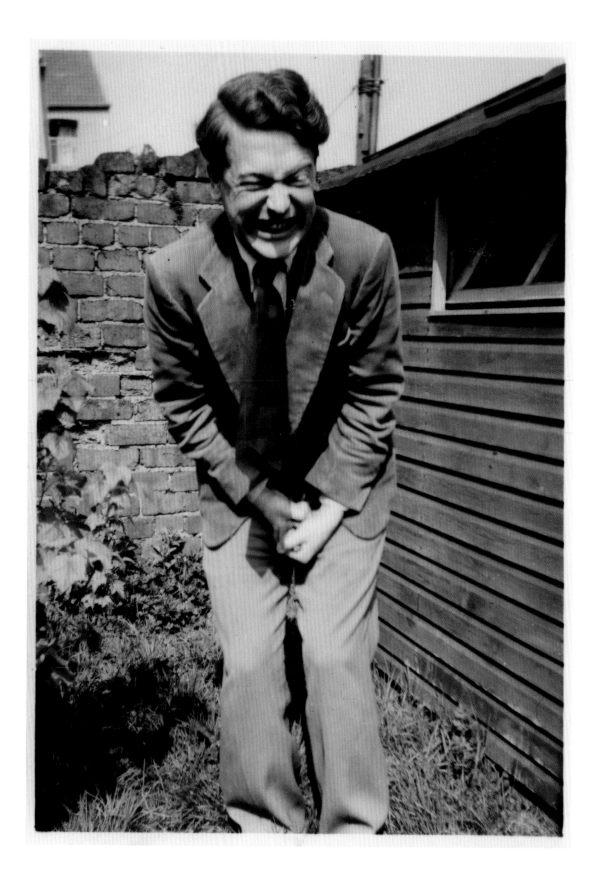

Chapter 10
Lucky Jim

During his time in Belfast Larkin evolved a balance between technical control and expressive idiosyncrasy that would be the cornerstone for most of his best verse, and at the same time he abandoned all further ambitions to publish fiction.

In 1950, shortly before he left for Belfast, Amis had written him an odd letter of thanks; odd because the cause of Amis's gratitude is not immediately evident. He reflects on their friendship, more in the manner of a man whose life, like his companion's, is drawing to a close. Soon, however, it becomes evident that the real topic of the piece is their correspondence. Amis has kept all of Larkin's letters to him and recorded a large number of his own in carbons. He has before him almost ten years of a confidential dialogue. 'During the week I turned out all my drawers, and re-read . . . your letters . . . Today you are my "inner audience", my watcher in Spanish, the reader over my shoulder . . .' Larkin might still have been puzzled by the letter because Amis is so excited that he forgets to mention why he is so engrossed with these shreds of confession, observation and character-assassination. Within a few months, however, Amis would explain the nature of his epiphany. Their letters were the inspiration for his latest attempt at fiction. Since being demobbed he had completed a novel, *The Legacy*, which had been rejected by at least eight mainstream publishers. The problem, he now recognised, was that he was trying to imitate the mannerisms of his elders and betters, figures who regarded humour – even as relief from a sanctimonious morality tale, à la Dickens – only as an occasionally indulged vulgarity. In short he was writing against character. He regarded the world as dysfunctional and absurd. Taking it seriously was hypocritical and doing so in writing even worse. So he had begun a novel that was at its most respectable a piece of social realism but which never strayed too far from the impudent snigger of the satirist, even the farceur.

Soon, Larkin became more actively involved – in that Amis sent him draft chapters, asking for comments and suggestions. Larkin responded generously and

Amis, in Swansea, photographed by Larkin in 1955.

it is clear that his new role as commentator on the evolving draft was an extension of the persona, 'the inner audience', that Amis had discovered in the letters of the 1940s. He was the dry straight man to Amis's joker and it was this dynamic that would make *Lucky Jim* (1954) such an astounding success: it is the tacit partnership between the cynically uninvolved narrator (Larkin) and the irresponsible, anarchic Jim (Amis) that drives the story forward.

In truth Larkin should be treated as the novel's co-author. Certainly the majority of it was first drafted by Amis but without Larkin the completed product would not have been so enthusiastically accepted by Gollancz.

Later Larkin treated Amis's fame with venom – he had after all spent much of the previous decade trying to become a novelist himself – but his bile was fuelled just as much by a conspiracy between them that he regretted even when he took part in it and which later aggravated his ever-present inclination to self-loathing.

Amis did more than borrow from the tone of their exchanges when he wrote the novel. He turned very real individuals, ridiculed in his letters, into the regiment of buffoons and intellectual pretenders who contributed to Jim Dixon's mood of anger and frustration. Notably Hilly's family, particularly her father Leonard, appear as the infuriating Welches; Neddy Welch the patriarch is Jim's head of department. Larkin's role as a steadying hand was crucial in this regard. He ensured that Hilly's family remained in disguise, sparing them knowledge of Amis's contempt. Even Hilly did not know that he had made use of her father until his letters were published after his death.

What remains a mystery is how Larkin could tolerate without complaint a far more malicious character assassination. It is beyond dispute that Monica Jones was the model for the odious Margaret Peel. Margaret is presented as a neurotic predator determined to turn Jim into her emotional retainer. Unlike his treatment of the Welches Amis worked very hard to ensure that anyone who knew Monica, and knew that he and Larkin were acquainted with her, would recognise her as Margaret. He gives inordinate attention to Margaret's habits of speech, and his concern with her hair, spectacles, the bone structure of her face and her taste in jewellery and clothing is relentless and extraordinary. She is, in these respects, an astonishingly precise replica of Monica. Why did he do this? The Margaret Peel who wishes to entrap and emasculate Jim was pure invention. Monica respected, admired, Larkin's independent spirit. Indeed it was a mutual recognition of innate idiosyncrasies and unorthodoxy that attracted them to each other and it was their close attachment that infuriated Amis. Larkin had found someone who was willing to share confidences, just the way he and Amis had done during the previous decade. Margaret Peel was a case of osmosis by fiction, an attempt to reinvent, and alienate, a woman who threatened Amis's own possessive relationship with Larkin.

After abandoning *No For an Answer* Larkin began another work of fiction called *New World Symphony*. He would never send it to a publisher; indeed one suspects he

never intended it to be published. It was a bizarre variation upon a notebook, one that included a companion, someone to whom he felt closer than anyone else. When what remains of the work went into print after Larkin's death Monica read it for the first time; she drew the editor's attention to several passages and stated, 'Yes, that's me.' The figure in the book is called Augusta Bax but Larkin gives such minute attention to her taste in jewellery and clothes – some fashionable, others provocatively unusual and bohemian – that anyone who knew Monica at all would recognise parallels. Never before had Larkin in his prose fiction been so meticulous regarding the appearance of his characters.

Moreover, he captured something of Monica's personality that betrayed equal degrees of mystification and endearment.

> Augusta admired the amateur tradition, the dislike of plodding, the careless production of masterpieces. She saw herself reading widely, pointlessly, fantastically, trailing through eighteenth century libraries, lounging in embrasures with folios, one hand turning a globe. Then a subject would spring up in her mind: a single strand electrifying several centuries . . . one followed one's nose, perhaps now and again a book might result.

Augusta, like Monica, is a junior academic in a provincial university and this passage catches perfectly the latter's preference for aestheticism over the combination of critical rigour – or 'close reading' as it was called – and scholarly pedantry that dominated the profession in the early 1950s.

The question of why he kept the book a secret from the woman who would be his partner for the rest of his life is fascinating, and tells us a great deal about him as a man and a writer. Augusta was the real Monica Jones, far from flawless but much more like the complex, sometimes conflicted figure that Larkin knew so well than Amis's scurrilous caricature. She was also a perverse variation on the standard notion of a fictional character: she would only be available to one reader, the man who created her.

Augusta can hardly be treated as Larkin's rejoinder to Amis, since the latter never knew anything of her, but she reflected the new level of intimacy that had developed between Larkin and Monica. He was beginning to see another side to Amis's reckless jocular personality and he reported regularly to Monica on how his friend seemed boorish and intemperate, a figure whose company he endured rather than enjoyed.

> Kingsley has gone, leaving me just able to support the horizontal weight of my salaried employment, but only just. He certainly dropped plenty of plates around though only 10 of my 15 pounds. On Saturday we went to

Dublin, drinking all the way there, there, all the way back, and back: I am only just about recovered.

He left me as usual feeling slightly critical of him: despite his organised self defence, I detect elements of artlessness? – no, what I mean to say is that despite his limpet-grip on life, terre-à-terrish & opportunist, there are times when I fancy I can see further than him in his own way. More of that, if needed, when we meet. However, he also intensified my predominant sensation of being a non-contiguous triangle in a circle [diagram of a triangle within a circle] – the inner life making no contact with the outer. Buried alive!

The atmosphere of the Amis household in Swansea, described by many, including their son Martin, as relaxed, hospitably hedonistic, is shown in a very different light by Larkin. Despite his fulsome thanks to Amis and insistence on how much he enjoyed his visits, Monica is offered what seems a more candid account.

Sluttishness, late hours, drink, squalling children . . . poor, insufficient food. Nor did the compensations for these seem as sufficient as in days of yore. I was read nearly ALL *Dixon and Christine*, & suggested it should be called *The man of feeling*, an idea wch Kingsley quite took to, but will probably not entertain finally . . .

I met Kingsley's ex-'mistress', a curious dark crooked-mouthed prognathic girl whose scarlet cheeks & burnt-cork eyebrows reminded me of Tod Slaughter made up for some villainy or other. Truly one man's meat is another man's buttered parsnips.

On the face of things Monica had by the mid-1950s become his true confidante. In his correspondence with Amis he retained the jokey, furtive, conspiratorial manner of their pre-*Lucky Jim* exchanges but now he disclosed to Monica the secrets his friend entrusted to him, supplemented by comments on how he really felt about the man he had begun to dislike. Yet at the same time he was practising a very selective form of candour; specifically, he cheated on Monica, first with Patsy Strang and later with others in Hull. In this respect one might judge him as no better than Amis but while the latter supplemented infidelity with disdain – boasting to others about how he had deceived Hilly and revelling in his plans for chicanery – there was at the core of Larkin's relationship with Monica a genuine seam of tenderness and intimacy. His letters to her on marriage, sex and his own emotional vulnerability show a special level of sincerity. Was he simply using her as his trusted, convenient, familiar? Previously, Sutton and Amis had been his closest temperamental confreres yet for both he swathed what he actually felt with various layers of self-caricature and evasion. Typically, to Monica:

. . . someone might do a little research on the inherent qualities of sex –
its cruelty, its bullyingness, for instance.

It seems to me that bending someone else to your will is the very stuff
of sex, by force or neglect if you are male, by spitefulness or nagging scenes
if you are female. And what's more, both sides would sooner have it that
way than not at all. I wouldn't.

Larkin, especially since the publication of the first volume of his letters, has been
routinely regarded as the archetype of reactionary misogyny. But this, from a man
writing in 1951, is remarkable. It prefigures feminist notions of sex as a reflection
of male dominance and power, and it was not a private deliberation. Rather, he was
sharing with his sexual partner his feelings about the inequality of the sexual act. 'It
seems to me,' he wrote to her, 'that what we have is a kind of homosexual relation,
disguised . . . I mean, I seem so entirely lacking in that desire to impose [myself],
that is such a feature of masculine behaviour.' This is an extraordinary attempt to
reconcile the competing instincts of love and male sexuality, and we know that he
would never have disclosed anything like this to Amis.

One remains puzzled however by his ability to be so emotionally candid with
Monica while continuing with the regime of cheating and misinformation. For
example, when he and Monica were on holiday in Mallaig in July 1953 he started
a letter with: 'Hotel paper, hotel pen, but I can still write you the beginnings of a
letter before breakfast as M [Monica] hasn't finished dressing yet.'

The letter was to Patsy and a week later, from Weymouth, he reports on how
he had 'plucked your letter from the rack like a cormorant snapping up a piece of
bread [while Monica is] sitting in the sun lounge looking across the front'. This time
his correspondent is Winifred, whom he was still attempting to seduce. Three days
later he wrote to Patsy and Colin, evidently with the knowledge of Monica, offering
a typically wry account of their travels in the Highlands and on the English south
coast. Alongside this, he had recently begun to tell Patsy about *New World Symphony*,
that it featured a near-facsimile of Monica and of the moral difficulties it presented:
he was, he recognised, now responsible for the fictional version of the woman he
cared for greatly. Monica visited Larkin in Belfast at least once a year. He introduced
her to Patsy and Winifred and there is no record that her time in the province was
attended by any sense of unease or tension. Rather they set off together for short
visits to the more picturesque parts of the region.

Larkin's escapades in duplicity carry the air of Brian Rix's Whitehall Farces, a
characteristically English sense of something naughty going on beneath the joviality,
but nothing terribly unsavoury. At the same time one detects a sense of purpose in
his antics. Throughout, he is attempting and largely succeeding in being one step
ahead of each of those closest to him. Clearly he kept his affair with Patsy secret from
Monica for practical, perhaps considerate, reasons but the rest of his secrecy seems to

be a game of untruths contrived for its own sake. It was as though he wanted to be quietly omnipresent, simultaneously confiding and withholding aspects of himself so that each would think they knew him while they knew only part of him.

In 1954 Colin Strang applied successfully for a lectureship in Newcastle and Patsy, sensing the move would be precipitous regarding the already fragile state of their marriage, asked Larkin if he wished to begin a proper, permanent relationship. He prevaricated and in the autumn she left Colin, went to Paris and began a relationship with the poet Richard Murphy. At the end of November following her whirlwind romance with Murphy she wrote to Larkin again, provocatively, stating that Murphy had proposed marriage but that she would think again if Larkin wanted her to return to Belfast. He answered tactfully that 'I think I'd better retire into the background of your life for a bit', and both of them knew he meant for good. Later in the letter he informs her, offhandedly, that 'I got that blasted Hull post, and am going there in March.'

The job was one of many that his boss in Belfast Jack Graneek had advised him to apply for that year. All were in university libraries and it is clear enough that Larkin felt he was ready for professional advancement. Significantly, he set aside for good the manuscript of *New World Symphony* at the same time. His conversation with Augusta ended at the moment he stopped writing to Winifred, and when Patsy, after he politely declined her proposal, married Murphy in Paris. His bizarre, private game of subterfuge could be drawn to a conclusion and it seemed to him appropriate that he should also release himself from the environment which in many ways inspired it. He would move back to England and grow closer to Monica, without the assistance of her fictional surrogate.

Amis near his first house in Swansea.

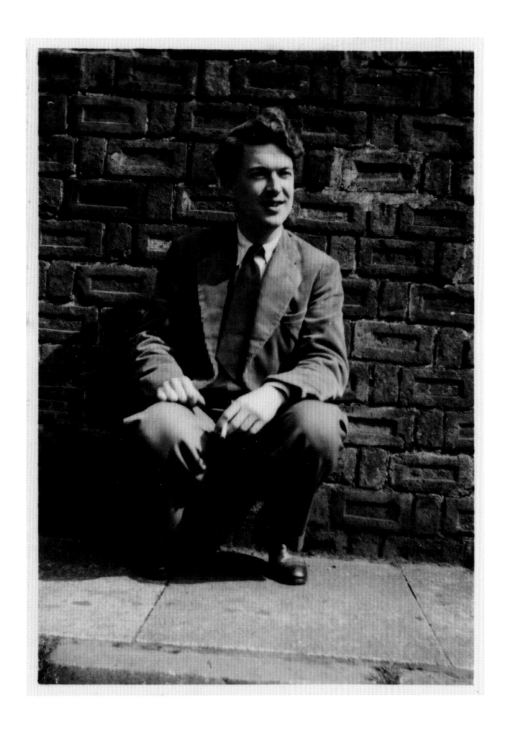

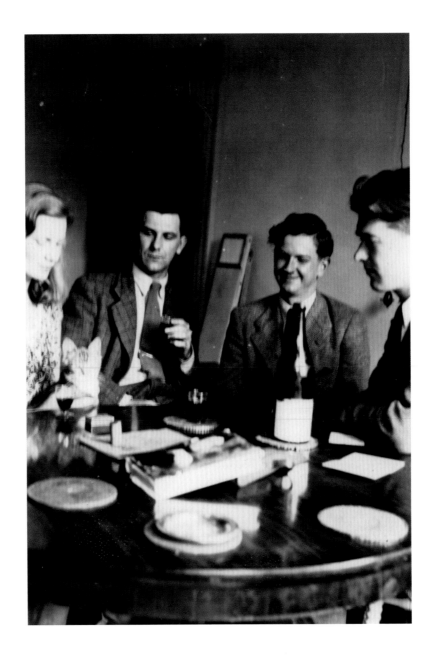

ABOVE Hilly, with cat, Norman Iles, Bruce Montgomery and Amis in Marriners Cottage, Eynsham; photographed by Larkin, 1948.

OPPOSITE TOP Passport-style photographs of Amis and Hilly, 1959; the last that Larkin would take of either of them.

OPPOSITE BOTTOM LEFT Sally Amis, aged two, photographed by Larkin in Swansea in 1956. He had written a poem for her, 'Born Yesterday', shortly after her birth in 1954.

OPPOSITE BOTTOM RIGHT Amis and Hilly photographed by Larkin outside Marriners Cottage, 1948.

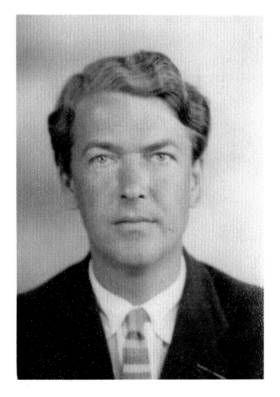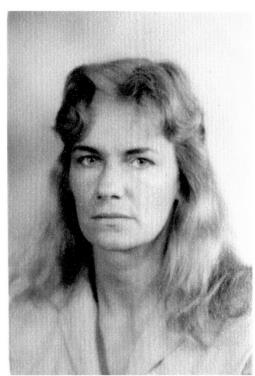

Hilly, above, at Marriners Cottage, and, right, in Swansea.

'. . . it's always very delightful having you stay as you must know… you must come to our party and get drunk and be my boy at it, and listen to all the good records.' (Hilly to Larkin from Marriners Cottage, 9 November 1948)

'I'm sick to death of all the men I love and admire going off with other women, usually much better looking than me. There's Kingsley with Barbara and Terry . . . I've got a weekend off in April, when I shall be going to London. I dream that I'm meeting you there, and that we'll have loads to drink and then go to bed together, but alas, only a dream.' (Hilly to Larkin from Swansea, 4 March 1950)

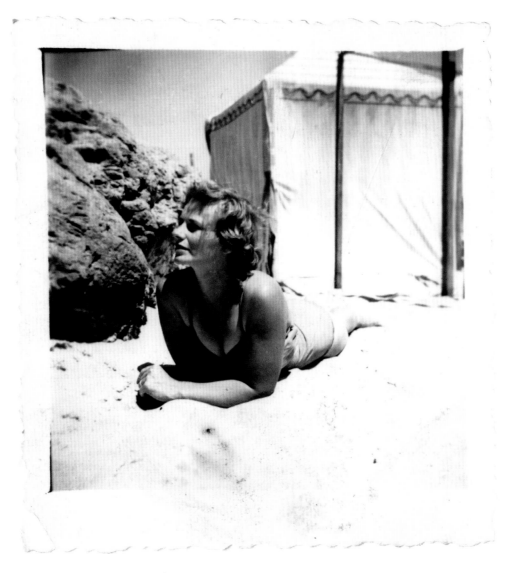

. . . I think you put your paw on the flaw in Churchgoing, a strong lack of continuity . . . The most important emotion – the church as a place where people came to be serious, were always serious . . . this emotion I feel does not come out nearly strongly enough.

Letter to Monica, 10 August 1954

'Church Going' was Larkin's first major poem and it points, albeit obliquely, to other new departures. He and Monica discovered that they shared a fascination with medieval religious architecture, but not in a conventional sense. They were entranced by churches and their surroundings as memorials to a collective state of mind. The photographs of the churches – some in the Cotswolds, others in Yorkshire and on Sark – were taken on their journeys during the 1950s and 1960s and each evokes a sense of a building at once compelling yet unused.

The unmown grass seemingly swallowing the ancient headstones might soon be dealt with by a churchwarden but for Larkin the photographer it evinced the feeling of irreparable loss that informs the poem: 'Grass, weedy pavement, brambles, buttress, sky, / A shape less recognisable each week'. He and Monica exchanged numerous letters as he sent her drafts and she replied with remarks and opinions. It was at Monica's suggestion that he included the lines on 'Mounting the lectern, I peruse a few / Hectoring large scale verses . . .' They too had done this in empty churches and the photograph of Monica at the lectern, taken several years after the poem was published, can be treated as a tribute to her contributions. Monica would continue as his most dependable literary adviser, an arrangement that reflected a sense of mutual trust and intimacy and a more straightforward, shared, affection for the kinds of places that inspired many of his best known verses. Notably he never mentioned any of this to Amis, often during the 1950s lying blatantly about his countryside holidays with Monica. Their habits – walking, seeking out quirky ruins and architectural curiosities, open-air picnics and so on – would, he knew, earn him limitless amounts of opprobrium and ridicule.

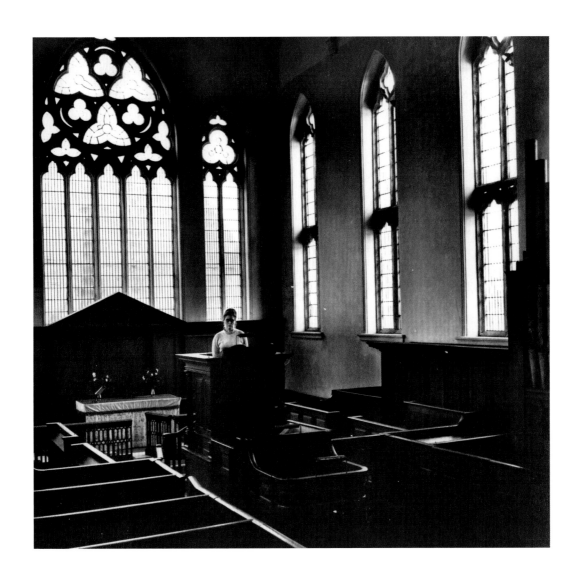

Hull and Elsewhere

Swerving east, from rich industrial shadows
And traffic all night north; swerving through fields
Too thin and thistled to be called meadows,
And now and then a harsh-named halt, that shields
Workmen at dawn; swerving to solitude
Of skies and scarecrows, haystacks, hares and pheasants,
And the widening river's slow presence,
The piled gold clouds, the shining gull-marked mud,

Gathers to the surprise of a large town.

From 'Here', 1961

Chapter 11
Hull

'Mr Bleaney' is an obliquely autobiographical poem, not so much based on a particular room as on a blurred composite recollection of places to which, despite himself, Larkin felt drawn. His first few months in Hull involved him once again in a characteristic odyssey through ever more dreary locations, beginning in March 1955 when he moved into Holtby House, a student residence in Cottingham – a one-time village now swallowed by the suburbs of Hull. He remained there for little more than three weeks until noise and lack of privacy drove him to look for private lodgings, which he found in a bed and breakfast just over a mile away. Why he chose this house remains a mystery, as within a few a few days of moving in he wrote to D.J. Enright of the 'nightmare' of his neighbour's 'blasted RADIO which seems to feature in everyone's life these days'.

In June he came upon an advertisement for lodgers in a boarding house owned and run by a genteel elderly lady, Mrs Squire, who requested that her tenants should respect their fellow residents' right to a quiet life. Mrs Squire fell ill a week after Larkin moved in and he found for himself, in the same street, a more spaciously appointed pair of rooms on the top floor of the house of Mr and Mrs Drinkwater. He was initially quite pleased at being their first and only lodger but this soon faded: they needed his rent to support their new and exceedingly noisy child who slept in the room below Larkin's.

Aside from the meticulously detailed particulars of 'Mr Bleaney', the impression we carry from the poem is one of a wearily accepted destiny. The landlady's reflections on the previous tenant are neither affectionate nor hostile; instead we sense that the new occupant, Larkin, feels she is introducing him to his drab role as Bleaney's suitable successor. One has to wonder if the procession of dull and irritating options that greeted him immediately after his arrival in Hull struck him as a distillation of all that fate, so far, had to offer. After the landlady has completed her account of the

A self-posed portrait of Larkin on the Hessle foreshore, 1969. He recalled that the 'Tyrannosaurus tree' had been there when he first visited George and Jean Hartley in the 1950s.

recently departed Bleaney, he runs through his own itinerary of dismal objects and items of furniture – the unshaded 'sixty watt' bulb, the door without a hook and so on – and then states: 'I'll take it.' Only three short words but each gathers from the rest of the poem an air of misanthropic glee. Thereafter he settles down to enjoy the ambient misery, speculates on Bleaney's existence beyond the poem – Christmas with what remains of his family in the Midlands, holidays in unexceptional very British resorts, the choice between sauce and gravy – and wonders if it resembles his own. As we now know, it did.

Monica wrote to him on 18 August 1955 after listening to a BBC Third Programme broadcast of his latest work.

> Mr Bleaney sounded so very like you – yr catalogue of the room's shortcomings! Like you & like me – I smiled at the radio as if I were smiling at you as it was read. And I like your poetry better than any that I ever see – oh, I am sure that you are the one of this generation! I am sure you will make yr name! yr mark, do I mean – really be a real poet, I feel more sure of it than ever before, it is you who are the one, I do think so. Oh, Philip – I don't know what to say. You will believe me because you know it doesn't make any difference to me whether you are or not, I shouldn't think any less of your value if yr poems seemed to me bad & if everyone said so: and because I've never said to you this is magnificent, this greatness triumphant, in yr hands the thing becomes a trumpet . . .

She shrewdly intuits his ability to interweave a guileless echo of his voice – 'Mr Bleaney sounded very much like you' – with something that very much rewards rereading.

He offered all of those close to him his first impressions of Hull and his pithy report to Robert Conquest sums up his feelings: 'a frightful dump' (24 July 1955). But his litany of complaints is so relentless that one detects a quiet masochism at their core. He seems fascinated by the sheer hopelessness of the place. On 9 June 1956 he wrote to the American book editor Donald Hall and took time to explain to someone probably unfamiliar with provincial England, that 'At present I am the Librarian of the institution referred to at the head of this sheet, and live a solitary life in the East Riding, which as you may or may not know is a remote triangle of Yorkshire, on the way to nowhere.' Before the war Hull was an unostentatious city and when Larkin arrived much of it was comprised of bomb sites; the Luftwaffe had made several attempts to obliterate the docklands but most of the bombs had fallen in the Victorian centre.

In September 1956 he visited Monica in Leicester and immediately after his return wrote to her:

Dearest

> Back to this dreary dump
> East Riding's dirty rump,
> Enough to make one jump
> Into the Humber –
> God! What a place to be:
> How it depresses me;
> Must I stay on, and see
> Years without number?

In October 1956 Larkin finally escaped the merry-go-round of dismal bed-sits and boarding houses crystallised in 'Mr Bleaney' and moved into a semi-furnished self-contained flat. Number 32 Pearson Park was owned by the university and contained three apartments intended to house newly appointed staff while they were looking for something permanent and more spacious. Few stayed for more than a term and tenants were advised that it was expected that they should treat their residence as temporary. It remains a mystery as to how Larkin managed to remain there for the subsequent eighteen years, leaving only after the university decided to sell the property. Shortly before moving in he wrote to Monica that the thought of becoming 'practically a householder' – including the prospect of buying furniture, bedclothes, kitchenware, and so on, to supplement the basic fittings provided by the university – 'gives me a sort of sinking feeling' (18 September 1956). He does not explain why, nor does he offer any reason for the faintly apologetic manner of his account, but Monica knew him well enough to appreciate the subtext. He also wrote that 'I'm being woven into the fabric of society so fast that my head is spinning.' Anything that carried even a remote indication of commitment, including such apparently innocuous activities as buying plates and table lamps, felt ominous to Larkin. There were plenty of other agreeable-enough privately owned flats and small houses available via local estate agents but his decision to take up long-term residence in a place intended only for those in transit was his token protest against the state of permanence to which he had already resigned himself.

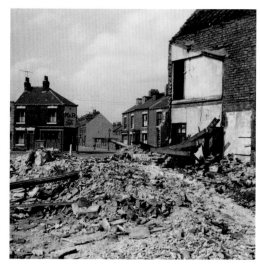
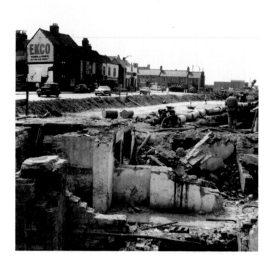

UPPER LEFT AND LOWER RIGHT Cranes at Hull docks, 1956.

UPPER RIGHT AND LOWER LEFT Bomb sites in Hull, *c.*1957, more than fifteen years after the Luftwaffe raids.

OPPOSITE Ruined timber ships on the Humber foreshore, 1957.

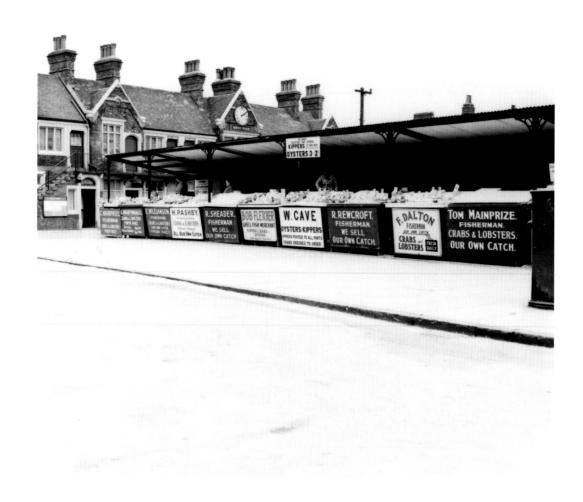

Larkin sometimes bought freshly landed fish from the stalls near the docks in Hull. The print is inscribed, 'large cool stalls'. He would write 'The Large Cool Store', inspired by the newly opened Hull branch of Marks & Spencer, in 1961.

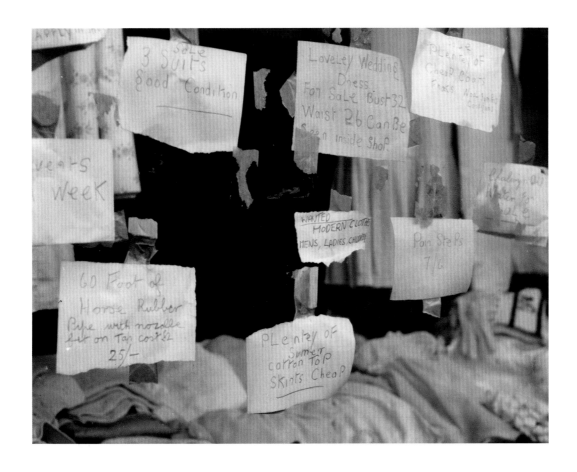

A shop front in Hull, 1956, that Larkin referred to as encapsulation of 'life'.

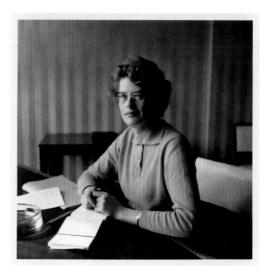

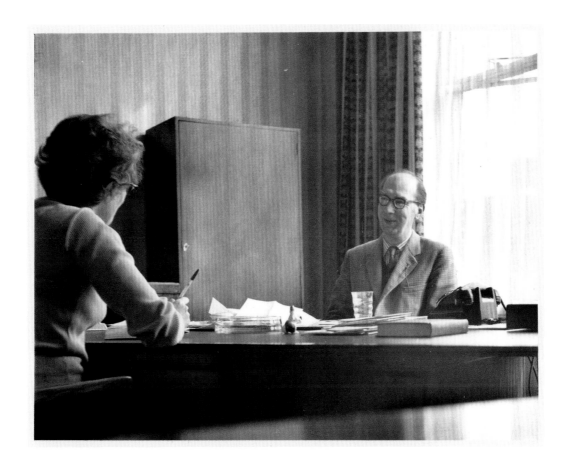

OPPOSITE, TOP LEFT The old campus at Hull, 1957.

OPPOSITE, TOP RIGHT When Larkin arrived at Hull the library was housed in a collection of Nissen huts.

OPPOSITE, BOTTOM RIGHT Betty Mackereth photographed by Larkin in the early 1960s.

OPPOSITE, BOTTOM LEFT On the same day that he took this photograph, 14 February, he sent Monica a card, inscribed,

> Snow on Valentine's Day!
> But it will go away.
> My love is not like snow:
> It will not go.

ABOVE Betty and Larkin in his office.

God knows how I shall ever get through the next few years, building this new library. A sad life for an unambitious creature.

Letter to Eva Larkin, 25 January 1956

Larkin's predecessor Agnes Cuming had negotiated a plan for the improvement and expansion of the Library but nothing was agreed regarding how much would be spent let alone whether the existing ramshackle buildings would be refurbished or replaced. Brynmor Jones, previously Head of Chemistry, had only a week earlier been appointed as the new Vice Chancellor and one of his first executive decisions involved a meeting with Larkin. He announced that a completely new library would be built, one to rival those of the established redbricks such as Manchester and Leeds, and Larkin would supervise its progress. He had eleven members of staff, two men and nine women, and with the expansion, over the following five years this number would double. Throughout the period in which the new library went from plans to a glamorous, at least by 1960s standards, Corbusier-style combination of glass and concrete, Larkin played the role of intermediary between the architects, the university fundholders, the site managers and the men who actually built it. He kept a detailed photographic record of its progress. The top right photograph shows Larkin, self-posed, surveying the site.

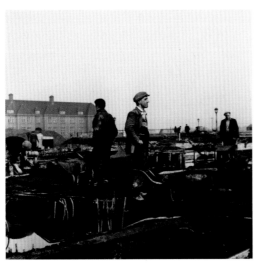
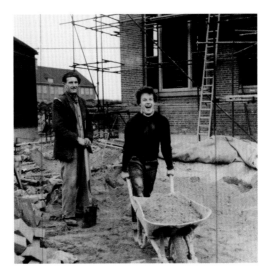

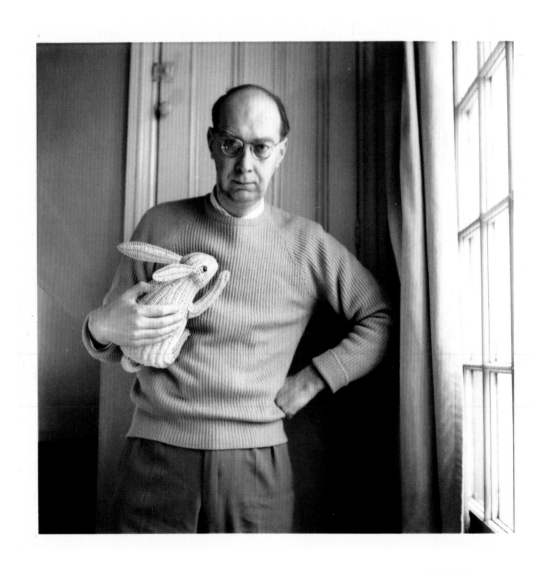

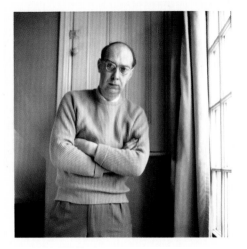

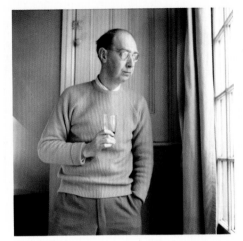

OPPOSITE Larkin and wicker rabbit (a present from Monica) beside the window of Pearson Park. Larkin, without rabbit, looks suitably dismayed. Finally, Larkin resigns himself to the creature's departure, takes a drink and stares into the familiar vistas of the Park. The sequence of photographs was taken by Monica in 1962.

ABOVE Bedroom, exact location unspecified, taken soon after his arrival in Hull.

Chapter 12
Around Hull

Pearson Park was a late Victorian terrace of characteristically eclectic demeanour, with tinges of Gothic, Tudor and Georgian appropriately suburbanised. Larkin's flat was made up of a reasonably spacious living room, one bedroom and a small kitchen and bathroom. The living room window afforded him a view of the park itself, and quite soon he had placed a pair of binoculars permanently on the sill and would eventually invest in a telescope.

The image of him as a hidden observer, monitoring the activities of those passing through the park and along the street has become an indelible part of the mythology of Larkin. On the first anniversary of his death BBC Radio 4 broadcast a series of interviews in which friends and colleagues reminisced on his habit of unobtrusively watching the world, leaving the impression that many of his poems grew out of these silent observations. After listening to the programme Amis offered a rather different interpretation to Robert Conquest: 'The only point of interest was that P had a telescope on his windowsill to get a better view of passing tits.' Amis did not know his old friend quite as well as he thought. The binoculars and telescope reflected routines that had become paramount since his time in Belfast. Their presence on his windowsill was temporary; he would take them with him, along with his camera, on his various journeys through the countryside. In Wellington and Leicester he had begun to find that weekends away in quiet market towns, particularly in the Cotswolds, brought some relief from the constant pressure of finding a role for himself as a writer. Eventually, avoidance mutated into inspiration: 'Church Going' evolved out of his fascination with how remote, apparently deserted, churches seemed as if they were being absorbed by the natural world.

Soon after he arrived in Belfast he had been struck by how suddenly the Victorian cityscape could be exchanged for moorland. He had always made use of a bicycle in preference to public transport and when he lived in Ulster he took to riding out with an ordnance survey map, binoculars and camera to see where the 'B' roads and then

Seagull on the Humber foreshore.

the lanes would take him. Less than a year following his arrival at Queen's he had written to Monica.

> It is a fine mild autumn Sunday and I've ridden up into the hills, aided by a kind south wind . . . the weather was soft and fine like the end of Wuthering Heights: I grubbed about for blackberries. In all I must have done nearly 20 miles and I feel tired and virtuous. I like the country up there, barren and featureless . . .

In 1955 he sent Monica an account of a visit, again by bicycle, to Beverley, almost twelve miles from Hull.

> 9.50 p.m. I went a long bike ride in boiling weather, enjoying it in snatches . . . I went to Beverley in a roundabout way, had tea at the Beverley Arms, then went west in a long arc round the villages and wolds to Kirk Ella and Hessle . . .
>
> In Beverley I went into St Mary's and found the rabbit (see enclosed leaflet). I like this church: I hope one day you'll see it. The rabbit is not a very attractive one: I should say it is sneering rather, and some of it has broken away. Then again it might be a hare, I suppose. But it is certainly wearing a satchel . . . a lone invader of a hated ecclesiastical stronghold. I expect the satchel contains carrots. Looking into a small paper shop for cricket scores I found a pile of Beatrix Potters, & read Apply Dapply's Nursery Rhymes . . . It made me wish you were with me.

They had discovered a mutual interest in medieval religious buildings and a shared affection for wild rabbits soon after they met – for the previous six years Larkin had routinely opened letters to her with 'Dearest Bun' (or sometimes 'Ears' or 'Forepaws'). The 'broken', 'not very attractive one' at Beverley was a ruined gargoyle on the Minster.

When he wrote to those closest to him he adopted his dejected, melancholic persona – but he knew that most would detect something that belied the performance, a smile beginning to form: 'Oh yes, well, it's very nice and flat for cycling': he begins for Judy and Ansell Egerton, 'that's about the best I can say. I usually pedal miles and miles at the week-end, always winding up at the Beverley Arms for tea . . .'

Again to the Egertons he opens with a litany of complaints about a provincial university well suited to its unwelcoming environment.

> This institution totters along, a cloister of mediocrities isolated by the bleak reaches of the East Riding, doomed to remain a small cottage-university of arts-and-sciences while the rest of the world zooms into the Age of Technology.

Then, suddenly, there is a change. It is not that the place has improved – no, it maintains its retrograde dreariness – but Larkin can no longer disguise that something about it suits him very well indeed.

> The corn waves, the sun shines on faded dusty streets, the level-crossings clank, bills are made out for 1957 under bill-heads designed in 1926, and the adjacent water shifts and glitters, hinting at Scandinavia . . . That's a nice piece of evocation for you.

The part played by Monica in Larkin's evolution from a good poet to a man who customised a very special form of verse writing is immense and inadvertent. His letters to her during the mid- to late 1950s seem like rehearsals for his poems; the same, almost symphonic, shifts in mood and perspective are discernible in both. He is tantalised by the notion of place, by a still unfamiliar yet biddable landscape which draws him in and enables him to anchor his more fanciful, speculative passages. Typically, there will be an overture involving mundane and unashamedly tedious details of his existence.

> I'm sitting in my, for once, overheated room, listening to Porgy & Bess from Brussels, but it's a hell of a bore except for the two famous tunes, neither of wch have been played yet. This is the only sheet of paper I have here – at least, I can't see any more & I know I left a pad in my desk at the Library.

As we leave the sentence it is as though a door is being quietly closed and while there is little reference to movement we sense him leaving the building and feel his humour lifted by the sunshine.

> Well, to give this place its due, the weather has been splendid yesterday & today. I have been quite transported by the sun, warm air, bees still burrowing into late flowers, the beautiful chill mauve blue of Michaelmas daisies in the churchyard; and in the villages, when I rode out this afternoon, the thick stacks behind the warm brick farmhouses. The sky was pale blue, with the immoveable small curly clouds of autumn in it. Yesterday – after a degree congregation and luncheon of *surpassing* foulness – the village seemed quite lovely.

Then there is a shift to an acceptance of others as part of his world.

> I went to the local library and strolled very slowly back up the main street, pausing to buy two teaspoons and a root of celery, feeling contented with the content that comes from feeling that the world is all right, even if I

am all wrong. The pavement outside the Union Hall (over the Cooperative Stores) was scattered with confetti, & inside they were dancing & drinking & singing *Let the rest of the world go by*.

He feels a sense of unaffiliated tenderness, not denying himself the 'contented' observation of moments of commitment, happiness, experienced by others,

Next he turns to a more recondite contemplative mood, perhaps prompted by the confetti outside the Union Hall: 'as you know, or have guessed, I am always, emotionally, "on the hop"(!) by feeling bound to "explain" why, if you mean so much to me, I don't "prewve it". I always feel so defensive about this.' It sounds like a prose version of one of his poems.

Perhaps his greatest poem, 'The Whitsun Weddings', is dovetailed with letters to Monica. The poem germinated in his report to her on 3 August 1955: 'I went home on Saturday, 1.30 to Grantham – a lovely run, the scorched land misty with heat, like a kind of bloom of heat – and at every station, Goole, Doncaster, Retford, Newark, importunate wedding parties, gawky and vociferous, seeing off couples to London.' In the poem we see the passing landscape, the figures on the platforms and in the carriages through his eyes, and he shares them with us unobtrusively. But as the piece draws to a close and the countryside is exchanged for suburbs – 'An Odeon . . . cooling tower, And someone running up to bowl. . .' – one senses that beneath the words Larkin is gathering his observations into something more than the sum of what has gone before. 'I thought of London', he writes, 'Its postal districts packed like squares of wheat'. For the first time he offers an image that is as much fanciful as descriptive and suddenly the sub-clause of the next line returns us to a sense of speed and imminence: 'There we were aimed.'

> . . . it was nearly done, this frail
> Travelling coincidence; and what it held stood
> Ready to be loosed, with all the power
> That being changed can give . . .

The closing two and a half lines have puzzled critics since the poem was published:

> . . . there swelled
> A sense of falling, like an arrow shower
> Sent out of sight, somewhere becoming rain.

The 'arrow shower' is an image both magnetic and unfathomable. Throughout the previous ten lines we are listening to Larkin's mind at work. Indeed, he wrote to Monica of his attempts to complete the final draft.

> I have spent nearly all evening trying to finish this poem: I've never known anything resist me so . . . I have just hammered it to an end, but really out of sheer desperation to see this fiendish eight verse in some kind of order . . . (18 October 1958)

Reading these lines we can pick up anticipatory traces of what would become that final gnomic image. He thinks of London, perversely perhaps, as something he is approaching from the sky, and envisions its postal districts 'spread out in the sun'; the rails that carry the speeding train towards its destination are bound together with 'knots'; there is a gathering sense of tension, of something 'ready to be loosed'. This cascade of potentially disparate sensations and impressions is suddenly found to have a common factor. When we reach the 'arrow shower' we feel, like him, that it is a suitable compound of what has recently passed through his mind, and now gone on to the page.

He kept a carbon of the letter to Monica of three years before, in which he gives an almost exact listing of the stations on the journey. Later in it he asks if 'This is England' means anything at all and continues '. . . talking about England, did you see Henry V is to be shown at the Academy, Oxford Street? I want to go.' He did, with Monica later that year, and three years after that when he completed the poem the stunning cinematic moment of the bowmen and the shower of arrows became part of a chain reaction that also involved memories of a train journey through the length of England and the elusive question of what England actually is.

When cycling through the largely flat East Riding countryside Larkin felt
the need to record the names of the small unremarkable villages, perhaps
to evoke something less tangible: small items, such as a chimney pot
apparently mimicking a railway signal, would catch his attention.

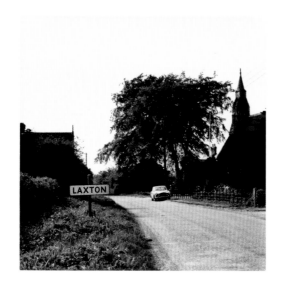

I went for a walk this afternoon. People had told me to 'walk the wolds' or the Dales . . . It was a sunny afternoon but there were cloudy intervals. Near home I stopped and watched about half a dozen Jersey cows. How lovely they are! Like Siamese cats, almost: the patches of white round their eyes and the soft way the coffee colour melts into their soft white underbelly. They were licking each other affectionately in pairs, on the chest and along the neck. When one stopped the other would begin licking back. The peaceable kingdom! . . . Never a rabbit did I see, alas.

Letter to Monica, 6 August 1955

OPPOSITE Cows on the Dales and in Scotland.

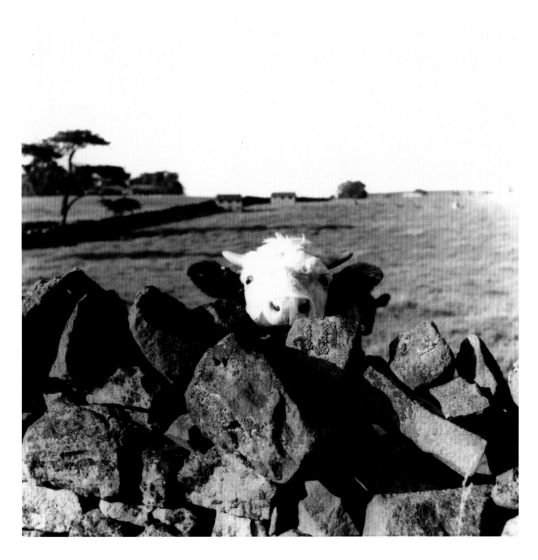

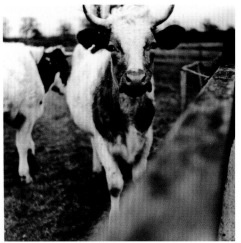

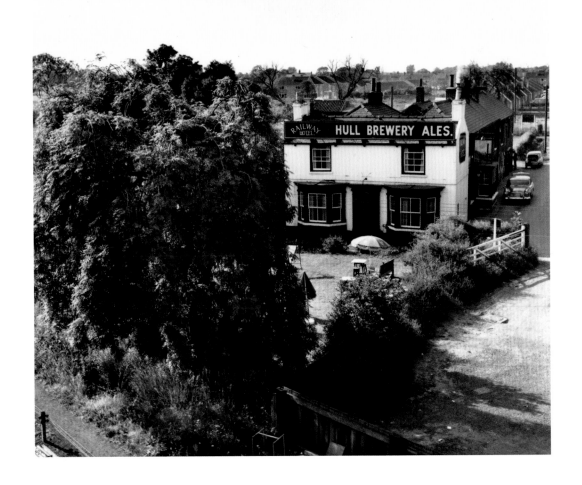

The Railway Hotel, just outside Hull.

Larkin and Monica in the Railway Hotel, 1958.

I fell asleep, waking at the fumes
And furnace-glares of Sheffield, where I changed,
And ate an awful pie, and walked along
The platform to its end to see the ranged
Joining and parting lines reflect a strong

Unhindered moon.

'Dockery and Son'

For Larkin railways always exercised a fascination that went beyond the trope of 'The Whitsun Weddings'. A later poem in the same collection, 'Dockery and Son' is treated as a ruminative glimpse into his past from a point in early middle-age, but its most engrossing lines involve the present day. He is returning to Hull from Oxford, and changing trains at Sheffield, he walks to the end of the platform,

> to see the ranged
> Joining and parting of lines reflect a strong
>
> Unhindered moon.

The contrast between the lines 'joining and parting' and the moon left 'unhindered' by their different trajectories can be related to Larkin's increasingly complicated private life. In the early 1960s he was maintaining relationships with two women, Monica and Maeve Brennan. In his first draft of the poem he had written, 'joining and parting of lines and thought how . . .', only to cross out the last three words. We can only speculate on what kind of disclosure might have followed, but a hint is whispered in his other major railway poem 'Friday Night in the Royal Station Hotel', set in the grand Edwardian hotel attached to the terminus in Hull city centre. He leads us through the building in a manner that is quietly terrifying, leaving in his wake a sense of arrivals and departures as warnings of the unforgiving nature of transience. He would entertain each of his partners there and sometimes wait on the platform for the arrival of one of them, Monica.

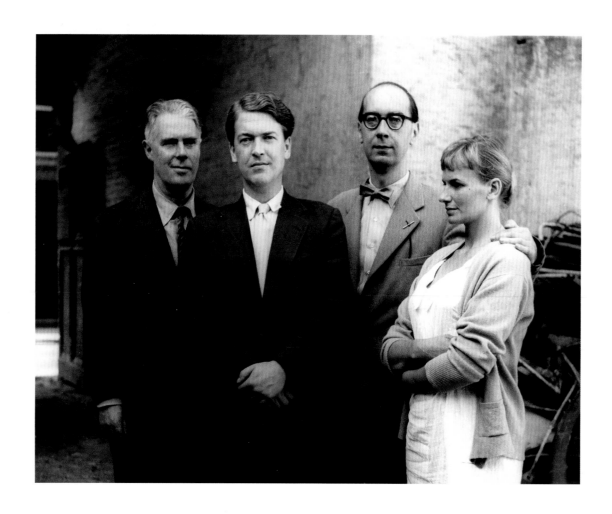

Chapter 13
Poets and Peers

Sometimes Larkin would cycle along the north bank of the Humber to the parish of Hessle, an untidy amalgam of small villages. It is now dwarfed by the Humber Bridge but in the fifties the locality had a certain bluff charm about it, the sort of place rarely visited by strangers. Larkin went there to see George and Jean Hartley.

The Hartleys lived in an early-nineteenth-century labourer's terraced cottage and had recently set up a publishing house called the Marvell Press, after Hull's best known poet. George and Jean were the only members of staff and the organisation was based exclusively in the front room of their house. Larkin and Jean got on well and remained on good terms, but Larkin always treated George with something like weary suspicion. Each owed the other quite a lot but both seemed to resist the fact: Marvell Press published *The Less Deceived* (1955), which established Larkin as a major poet, and the success of the volume rescued Hartley's enterprise from almost certain obscurity.

Larkin's arrangement with the Marvell Press could have provided material for the fashionably dry comedy of contemporary fiction. The 'contract' for *The Less Deceived* was actually signed three months after the book went to press, mainly because George, despite persistent enquiries from Larkin, had forgotten to draft it. In the end he drew up the kind of agreement more familiar to players of Monopoly than book-trade professionals, undertaking to pay Larkin simply 'an equal share of the profit'. He did not mention that the first print run would be limited to 300 copies, each purchased by individual subscription; the percentage of the latter which amounted to 'profit' was vague and debatable. After 1955 Larkin's bicycle trips to Hessle became monthly events. Jean would provide him with beer and sandwiches and his 'profits' would be passed to him by George in brown envelopes stuffed with bank notes, a means by which Hartley could secure his enterprises from the attentions of the Inland Revenue. Larkin began to refer to Hartley as 'the Ponce of Hessle', though he never used the

Anthony Powell, the Amises and Larkin, London, 1958. Larkin and Monica later became regular guests of the Powells at The Chantry, their grand Regency house in South Gloucestershire.

term in his company. He saw the Marvell Press as a provincial version of eighteenth century Grub Street, where the sub-culture of independent publishing co-existed with less salubrious activities. Hartley supplemented his irregular income from the press by working for the Hull branch of Austin Reed, gentleman's outfitter, but he preferred rather shadier attire causing him to resemble, in Larkin's opinion, a cross between Graham Greene's Pinkie and a Teddy Boy.

In 1958 Hartley proposed that they should record *The Less Deceived* on disc, with Larkin as reader. Larkin had already done several readings of individual poems for the BBC and Hartley was convinced that a long-playing record of his verse would be the high-cultural equivalent of jazz and rock 'n' roll. Larkin, reluctantly, was persuaded and the two of them set off on 23 October for a day-long booking in London of the HMV Studios. The original record is a darkly hilarious reflection of Larkin as the man who was almost there; his stammer is suppressed but not so much that one might notice its absence, and traces remain of his Coventry accent. Oddly one can also hear things going on in the background – doors closing, lavatories flushing – and although Larkin claimed to loathe the recording it is a wonderful testament to the beauty of verse that is unashamedly rooted in the inconsequential and everyday.

There is a fascinating nuance in his reading of 'Lines on a Young Lady's Photograph Album'. He recited the line 'But O, photography! as no art is . . .' with 'art' given undue emphasis. He seems to be asking himself a question: is it 'art'? The fact that he considers this at all testifies to the importance for him of his camera. Just as his poems began to say a great deal without seeming to tell us anything, so he was becoming equally entranced by the way that photography could capture a mood, an inflection, perhaps a comfortable absurdity while appearing not to notice them.

By the mid-1950s the consensus within the literary establishment and in publishing houses was that despite the general acceptance of modernism as now part of the cultural landscape the ordinary reader still preferred accessibility in poetry and realism in fiction. But all of this was happening in London and fate seemed to be playing a particularly baleful trick when Larkin received a letter from Charles Monteith of Faber and Faber. Monteith had read 'Church Going' in *The Spectator*, was so impressed that he had tracked down several other of Larkin's pieces published in magazines and on the strength of this stated that Faber would be willing to offer him a generous contract for a collection. All of the verses referred to by Monteith had gone into *The Less Deceived*, which had appeared two weeks before Monteith wrote to Larkin. Monteith was not aware that his suggested volume was already in print and once more Larkin felt as if he had drawn the short straw. In 1955 Amis completed his second novel, *That Uncertain Feeling*, and film makers had already begun bidding for the rights to adapt *Lucky Jim* for the screen. When Larkin read the new novel he was caught between amusement and vitriol. The charming anti-hero, and narrator, John Lewis, is a librarian obliged to waste his days catering for borrowers in a provincial public library. Amis had unashamedly refashioned the droll anecdotes that Larkin

had reported to him when working in Wellington. Even worse, Lewis was a hybrid of Larkin and Amis, drawing all of his disgraceful hedonistic and undeniably attractive features from the latter while pressing the former into service for everything that Lewis, and the reader, would prefer to hide. Larkin first read the novel as Amis's editorial advisor, just before it went to the publisher, and he wrote to Monica: 'oh please God, make them [Gollancz] return it, with a suggestion that "he rewrites certain passages"! Nothing would delight me more. And I refuse to believe he can write a book on his own – at least a good one.'

Larkin's poetic output between 1956 and 1960 was relatively infrequent – on average two and a half poems a year – and in letters to friends he usually claimed that he lacked inspiration. The true cause was far more intriguing. He was producing some of his finest verse and it was good because it suited the slow tempo of his life: he found inspiration in what most would regard as the routine of the hopelessly mundane.

The mid-1950s is regarded by most as marking a sea change in the history of British writing and in poetry this phenomenon acquired the collective title of the Movement while fiction and drama encouraged the less reflective mannerisms of the so-called Angry Young Men. The prototypical collection of the former was probably the 1953 PEN anthology containing verse by, amongst others, Larkin, Amis, Elizabeth Jennings and one Robert Conquest. Conquest would go on to become the intellectual impresario for counter-modernist verse, and his Introduction to the collection *New Lines* (1956) was regarded as its manifesto. Conquest wrote that poetry should be 'empirical in its attitude to all that comes', should 'resist the agglomeration of unconscious commands' and 'maintain a rational structure and comprehensible language'. The volume included verse by D.J. Enright, John Holloway, John Wain, Elizabeth Jennings, Donald Davie, Amis and Larkin.

Many writers associated with the Movement and the Angry Young Men in their early careers would go on to disclaim any great sense of affiliation, let alone a collective agenda, which is understandable given that few artists allow their individuality to be compromised by clannishness. Larkin, however, was feeling uneasy and resentful as early as 1954. In a letter to Patsy Strang:

People like Anthony Hartley and G.S. Fraser are very stupidly crying us all up these days: take my word for it, people will get very sick of us (or them; that is, Wain, Gunn, Davie, Amis) and then, UNLESS they produce some unassailably good work, I think the tide will turn rapidly and they will rapidly be discredited. I'm sure I don't care.

The only other literary figure with whom Larkin became closely acquainted during the 1950s came from a different era and class, but Anthony Powell admired the new generation's apparent commitment to elegant readability; this had been his working principle since the 1930s. Amis had been on good terms with the Powells

since 1953 and would amuse friends with accounts of how Lady Violet would leave a ten shilling note under the pillow when they stayed in the Amises' Swansea house, 'for the maid', which Hilly, the maid, greatly appreciated. In August 1958 Amis was due in London to deliver the seventh PEN Anthology to the printers. He had also arranged to have lunch with Powell at the famous Ivy restaurant and he invited Larkin. Larkin agreed and insisted that Hilly should come too. Larkin took a number of photographs and later reported his impressions of Powell to Judy Egerton. He found him '"charming" and funny, at least he never says anything really funny, but he's full of droll anecdotes and laughs a lot, so one imagines he's funny. He dresses in a country style and has a big red spotty handkerchief to wipe the tears of laughter away with.'

After seeing a pre-proof copy of *New Lines* Larkin wrote to Conquest offering him rather grudging support for his manifesto for the new generation and ended by agreeing with Conquest that verse should be 'a fuller and more sensitive response to life as it appears from day to day' rather than involving 'Mediterranean holidays financed by the British Council'. Amis had recently won the Somerset Maughan award for *Lucky Jim*, a proviso of which was that the winner must spend some of the generous £400 prize on three months abroad. Amis had decided to rent a villa on the southern Portuguese coast.

Even when Larkin and Conquest first arranged to meet in person, Larkin, in a letter of September 1955, sounds almost apologetic for being out of his depth among the metropolitan elite. 'I don't know the place at all,' he says of the Strand Palace Hotel, 'but I expect we shall be where drinking takes place.' Next he seems to be preparing Conquest for a disappointment. 'I am tall bespectacled, balding (sounds like Time), possibly wearing a seawater coloured suit.'

Over the previous three years Amis had entertained him with stories of his rakish adventures with his new friend. Even before Amis had obtained overnight fame with *Lucky Jim* Conquest had shown him an alternative to the monochrome gloom of post-war Britain, sometimes hosting parties for Amis and Hilly at his Hampstead home and just as often arranging for himself and Kingsley to enjoy bachelor-style weekends roaming through the less salubrious parts of London's club land. By 1954 Conquest was providing Amis with alibis and lending him flats in central London for his frequent extra-marital liaisons.

In 1956 Larkin wrote to Conquest asking why he had 'chucked up his job' at the Foreign Office, about which he had always been evasive, to become a Research Fellow in the London School of Economics. 'I can't imagine what you are doing,' pondered Larkin; 'is it research?' Yes, but not quite in the way that Larkin imagined. Conquest was a Sovietologist who produced many informed publications on the political, military and economic state of the Soviet bloc; his 1960 *The Great Terror* was the first large-scale disclosure that Stalinism was a regime just as dictatorial and murderous as Nazism. In truth Conquest worked on the margins of the Intelligence services. For Larkin this aspect of Conquest's life fitted the mould of his friendship with Amis: there

was something furtive and tantalising about both. He, on the other hand, appeared destined for the role of hapless spectator. Conquest was the impresario and Aladdin for Amis's adulterous double life but for Larkin he supplied pornographic magazines that were well before their time with regard to the complexity and sophistication of the acts depicted. In his letter to Conquest he is fulsome in expressions of gratitude and alongside this there is an appreciation of the quality of the product that might have been written by F.R. Leavis on one of his favourite novelists. 'I admire the painstaking realism of it . . . the action and standard of definition left something to be desired.'

Amis and Conquest advised each other on strategies of seduction and avoidance – Conquest too was a serial adulterer – while the latter catered to Larkin's taste for voyeurism. Larkin wrote to Conquest in July 1957: 'I greatly enjoyed our tour of the dens.' The 'dens' were strip clubs and in Larkin's view 'that place in Greek Street [Soho] is as good as any'. It allowed customers to take photographs of strippers: 'my 2 sets were very mixed – one bloody awful and I enclose it, you can have it (hope the letter doesn't go astray!)' Conquest was sufficiently charmed by Larkin's flippant reference to the questionable content of the letter falling into the hands of the authorities to turn the joke around. Some months later Larkin opened a Scotland Yard embossed envelope informing him that he, Philip Arthur Larkin, should make himself ready to attend court proceedings already being undertaken under the Obscene Publications Act of 1921, leaving it unclear as to whether he was being called as a witness or a defendant. Larkin telephoned the library to report debilitating flu-like symptoms and spent the day in the offices of his solicitor who first advised him that they were unable to act until a warrant for his arrest was issued and eventually noticed that the Obscene Publications Act of 1921 did not exist. Conquest had invented it. Amis wrote to Larkin and commiserated. 'What a day for you . . . the Bloody fool [Conquest] . . . God had it happened to me I would have been suicidal.' His sympathetic comments were disingenuous. He had colluded with Conquest in the ruse and shared his amusement at Larkin's account of his day with the solicitor.

The joke confirmed for Larkin that Amis and Conquest always be the rogues and he the luckless straight man, but his acceptance of this role was not an act of acquiescence. He no longer felt the need to pretend to be like them. Instead he could build a world of his own, one that he kept largely to himself. He would perform for them as the dull slightly comic subordinate while concealing from them a way of life that became his routine and which he privately enjoyed, despite his habitual complaints.

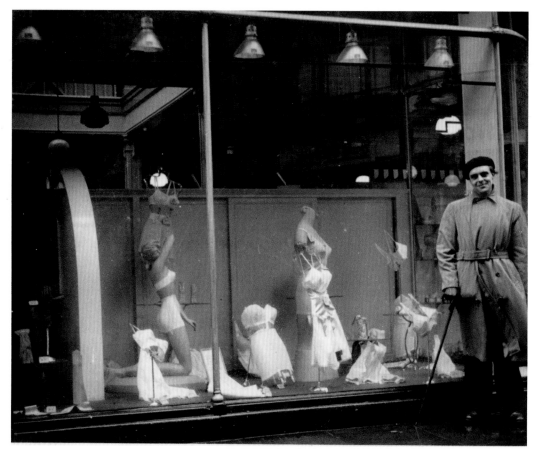

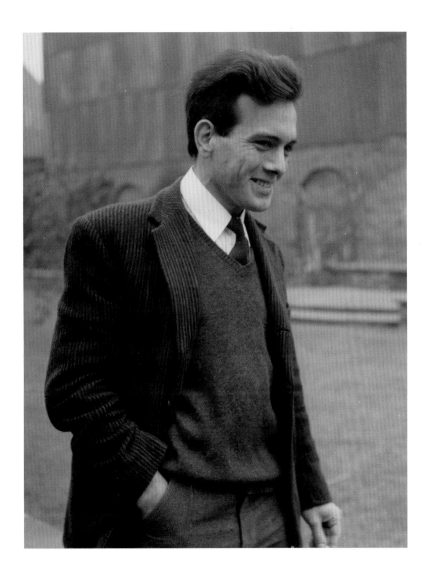

John Wain's *Hurry on Down* had been greeted with as much acclaim as *Lucky Jim* but soon Amis's fame eclipsed Wain's. This, however, did not diminish Amis's loathing for a man he saw as his unworthy rival and throughout the 1950s Amis's letters to Larkin are filled with abuse for Wain. Larkin continued to treat him as a friend, albeit one that he sometimes had to indulge.

OPPOSITE, TOP LEFT Wain in the Pearson Park flat, 1956.

OPPOSITE, TOP RIGHT AND BOTTOM
Larkin remained fascinated by Wain's unaffected eccentricities, such as when he insisted on journeying to Hull from his home in Wolvercote, Oxfordshire, on his underpowered motorcycle and his suggestion that Larkin should photograph him in his archly sleazy raincoat in front of an underwear display in Hull city centre.

ABOVE George Hartley, photographed by Larkin.

Powell, the Amises and Larkin in London. The picture was taken by
Larkin, using his timed camera.

Amis and Anthony Powell, London, 1958.

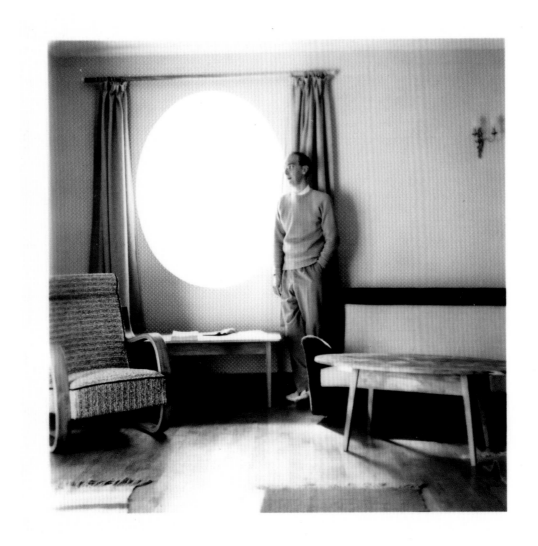

OPPOSITE Conquest, photographed by Larkin in the mid-1950s.

ABOVE Self-portrait of Larkin in one of Conquest's swish apartments in London, 1957.

For some years now the poems of Philip Larkin have been increasingly well-known for their unusual combination of deep personal feeling and exact, almost sophisticated choice of words . . . their author . . . while no less witty and intelligent than his contemporaries, deals with emotion more simply and intensely than is common today . . .

Larkin's draft blurb for *The Less Deceived*

Larkin was asked by Hartley to write a promotional blurb for *The Less Deceived*. He did not complete the draft and nor did he send what he had written to Hartley (see above).

The other poets selected for *New Lines* were being promoted by their London-based publishers in just the way that Larkin presents himself in the unfinished draft. The grim irony, as he saw it, was that while he was indeed just as 'witty and intelligent' as his peers, he was, unlike them, a virtual nonentity. He ended the encomium in mid-sentence but took a moment to scribble 'cock and balls!' across the page.

Larkin took this self-posed photograph shortly after drafting the blurb.

Chapter 14
Away from Hull

Before he left England for Belfast Larkin and Monica had begun to spend long weekends together in the Cotswolds and the more agreeable villages and market towns of Leicestershire and the East Midlands. From 1952 onwards they would take longer holidays, two or three times per year in various parts of Ireland and Britain. In Easter 1952, for example, they took the train from Belfast westwards towards Derry, changed for a bus at Antrim and spent five days in a bed and breakfast on the coast close to the Giant's Causeway. He wrote to his mother about a day in Glenarm, 'a lovely little town on the Antrim coast above Larne'. Eva was aware that they were lovers and never thought it necessary to comment on this, at least in her correspondence with her son. The following Easter he and Monica visited Dublin and in July spent a week on the Isle of Skye, the beginning of an affection for Scotland and the islands that would last for almost three decades. There is, of course, nothing unusual about a couple taking regular holidays together but it is noticeable that Larkin never mentioned his excursions with Monica to either Amis or Conquest.

He certainly did not conceal from either of them the fact that he and Monica had begun a serious, perhaps permanent, relationship but he was very secretive about what they did in their spare time. It was as if the image of them enjoying remote countryside and inspecting old buildings was one that he preferred to keep in a separate compartment of his life. For example in April 1954 during the Easter break he spent four days in Swansea with the Amises, the first time he had seen his friend since *Lucky Jim* had gone into print in January and piloted Amis from obscurity to fame. Larkin enjoyed the celebrations – the book was dedicated to him – but later confessed his feelings of envy to Patsy and Monica. The oddest feature of the occasion, however, was his lie to the Amises that he would be travelling to Swansea via Loughborough after a visit to his mother. Actually, after leaving the ferry in Holyhead he had gone directly to meet Monica in Great Malvern where they would spend five days enjoying early spring in the surrounding unspoilt villages of Worcestershire.

When he first met Conquest at the Strand Hotel, London, in September 1955 it was clear enough to all three men that he was being formally admitted to a charmed circle, a triumvirate; Amis was not present but he might as well have been. Again he

said nothing to either man that after lunch his destination was Paddington station where he would meet Monica. They would then take a night train to Portsmouth and next morning the ferry to Guernsey and then on to Sark.

They stayed at the pretty, eighteenth-century Dixcart Hotel and he reported only to his mother on the holiday. His unforced delight in the charm of the place is evident: 'The island is about three miles by one and a half miles and is traversed by small lanes wide enough to be used by horses and traps . . . There are also many footpaths . . . All we do (if it's fine) is walk to some point up the coast and sit there till lunch or tea. Evenings are spent sitting or mopping up drinks.'

A question remains as to how, if at all, Eva responded to her son's confidences but it is clear enough that he regarded her as one of the few of his most intimate correspondents to whom he could disclose those parts of his life which made him happy. After spending Christmas with her in 1955 he took the train south to spend the New Year in Winchester with Monica, where they walked through the Cathedral and surrounding closes ('so beautifully quiet' he wrote to Eva). After Winchester they went on to Devon to stay with Bruce Montgomery and, as he reported again to Eva, his mood sank: 'I didn't enjoy my visit to Bruce . . . Really his way of life is not mine.'

Gradually, Larkin was securing his time with Monica against everything else. After a week with the Amises in August 1956, from which he wrote to Monica that 'Kingsley is . . . not interested in much more than showing off,' he took the train to the Midlands, telling the Amises, once more, that he would then spend time with Eva and his sister's family. In truth, he and Monica caught the express train to Scotland and on to Skye. Their photographs reflect a shared appreciation of isolation, intimacy and, to a degree, secrecy.

ABOVE LEFT A semi-derelict cottage in the valley in the Isle of Skye
where they spent the day away from their hotel, with a picnic.

ABOVE RIGHT Inscribed 'Isolation' and taken in Scotland in 1964.

OPPOSITE 'Monarch of the Glen', as Monica later commented in their
'Holiday Diaries'.

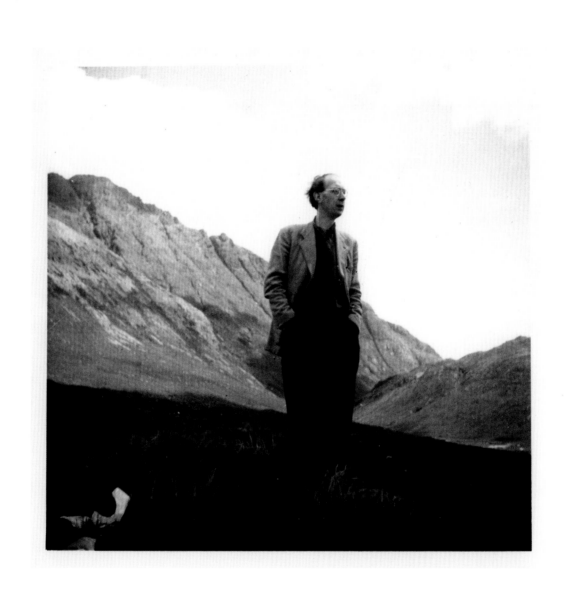

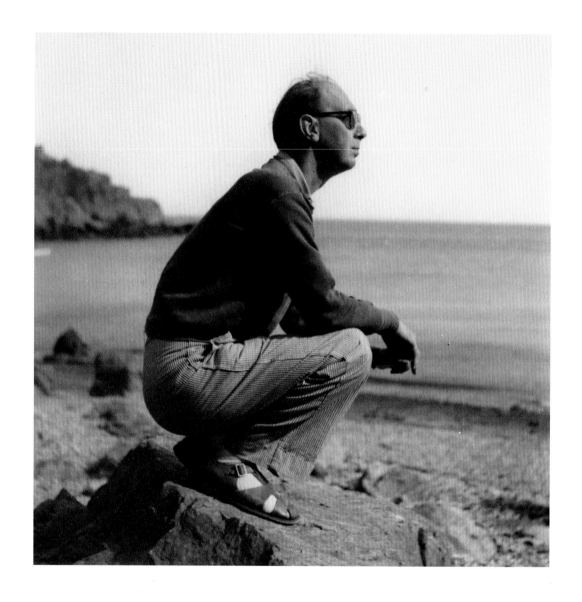

ABOVE Larkin on Sark.

OPPOSITE ABOVE Monica posing by a signpost on Sark.

OPPOSITE BOTTOM, LEFT TO RIGHT Sark, docks and coast.

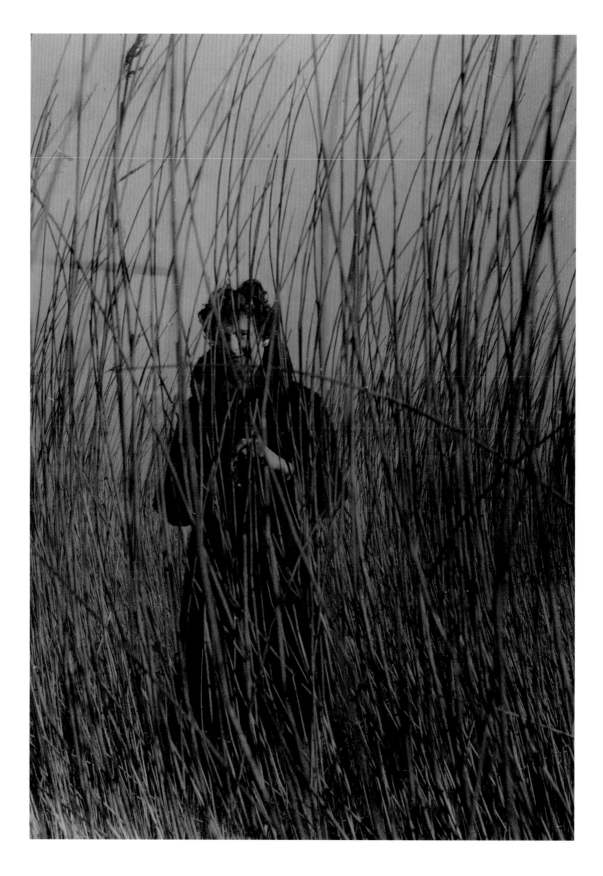

Chapter 15
Maeve

Larkin's 'Letter to a Friend About Girls' first appeared in his *Collected Poems* after his death. The version in print, selected by Anthony Thwaite, the editor of the posthumous volume, was sent to Amis by Larkin in 1957. It is a wry, polished encapsulation of their friendship, with Larkin resigned to his role as subordinate, happy to listen to his pal's stories of conquests and deceits while having no exciting news of his own.

Between October and December 1959, Larkin set aside all of his other projects and began to rewrite and extend the poem, laying down his pen on 15 December, the final day of his working year. This was symbolic because while the revised draft remained unfinished it was intended as Larkin's goodbye note to the decade that preceded it. It is addressed to Amis but unlike its more concise predecessor, Larkin did not intend to show it to him. It was his private act of catharsis.

> I see your sort all over the place,
> Pushing the glass doors open with their breasts
> (Forty-one, twenty-two, thirty-nine).
> Though you probably can't see mine:
> Only cameras memorise her face
> Her clothes would never hang among your interests.

It is almost certain that when writing this Larkin had in mind a patchwork of letters from Amis. In 1957, for example, Amis wrote when he, Larkin, was considering an affair with a woman in London, to whom he had been introduced by Conquest. Amis opens with 'I found her attractive in that funny sort of way,' which carries a smirking subtext: 'acceptable, given your limited expectations, but not quite good enough for me'. When reporting on his own sex life Amis gives almost equal emphasis to his apparently inexhaustible and effortless ability to attract women to him.

Maeve Brennan photographed by Larkin, 1961.

In the new version of the poem Larkin also writes of how

> . . . girls deflowered at twelve wait by white phones
> And crimson table lamps in cobbled mews
> For you . . .

In 1947, when he was first seeing Hilly, Amis wrote to Larkin of a young lady he had met at a dance, with 'noticeable breasts'. A few weeks later he added: 'There's only one fresh thing to report about my school girl; whatever I did she would not respond beyond blushing and giggling and wriggling a little as if tickled, smiling affectionately at me rubbing her warm cheek against mine'.

The image in Larkin's draft is clearly derived from this correspondence, as well as another sequence of letters Amis wrote in 1946–7, relating his encounters with at least four girls aged between twelve and fourteen. Larkin kept these letters and, more than a decade later, when he experimented with the unpublished second draft of his poem, he compared the past and present. Since the mid-1950s, Conquest had regularly provided Amis with flats in fashionable parts of west London, where the latter would pursue his numerous extramarital liaisons. The young girls of the 1940s letters would, by 1959, be in their twenties, and it is these two points in time which coalesced in Larkin's imagination as the 'girls deflowered at twelve' became sexually mature adults waiting by the 'white phones' for a call from Amis. Larkin was particularly preoccupied with the elegant locations of Amis's carnality, rewriting the stanza several times to involve 'top floor flatlets' and 'cobbled mews'. On the last page of the still unfinished draft, Larkin scribbled '15, xii, 59', never to return to it.

The passages on the young girls are a small fraction of the sprawling ten-page draft, but they epitomise it. Everywhere there are parallels between Larkin's tortured, heavily revised stanzas and the history of his friendship with Amis; a friendship and dialogue that had become one-sided, with Amis talking endlessly and never waiting for a reply, never listening. In writing the draft, Larkin was posing himself a question: what would happen if he went against Amis's apparent expectations of him as the respectful, indulgent listener? Once the next decade had begun, he adopted this experiment in the real world – he stopped sending letters to Amis. The result was much as he anticipated: Amis seemed not to notice. Hilly would leave Amis in 1963 and two years later he would marry the novelist Elizabeth Jane Howard. Shortly after the marriage Hilly wrote to Larkin, and opens by congratulating him on receiving the Queen's Gold Medal for Poetry. Eventually, her manner becomes a little more relaxed, as it had been when she would write to him in the 1940s and 1950s. 'Anyway I'm glad I had those years with K because I can't imagine anyone else teaching me so much and making me laugh as much and parts of it were wonderful.' This must have involved an extraordinary exercise in forgetfulness, let alone self-degradation.

Larkin and Amis would meet only once more during the next seven years, for lunch arranged by Elizabeth Jane Howard in late 1965, and no letters were exchanged. In March 1968, Conquest tried to persuade Larkin to attend a lunch at Bertorelli's, a London restaurant frequented by himself, Amis and other right-leaning figures. It was planned to welcome Amis home after his year as writer in residence at Vanderbilt University, Nashville. Larkin declined and commented on their last meeting three years earlier, when, he alleged, Amis's drunkenness, 'insane cackling and truculent conduct' had drawn 'many curious looks'. Despite this, in the early 1970s they did return to something resembling the old days and remained on amicable terms until Larkin's death in 1985.

Clearly Larkin could no longer endure the one-sidedness of their friendship but his reasons for distancing himself from Amis were even more complicated than that.

In the summer of 1959 Larkin enhanced his reputation as a thoughtful, benevolent boss by starting classes for members of his staff who wanted to take the Library Association Registration examination to boost their long-term career. One of the seven who signed up was Maeve Brennan and by 1960 she and Larkin had begun to meet up informally. During that year Maeve, Larkin and the Rexes, a young couple then occupying the ground floor of 32 Pearson Park, regularly made up a 'foursome' for films, drinks, parties and on one occasion an Acker Bilk concert.

Maeve was, one would have thought, a very unlikely magnet for Larkin's attentions. She was plain, bright enough but unsophisticated – she had not gone to university – and a practising Roman Catholic who treated the teachings of the Church as inflexible truths and regulations, particularly regarding sex. But this, perversely, was what attracted him to her. In February 1961 Maeve passed her Library Association examination and she had gone with Larkin for a celebratory meal in Beverley. Maeve later wrote in *The Philip Larkin I Knew*: 'from that evening our friendship entered a new and headier phase which was to have greater significance than either of us could have envisaged then'. What she means, though stated with distracted euphemism, is that Larkin declared that he wanted a physical, sexual relationship with her, despite her moral convictions.

She was by parts flattered and unsettled. He was play-acting, which was the motive for his pursuit of her. Gradually he began to replicate, with appropriate adjustments, aspects of his relationship with Monica. They would read literature together – Sassoon, Owen, Betjeman, Hardy, Yeats – and while Monica was Bunny or Bun, Maeve became Miss Mouse or simply Mouse. Equally, however, there were differences. Monica challenged him, intellectually and emotionally, while Maeve mirrored the parts of his temperament that he had largely concealed or subdued, particularly his crippling anxiety, shyness and insularity. She would, as 'Letters to a Friend' has it, be his appropriate and deserved girl. Just as Amis had discovered an apparently limitless number of women who embodied his wildest fantasies, so Larkin sought out one who would guarantee feelings of disappointment. Amis knew

nothing of her until after Larkin's death. Like the revised version of the poem she was his gesture of resignation and detachment.

The most engrossing passages of his poem are those which tell of how Larkin's women show themselves to the world. Unlike Amis's conquests – conspicuously sexy and well-upholstered – Larkin is content with the ordinary girl: 'Only cameras memorise her face, her clothes would never hang among your interests.' These lines are both coy and revealing. Why, one might ask, would 'her face' be recorded, memorised, on camera when she goes largely unnoticed by men in the same crowded room or the street? Larkin is referring here to his habit of taking portrait photographs of his lovers. It began during his relationship with Ruth and it would provide psychologists with sufficient material for a conference. Monica was his favourite. In many of the portrait photographs of the late 1940s and early 1950s she is beautifully, erotically poised, but at the same time Larkin makes no excuses for her occasional expressions of distraction or sheer boredom.

By contrast his photographs of Maeve, from the beginning of the relationship, present her as a woman from a different era; often she seems caught in an Edwardian time warp and Larkin took care to capture a physiognomy that was not classically handsome, one which combined the combative features of maleness with a weary acceptance of middle age.

The single poem that relates directly to his relationship with Maeve is the lengthy and unfinished 'The Dance'. The titular event was real, held in the Hull SCR in 1963. Maeve persuaded Larkin to attend, not quite as her formal partner but along with a group of junior staff who were mostly friends of hers. He began the first draft a few months after the event.

> Chuckles from the drains
> Decide me suddenly:
> *Ring for a car right now*. But doing so
>
> Needs pennies, and in making for the bar
> For change I see your lot are waving, till
> I have to cross and smile and stay and share
> Instead of walking out . . .

He does not want to be there, but more significantly the 'you' of the poem – Maeve – clearly inspires as much his desire to escape, to retire into his privacy, as the event that he has reluctantly attended. 'The Dance' demands comparison with the later poem 'Vers de Société' in which he gives voice to his loathing for virtually all others at a drinks party he has attended, memorably 'that ass' with his 'fool research' and 'some bitch / Who's read nothing but *Which*'. But in 'The Dance' he continually returns us to 'you', the woman who has brought him there, and it is clear that his

resentment against her goes deeper than his being persuaded to attend the dance. The evening causes him to recognise that as individuals, let alone lovers, they are preposterously incompatible.

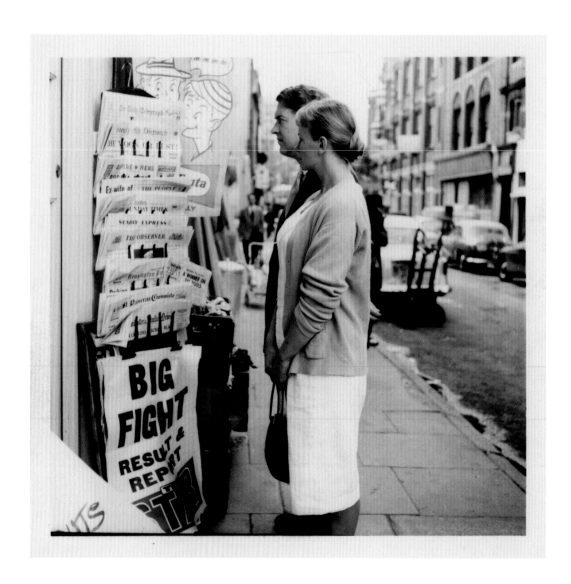

'Life with Amis remains the same and I'm sure nothing will ever change much in this way – and I suppose I'm lucky in gleaning the droppings of his success . . . the fucking bastard deserves to be shot . . . Please come and stay soon [but] let me know when you can come.' (Hilly to Larkin from Swansea, no postmark, 1959.) Larkin never took up the invitation to visit Swansea again.

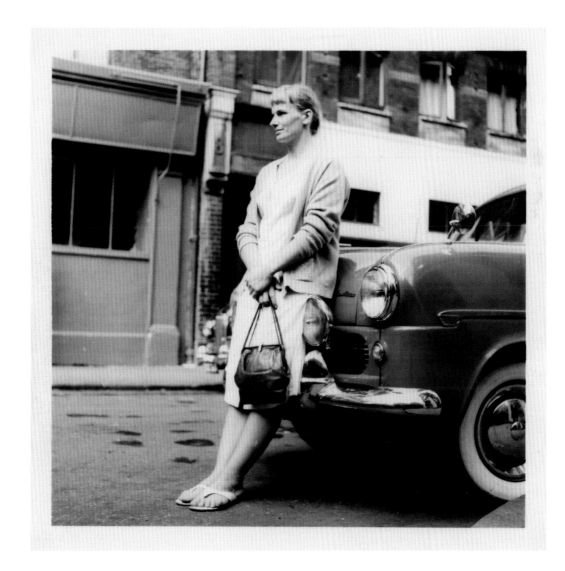

Hilly Amis, London, 1958. 'Hilly had a particular fondness for Philip. She admired him as a poet but more than that she was closer to him than to any other of Kingsley's male friends. She felt at ease with him. Those were times when she very much needed his support, because of Kingsley, and he gave it. During the worst times the only person she really felt able to talk to, the only person who knew Kingsley and who'd listen, was Philip.' (Mavis Nicholson to author)

OPPOSITE Maeve Brennan, photographed by Larkin in 1960.

ABOVE Maeve taking breakfast in a hotel in Hornsea, where she had spent the night with Larkin, 1963. The SCR Dance had taken place a few weeks earlier.

OPPOSITE In contrast to his alluring, often enigmatic portraits of Monica, Maeve is presented as happily uncultured.

ABOVE Maeve in Pearson Park shortly after they had agreed to end their relationship in 1971.

Chapter 16
Celebrity

The Whitsun Weddings was published in 1964. Most reviews were enthusiastic but its doubters included eminent figures who saw it as ruminatively unadventurous. Typically A. Alvarez in *The Observer* accused Larkin of dwelling upon the ordinariness of England and Englishness in a manner that echoed the drab circumspection of its subject. Some, fans and begrudgers alike, spoke of him as a parochial late-twentieth-century version of Betjeman, and Betjeman himself seemed to nominate him as his heir in *The Listener*. Larkin had, he wrote, become 'The John Clare of the building estates' and more significantly he praised him for closing 'the gap between poetry and the public which the experiments and obscurity of the last fifty years have done so much to widen'.

Two months after the publication of the volume Larkin was elected to a Fellowship of the Royal Society of Literature. He had become a cultural celebrity and in the same month he received a letter from the TV film producer Patrick Garland asking if he would consider being the subject of the next episode in the BBC *Monitor* series on eminent figures in the arts. Previously *Monitor* had covered Pound, Graves and R.S. Thomas. Larkin answered with caution, writing that 'I've always believed that it is best to leave oneself to the reader's imagination.' There is some sincerity here, because while his perception of Amis's public presence was tinged with envy – the recent press coverage of his new relationship with the beautiful novelist Elizabeth Jane Howard begged comparison with portrayals of the Burton-Taylor saga – he was anxious that his curiosities (the ambling, bald figure with the hint of a stammer) would deflect interest from his qualities as a poet.

Larkin was persuaded after Garland announced that the programme would be a dialogue between him and Betjeman, filmed in home territory – Hull and its environs – and by its nature implying that the most loved custodian of the accessible in English poetry was conversing with his designated successor.

The filming took place between 3 and 10 June and during it Larkin became aware that he could reverse what he had most feared: his private self-image, which often embarrassed him, could be remodelled as one that would amuse and fascinate viewers, and his readers. In the film the sheer ugliness of Hull and its suburbs is

almost celebrated. The industrialised landscape of the north of the city, bisected by open drains, is intercut with Larkin and Betjeman set against backdrops of scrubby beaches, the view from the Humber ferry, and the unforgiving coastline. Most brilliantly, Spring Bank cemetery projects a mood of rural quietness into an environment of unappealing urbanity – cranes and fish markets included. Throughout, Larkin maintains what appears to be contentment with the anomalous features of his environment while Betjeman, standing between gravestones, seems the uneasy outsider.

Betjeman reads from Larkin's 'Ambulances' rather hesitantly, misquoting a key passage, while Larkin gazes on indulgently. Garland impressed Larkin when he suggested that he might bicycle towards a church and take off his cycle clips with 'awkward reverence'. There was some fraudulence about this, given that three months earlier he had purchased his first car, a Singer Vogue, and despite his previous reservations had ceased to rely on public transport, let alone a bicycle.

Garland was aware of this but what impressed Larkin was the cunning rationale for his suggestion. He too had read Alvarez's *Observer* article and his diatribe against Larkin and his like in the introduction to *The New Poetry* (1962). Alvarez accused Larkin of epitomising the 'post Welfare State Englishman: shabby but not concerned with his appearance . . . he has a bike, not a car; gauche but full of agnostic piety'. He is a class lower than Betjeman but 'The concept of gentility still reigns supreme', and with it predictability: 'The idea that life in England goes on much as it always has.' Larkin's appearance as the bald, slim, bespectacled man, clad in a very ordinary mackintosh who does indeed ride a bicycle and who on entering a church removes his bicycle clips would have reinforced Alvarez's image of reactionary monotony, had Garland not cleverly altered the panorama, making sure that the church is derelict and sinister in aspect and the entire landscape through which the camera follows Larkin anything but the backdrop for nostalgic revisionism.

The programme was broadcast on 15 November. Larkin did not have a television so he arranged to watch it with his acquaintance John Kenyon and his wife Angela at their house on the Moors. Maeve accompanied him. She had been present during most of the days of filming in June – Monica, conveniently, was busy in Leicester – and she later remembered 'just standing around or following the crew'. It was evident to all involved that she was more than just an incidental onlooker but Larkin made a point of not explaining her presence to Garland or Betjeman. She would, throughout, remain off-camera but the fact that she was puzzlingly there reinforced for all concerned with the production that its subject had subtly appropriated its mood. Appearances gave way to enigmas: What does he do when not in his library or talking with Betjeman in the cemetery? Who does he meet after leaving the train in London after *The Whitsun Weddings*?

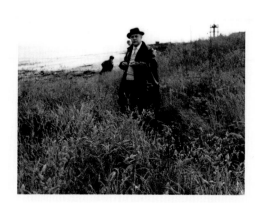

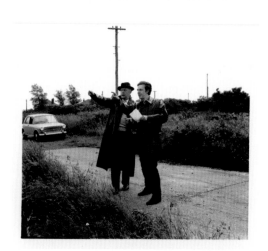

OPPOSITE, TOP RIGHT Betjeman, photographed by Larkin on the Humber foreshore.

OPPOSITE, BOTTOM RIGHT Betjeman and Garland on the lane leading to the Humber foreshore.

OPPOSITE, BOTTOM LEFT Betjeman chalks the closing stanza of Larkin's 'Here' on to a sheet of black plastic, as a visual aid. The poem records Larkin's unromantic impressions of Hull and the East Riding.

ABOVE Larkin and Betjeman on the ferry across the Humber.

The sky split apart in malice,
Stars rattled like pans on the shelf,
Crow shat on Buckingham Palace,
God pissed himself.

Letter to Charles Monteith, 2 March 1978

Richard Murphy, Douglas Dunn, Larkin and Ted Hughes, involved in a promotional exercise for Faber (they were called 'The Faber Quartet'). The photograph was taken in 1969 at Lockington, a village near Beverley. Larkin admired the work of Dunn and Murphy, with some reservations, and while he remained on amicable terms with Hughes his contempt for him as a poet is evident in comments to friends too numerous to quote in full. The most amusing is a brief piece, quoted above, 'in the manner of' Hughes that he sent to Charles Monteith to commemorate the Queen's Silver Jubilee in 1977.

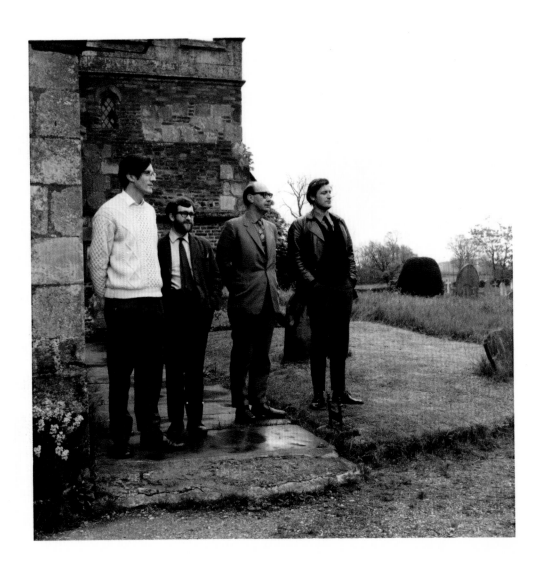

Chapter 17
Self's the Man

The poem that best crystallises the smoke and mirrors effect of the *Monitor* film is 'Self's the Man' written just over five years earlier. It was inspired by Larkin's seemingly inexhaustible loathing for his junior, deputy librarian Arthur Wood. Wood had never directly caused offence to Larkin and was competent enough at his job but Larkin appeared to hate him simply for existing. Wood was an eccentric who had a particular interest in new library acquisitions, especially material that suited his taste for the arcane and the curious. He seemed to treat collecting books for his employer as a hobby, irrespective of their relevance for the university, and his inclination to regard long beery lunches as a personal entitlement was legendary. One might then assume that he and Larkin would be well suited. For each, their private idiosyncrasies often evolved into a quiet refusal to conform. At Wellington, Leicester and Belfast librarianship was an adjunct to activities that reflected Larkin's predispositions, but at Hull this had changed. Despite himself Larkin had embraced managerial responsibility, become accountable as coordinator of the expansion of the new library, and every day Wood reminded him of the individual he used to be. This irritated him, and in 'Self's the Man' he found an apposite means for revenge: irrespective of his behaviour at work Wood was always obliged to return to the demanding conventions of his wife and family.

He begins,

> Oh, no one can deny
> That Arnold is less selfish than I.
> He married a woman to stop her getting away
> Now she's there all day,

which contains a contradiction: surely the fact that he married her to 'stop her getting away' invalidates the declaration of his selflessness. Larkin recognises this:

> But wait, not so fast:
> Is there such a contrast?

He was out for his own ends
Not just pleasing his friends;
And if it was such a mistake
He still did it for his own sake,
Playing his own game.
So he and I are the same, . . .

Throughout the poem Larkin tries to maintain his contempt for Arnold but it becomes clear that he hates him because he detects features of his existence that mirror his own, or to be more accurate decisions that he might have taken but instead avoided – particularly regarding commitment and marriage. He himself had almost married a woman to 'stop her getting away' – Ruth Bowman – and his bizarre letters to Monica about Maeve often seem as though they are being written by two versions of the same man.

Often, Larkin placed a large mirror behind the timed camera so that he could form an expression that perfectly suited his desired shift between transparency and something more enigmatic. In much of his finest lyric verse one detects behind the words an expression forming on his face, a quiet supplement to what is actually being said. But at some point this sense of intimacy will become clouded by something more oblique, as if he is turning his head away from us, leaving us with a hint of what he might be thinking, accompanied by doubts. A classic instance is the closing stanza of 'An Arundel Tomb'.

The stone fidelity
They hardly meant has come to be
Their final blazon, and to prove
Our almost instinct almost true:
What will survive of us is love.

The euphoric cascade of verbs and nouns – 'stone fidelity', 'has come to be', 'their final blazon', 'instinct', 'true' – promises much, and the last line appears to be a triumphant celebration of what it says. But we carry into it the modifiers 'hardly' and, twice, 'almost' which nag at what we hoped for: an 'almost true' will always be a lie. Poems such as this are, like his self-portraits, exercises in devious candour.

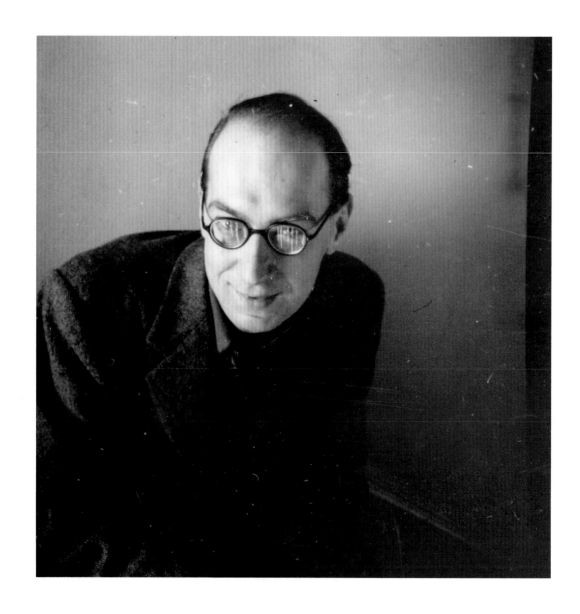

This was taken shortly after his arrival in Hull. His cheery smile is gainsaid by something behind his spectacle lenses. This, calculated, expressive vacillation would become a common feature of his self-portraits.

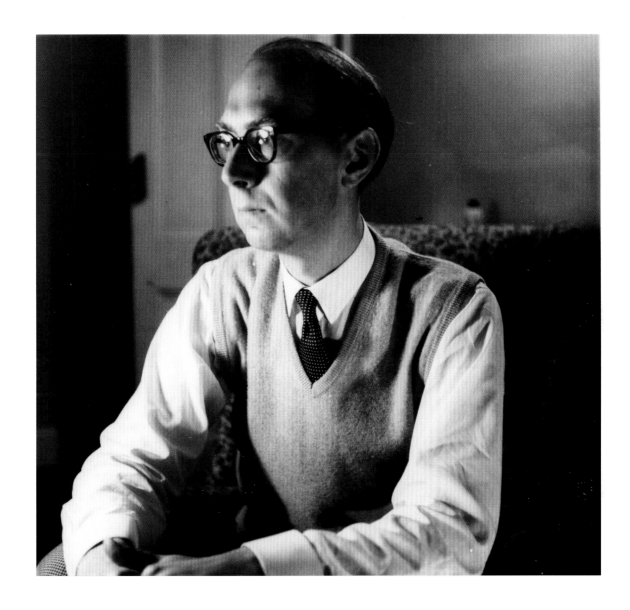

His face, pensive, seems directed towards something to the left of the camera yet his eyes betray an almost guilty interest in the capturing of his own image.

In Pearson Park, casually dressed. The half-opened drawers seem
in some way part of a story, one that also involves the subject of his
concerned attention.

'I tried to get the photographs off on Friday [above self-portrait included] . . . I hoped you liked the music tonight, but it distracted me from you, and wasn't really a good idea. I felt as if there was a distance (as there is) between us, only a physical one, but a distance.' (Letter to Monica, 3 November 1958.) Often they would arrange to listen to the same music broadcasts and then share their thoughts and feelings by exchange of post.

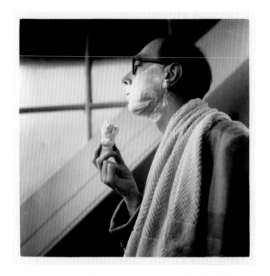

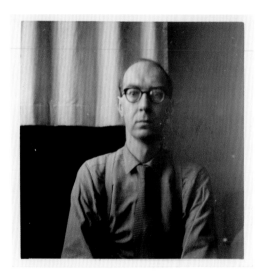

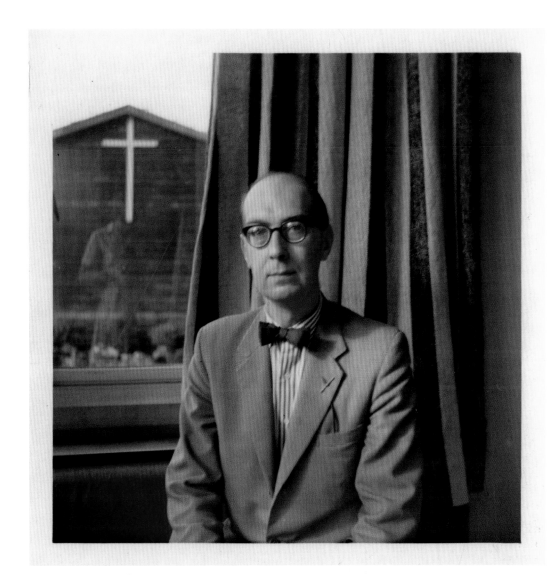

OPPOSITE These self-portraits, taken on the same day in 1957, could be called 'A day in the life of . . .', involving as they do Larkin shaving, taking breakfast, dressed — in shirt and tie — and about to leave for work, and back at Pearson Park, early evening, more casually dressed.

ABOVE Taken in Scotland by Monica, whose reflection is visible in the window pane. Although the barn-like church in the background with its strident cross is unlike the gently decaying buildings that informed 'Church Going', this carefully composed image reiterates Larkin and Monica's interest in the vestiges of faith.

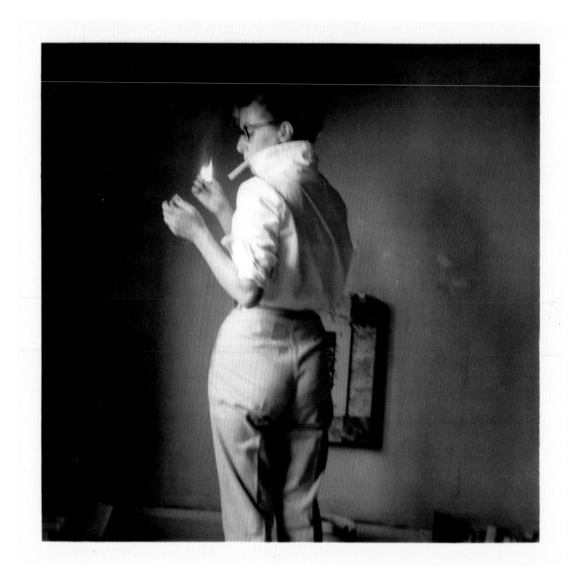

Chapter 18

Talking in Bed

When exactly Monica became aware that Larkin was seeing someone else is unclear but by 1961 guarded references to his having caused her distress begin to appear regularly in his letters. Typically: 'I'm terribly sorry you feel so miserable these days, though not surprised – it is a most trying position to be in, and I should hate it and feel utterly down and out, hopeless, scared to death, just as you do.' The sense of empathy and compassion is by parts convincing and bizarre. He has caused her misery yet he seems to have taken a step back to a point where he can console her without a collateral requirement to take responsibility, let alone apologise.

Over the following three years Larkin wrote to Monica of Maeve as a person, almost a condition, with which he was unwittingly associated. 'Cry all you need. It is not right to think you have to spare me the pain of remorse caused by injury to you is it?' He sounds like someone who has behaved less than properly at his friend's dinner party, which is peculiar enough, but later in the same letter of August 1964, we come upon a passage that is almost surreal. 'But then I wonder if there is a "situation" – do I really want a RC wedding with Maeve and a "reception somewhere in Hull" etc.' Has he, one wonders, posted the wrong letter to Monica? Did he think he was addressing his mother? No. In the rest of it he is clearly writing to Monica about his relationship with another woman, but he signs himself off with the cheerily erotic: 'Anyway, dear, I wish I were with you now, especially if you are wearing your mauve dress.' References to Monica's clothes, underwear included, feature habitually in his letters to her. He revelled in her willingness to play the role of sex-object, to become as much the figure of his fantasies as the individual with whom he talked about literature and architecture. She too enjoyed shifting between these roles and was happy, often flattered, to pose for the many mildly erotic photographs he took of her.

During the period that he first began his apologies to Monica about Maeve, he composed the first draft of 'Love'.

Monica in the bedroom of Pearson Park, 1957.

> The difficult part of love
> Is being selfish enough,
> Is having the blind persistence
> To upset an existence
> Just for your own sake.
> What cheek it must take.

He goes on to contemplate his 'unselfish side' and dismisses it immediately as a foolhardy hypothesis: 'How can you be satisfied, | Putting someone else first | So that you come off the worst.' Most would treat the speaker as an experiment in the nature of self-interest and emotional paralysis, beautifully executed but not based on a particular person: it was surely impossible for anyone to be quite so insensitive and honest about it. But Larkin's letters during this period show that the poem was transparently autobiographical. 'As I say,' he wrote to Monica in May 1964, 'I think sometimes I am ultimately an auto erotic writer incapable of love for anyone but himself.'

He made it clear enough to Monica that Maeve was something close to an exercise in erotic self-recrimination: 'I think Maeve is a kind of 40-ish aberration of mine, and her family and religion and desire for marriage and children and all that would scare me out of the county if I were left along with them.' Why, then, she might have wondered, don't you finish with her? He anticipates her enquiry: 'we have – that's you and I have – got into a sort of rut . . . you reflect what I am, she what I might have been – manager of a local insurance branch, I should guess . . .' He reassures Monica, if that's the appropriate term, by depicting Maeve as an antidote to the kind of stagnation to which all long-term relationships are prone. He avoids any reference to the fact that his immersion in the bleak landscape of what-might-have-been also involves sex; perhaps he assumed Monica would regard this too as a masochistic ordeal, a means of securing their own physical relationship against lassitude.

Despite the fact that Larkin maintained his relationship with Maeve throughout the 1960s, Monica appeared to accept her role as his legitimate, albeit routinely cuckolded, partner. At the close of 1961 she made use of a modest legacy from her parents, both of whom had died two years earlier, to purchase a cottage in Haydon Bridge in the Northumberland countryside. She had not previously shown any interest in owning property – she still lived in a rented flat in Leicester – and her decision to buy the Haydon Bridge house was related to her fear that his relationship with Maeve might, despite his denials, come to threaten theirs. Very distant relatives of hers had come from the region but this was a token explanation for a choice made with some tactical astuteness. She could have found somewhere just as affordable and prettier in the East Riding or the Dales but to put herself within commuting distance of Hull would, she knew, have terrified Larkin: it would seem she was making some claim upon him.

Even their visits to the south coast of England, the Scilly Isles, Sark or the West Country began with a day or two in the cottage. Monica would arrive the day before Larkin, smarten the place up, stock the refrigerator with enough food and drink for their stay-over and make sandwiches for the first leg of their travels. They only met there four or five times a year but Haydon Bridge transformed Monica into something like a homemaker, and by implication wife, providing comfort for her hardworking husband, and there is circumstantial evidence that Larkin was aware of, indeed content with, this tacit arrangement.

Monica, photographed by Larkin in the library, Hull, 1957.
The building was closed and they had the run of it to themselves.

You've been cavorting in my mind dressed in pink shoes and pink pop-beads and nothing else. All to the detriment of my typing.

Letter to Monica, 17 August 1963

Since the early fifties Monica had sent Larkin photographs of herself, often semi-clad, and included commentaries on what they might be doing if the photographic image were real. She was aware that he would not ask or expect such favours from Maeve and this prompted her to maintain a regular supply of prints he had taught her to produce using full-length mirrors and timed camera exposures. He wrote on 17 August 1963 to thank her profusely for the most recent 'pictures' which had done a great deal for his 'condition of randiness'. He goes on to state that the pictures make 'me think of you in these respects and I get colossally excited . . . As you said, I dwell in my own imagination. I spend too much time on . . . visions – and honestly 95 per cent are about you.'

OPPOSITE Monica in her flat, 1960. The striped tights, which Larkin greatly appreciated, were a gift to Monica from Eva.

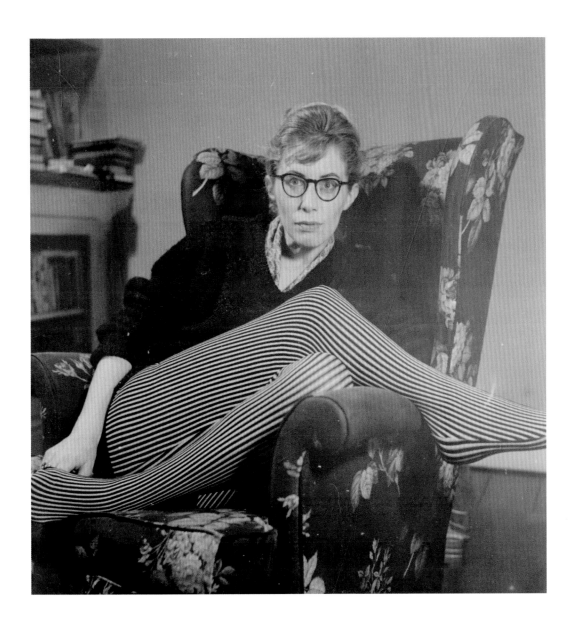

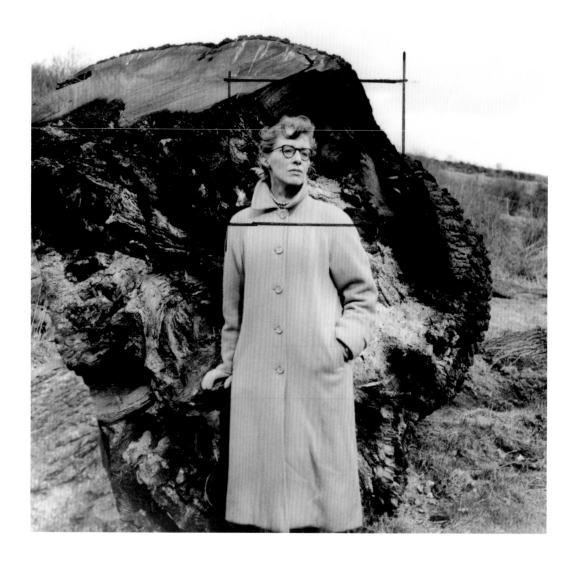

Above, Monica on the Hull foreshore and, opposite, a derelict
cinema in the city. Both photographs were taken shortly after
Monica became aware of his relationship with Maeve.

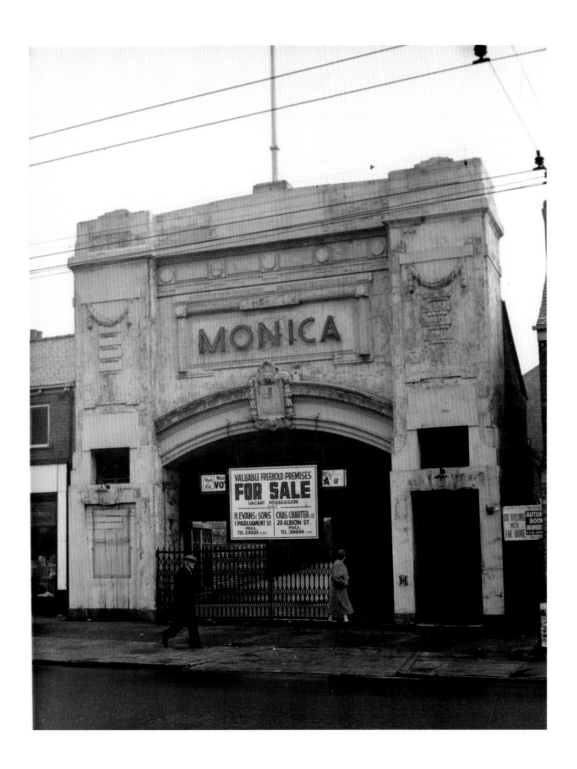

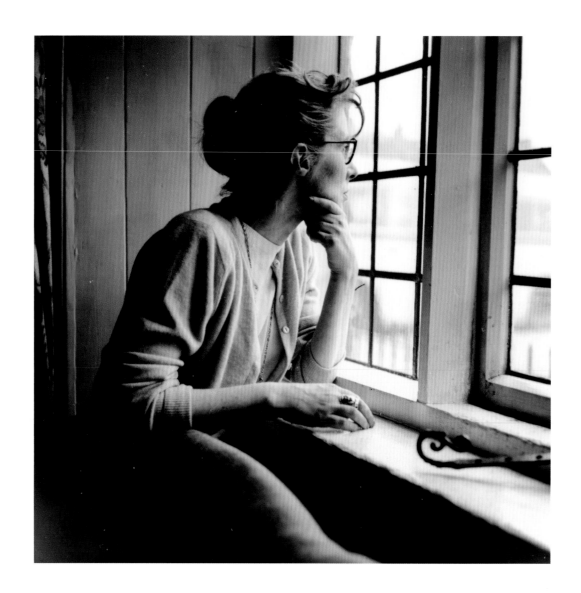

Monica in her Leicester flat, 1962.

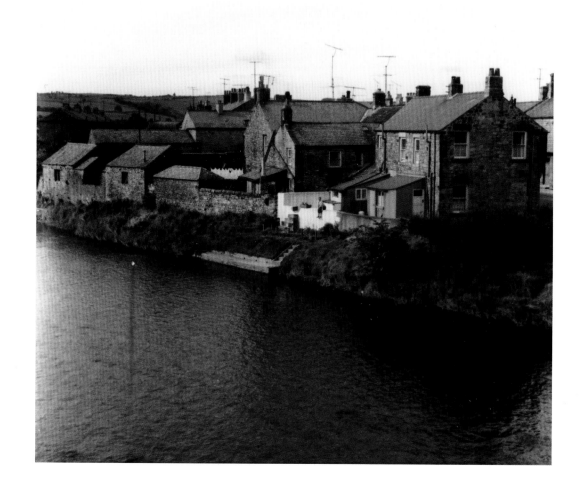

Monica's cottage in Haydon Bridge, with Monica seated on the white wall.

Chapter 19
The Holiday Diary

The only full-length diary that Larkin did not order to be destroyed after his death runs to almost 300 notebook pages and is devoted exclusively to his holidays with Monica. 'Diary' is a misnomer since a considerable part of it is made up of entries from Monica: 'Conversation' would be a better description. Sometimes one or the other will add a marginal or interlineal comment on the main entry ('Dull, hopeless, rainy day'; 'Bloody terrible'!) but more frequently page-length passages from each of them will lie face to face on opposing sides of the notebook, reminding one of the adjoining statues at Chichester which inspired 'An Arundel Tomb'. These contain their respective impressions of places they have stayed and opinions on landscapes and people encountered. Often it resembles a dialogue between a curmudgeonly version of Mr and Mrs Pooter but just as frequently something more intriguing slips through the catalogue of disappointing hotels and locked public toilets. Reading the diary you feel that you are listening in to two people attuned to, comfortable with, each other. No great passion is expressed, even implied, but the very nature of the document – a record of them together, in words – indicated an enduring partnership. We have no record of what prompted this enterprise but its inspiration is clear enough. They began to keep the diary in 1967, the point at which Larkin's relationship with Maeve was pressing Monica's considerable levels of indulgence almost beyond endurance.

On 8 October 1966 Larkin sent Monica a letter in which he ticks off each reprehensible incident – such as when he provided Maeve with the addresses of hotels that he and Monica would use during their holiday and Maeve ensured that a letter or card full of endearments to Larkin would await them at each point – and apologises. '. . . I've encouraged her [Maeve] to depend on me [and] it seems cruel to turn her away. If she wanted to be free it would be different.'

Out of this – specifically Maeve's intrusion by letter upon their time together – was born the shared diary. It would be a testament to their new settlement, something exclusive to the two of them from which Maeve would be forever excluded. On 1 August 1967 they left Haydon Bridge for the West Country and it is clear that Larkin showed Monica his entries immediately after completing them. At Gilberdike 'a fool' had backed into the rear of the car: 'From then on we drive

in a stupor of depression through Pontefract, Barnsley, Glossop, Buxton (we stroll about here) . . .' and Monica comments, 'seeing Jodrell Bank as well'. Their hotel, in Oswestry, has in Larkin's view, a 'Good bar'. 'Bar good if you like crowds,' adds Monica.

Neither Maeve nor later Betty are referred to in the diaries but this does not indicate a particular self-censoring ordinance because nor are the likes of Amis or Conquest. At the same time the accounts are not emotionless; it is simply that the feelings and impressions recorded are exclusive to the two of them.

Throughout, they mark up their 'Rabbit Score' at the end of each day, with entries such as 'M, 3; P, 2' followed by grumpy or triumphant comments on who was more alert to the presence of furry creatures. Trivial, perhaps self-parodic, but their shared affection for rabbits allows an insight into a more pervasive sense of intimacy and permanence.

After an unsatisfactory dinner ('gammon and pineapple . . . goangetz tuft') Larkin closes with 'Have come to the conclusion that the difficulty of holidays is that they increase your resentment quota.' His resentment is directed against over-talkative, fellow guests and indigent staff, but certainly not his companion.

Wells Cathedral

Go into the Cathedral and hear some Evensong. Reflect it is 28 years since I and my father came there with our bicycles. The buttress of the bishop's palace I photographed [then] still looks the same . . . M has never seen the Cathedral before and the steps to the Chapter house . . .

'Holiday Diaries', 6 August 1967

In the film version of *Lucky Jim* Margaret Peel tends to use the Gothic staircase of the college quadrangle as a stage for her bouts of hysteria. Larkin and Monica found this amusing and there are a remarkable number of photographs by Larkin of Monica posed sternly on staircases or other grand promontories.

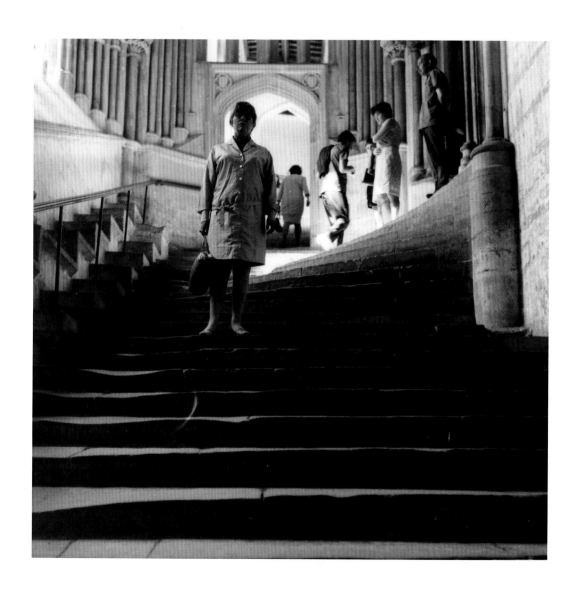

Never as clean again!

Ed. Bay
Shortly after, I fell
in nettles

 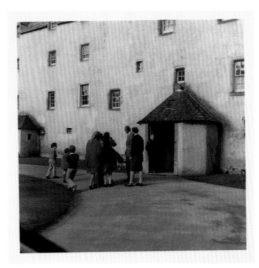

OPPOSITE TOP Larkin's stately Vanden Plas, polished and ready for their next excursion, 1971.

OPPOSITE BOTTOM Scotland, September 1968. 'Continue to Eddrachillis Bay, where we settle in a sheep fold and have our lunch . . . Go to sleep . . . Go up hill behind the s/fold and take a photograph' ('Holiday Diaries'). To the left is Larkin's Singer Vogue and Monica, to the right, stares out across the bay.

ABOVE Scotland, 1975: 'After lunch rest, go to Traquair House, about ten miles off – oldest house still inhabited in Scotland. Very interesting, but crowded – foul kids [Monica adds in footnote: "Could have twisted their heads off w. own hands. Mothers' too . . ."] . . . Nice wood panels in the official chapel, in Dutch Style . . . The Laird in horse dealer's suit, and looking like criminal degenerate, bounding around and counting . . . the takings.'

(tune: The Anti-Gallican Privateer)

The Chiel Postgate says it's great,
You drive until you're nearly beat,
The midges have you for their tea –
From The Altnacealgach haste away.

The grub is laid out on the side,
A half a sheep that lately died,
Your table-mates will cause dismay –
From the Altnacealgach haste away.

You write your drinks down in a book,
The man behind you is a crook,
He makes your two into a four –
From the Altnacealgach haste away.

The single rooms are on the road,
The traffic does not incommode,
Except for keeping sleep at bay –
From the Altnacealgach haste away.

The management's a reet old hag
The kind a queen you want to shag,
You wave goodbye with joyous twa –
From the Altnacealgach haste awa.

This previously unpublished poem was entered in
the diary during their 1972 holiday in Scotland.

OPPOSITE TOP Yester Parish Church, Moffat,
Scotland. 'Behold the Ram of God.'

OPPOSITE BOTTOM Scotland, location
undisclosed. Larkin's note in the Holiday Diary reads
'Thrust thy sharp sickle, and gather the clusters of the
vine of the earth.' [Revelations] followed by 'bloody
awful red at dinner'.

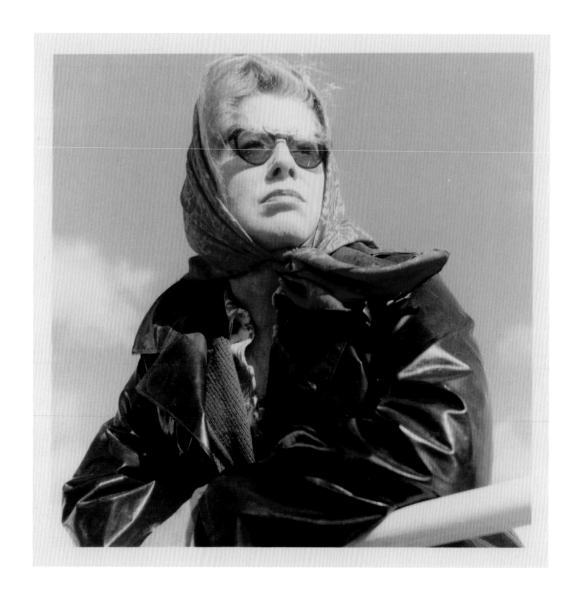

Monica in Mull, 1971.

Larkin at Gleneagles Hotel. 'Go back to hotel after a delightful day, seeing the black rabbit out sunning himself again. He is an extraordinary feature of the district, quite unperturbed and cheerful . . . Buy a hat M thinks ridiculous: it would look well on Dizzy Gillespie or Binns' (7 September 1968).

Strathnaver, Church of Scotland Church, Oban.
'P says it reminds him of Grant Wood's painting,
"American Gothic'', without the morose farmers.'

'The Rover [2000, his new car] can't be slept in like the old Princess . . .
Drive towards the coast and come across the extraordinary graveyard
we visited ten years before.'

The wrestling starts, late; a wide ring of people; then cars;
Then trees; then pale sky. Two young men in acrobats' tights
And embroidered trunks hug each other: rock over the grass,
Stiff-legged, in a two-man scrum. One falls: they shake hands.
Two more start, one grey-haired: he wins, though. They're not so much fights
As long immobile strainings that end in unbalance
With one on his back, unharmed, while the other stands
Smoothing his hair . . .

'Show Saturday'

'I enclose 3 more Bellingham pictures. I love the one of the wrestlers – it absolutely has the scene as it was, the odd ritualistic garb and stance of the wrestlers, and the rural crowd in a circle. What a lovely day it was! It will stay in my mind for ever, it was lovely.'

The Bellingham Country Show was held every year near Monica's cottage in Haydon Bridge and Larkin and Monica attended on several occasions. After their 1973 visit he began the poem 'Show Saturday' in which the two wrestlers have a stanza to themselves. It is clear from the letter that the photographs were taken four years earlier and had been the inspiration for the poem.

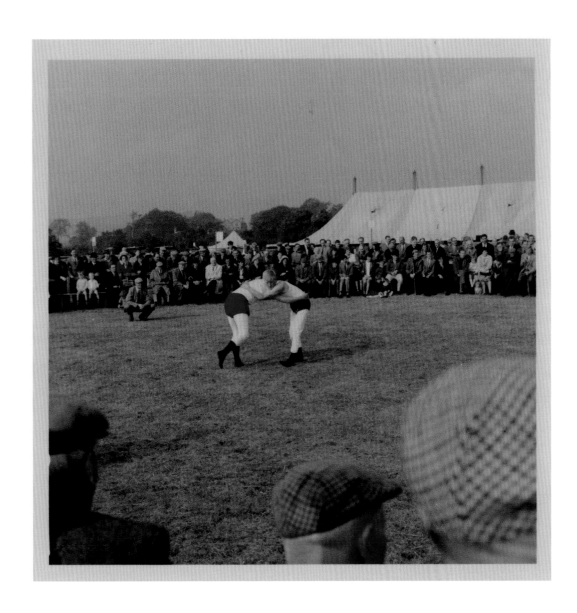

Chapter 20
Return to Ireland

Revisiting Wells in 1967 was one of several returns to Larkin's past, some of which were more impulsive. Nine months earlier he suddenly decided, late one Saturday afternoon, to visit Monica in Leicester. He threw some clothes into a bag and drove off, only to find that after an hour on the road his petrol gauge indicated a near empty tank and that he had forgotten to bring any more than the loose change in his jacket. He managed to get back to Pearson Park, just, and immediately drafted Monica a letter reporting, a little proudly, on his uncharacteristically impetuous gesture. She was comforted that something of the passion and energy of the first years of their relationship had endured into their middle age. Later in the same letter he assures her that while the thought of being with her caused him to drive south the impulse brought with it broader reflections.

> I feel I am landed on my 45th year as if washed up on a rock, not knowing how I got here or never having a chance of being anywhere else . . . Of course my external surroundings have changed, but inside I've been the same, trying to hold everything off in order to 'write'.

Within eighteen months he would again be asked to exchange the 'external surroundings' of the present day for those of his past.

In February 1969 Queen's University Belfast informed him that he was to be awarded an honorary D.Litt at the graduation ceremony in July. He and Monica flew over and stayed one night only. The mood of the Province was tense, with the Civil Rights marches provoking sometimes brutal responses from the RUC and, on both sides of the sectarian divide, there were incipient stirrings of paramilitary activity.

That year the Unionist celebration of the anniversary of the Battle of the Boyne on 12 July seemed like a countdown to something more than the annual display of marching Orangemen and pipe bands. The degree ceremony was held little more

Belfast, a few days before the 12 July festivities, 1969.

than a week before the twelfth and while Larkin had a clear recollection of what routinely happened in Belfast and the rest of the Six Counties in mid-July, this time he noticed that young men, even children in shorts, appeared intent on building bonfires larger than any he had previously witnessed, making use of every combustible item available. He walked along the same streets and through the same parks he had known so well fourteen years earlier. The buildings were largely unchanged but a siege mentality was abroad, and he took photographs which capture something of Ulster on the brink of three decades of sectarian violence.

Shortly before the ceremony he composed a poem and sent it to the Revd A.H. Quinn, then at Keele University and previously an acquaintance during his years at Queen's.

> See the Pope of Ulster stand,
> Spiked shillelagh in each hand,
> Vowing to uphold the Border,
> Father, Son and Orange Order

The 'Pope of Ulster' was Ian Paisley, the Protestant evangelist frequently referred to by Irish Republican terrorists as their best 'recruiting sergeant'.

Despite Larkin's trepidations about Ulster he and Monica decided to spend almost three weeks in Ireland later that year, departing on 25 August and boarding the ferry back from Dublin on 12 September, one of their longest holidays. They chose to avoid the North but made a point of returning to locations in Dublin and on the west coast they had visited via slow steam trains from Belfast in the 1950s. Larkin calculated that they would cover at least 2,000 miles and was looking forward to testing his new car. A month earlier he had exchanged his Singer Vogue for an Austin Princess Vanden Plas which he joyously described to Barbara Pym as: 'an enormous 4-litre Vanden Plas Princess, *with a Rolls Royce engine . . .* love at first sight, one of the few cars I can bear the look of . . . huge and ponderous, like an old drawing room, and does 80 without turning a hair.'

They visited Dublin, and returned to locations they had known in the early 1950s: tea in the Shelbourne, a trip to the National Gallery and Trinity College. Had things changed? Larkin reflected that Ireland was no longer '(a) remote . . . (b) censor ridden – *News of the World* and *Ulysses* available . . . (c) poverty stricken – all houses seem freshly done up and there are no barefoot children etc (mostly riding bicycles anyway).' But unlike the citizens of the older Dublin those of the modern metropolis were no longer 'courteous', 'as I'm sure M[onica] would add . . . having been bunted to and fro on Dublin pavements.' ('Holiday Diaries', 1969) Constantly, Larkin was comparing the present with the past. Ireland had changed – in the South at least, it seemed to him more like Britain – but he was unable or unwilling to voice his feelings about this, at least until June 1970 when he composed a poem, 'Dublinesque'. He sent

the draft to Monica, claiming it originated from 'an odd dream' but she would have known that it was distilled from what they had felt nine months earlier in Ireland.

> Down stucco sidestreets,
> Where light is pewter
> And afternoon mist
> Brings lights on in shops
> Above race-guides and rosaries,
> A funeral passes.

We learn nothing of the deceased but the procession, roughly sketched, accompanies us through the rest of the poem. The hearse is followed by

> . . . streetwalkers
> In wide flowered hats,
> Leg-of-mutton sleeves,
> And ankle-length dresses.

Images from the past shuffle through dimly lit streets and it seems that a collective state of mind is being laid to rest rather than an individual.

> There is an air of great friendliness,
> As if they were honouring
> One they were fond of . . .

> And of great sadness also
> As they wend their way away
> A voice is heard singing
> Of Kitty, or Katy
> As if the name meant once
> All love, all beauty.

Ireland, from Larkin's recent visit, is burying its past, emerging from the sentimental, perhaps patronising image cultivated largely by the English. But the Irish seem also to have disposed of something vital, something 'they were fond of', its absence causing a 'great sadness'.

ABOVE LEFT Waterville, in the Irish Republic. 'A dingy little town, smelling of piss, but not unpleasant in an Irish kind of way' ('Holiday Diaries', September 1969).

ABOVE RIGHT A street bonfire being built in Belfast during the run-up to 12 July 1969. The running commentary in the 'Holiday Diaries' on the comparative state of Ireland, North and South, is echoed succinctly in the photographs.

ABOVE Larkin's Vanden Plas parked near the west coast, Ireland, 1969.
On the other side of the road an older motor vehicle had found its final
resting place.

You surely must know that I'm not likely to cheat on you with Patsy.

Letter to Monica, 16 November 1966.

They spent a week as guests of Richard Murphy at the latter's delightfully restored cottage near Westport. Charles Monteith, head of Faber and Faber, who also published Murphy's verse, joined them, but it is notable that in the Diary Larkin refers only to their arrival at the Murphys and his and Monica's occasional excursions from the house. Monica enters no comments, and Patsy, who was spoken of by Murphy, is never mentioned. They had been divorced for ten years. Just over two years earlier Patsy had visited Larkin in Hull. The alluring bohemian with whom he had had an affair had returned as a morose, volatile alcoholic. Commendably, he reported the visit to Monica, stating that Patsy had 'brought with her an aura of death and madness in a general sort of way' (15 November 1966). She asked if she could return to Hull the following year but he declined her request and again informed Monica, by way of reassurance, that he had done so. Richard Murphy told them how his marriage to Patsy had gone into terminal decline and neither Larkin nor Monica enjoyed what they heard, though Larkin knew something of this already; a year after the birth of her daughter Emily, Patsy had arranged a clandestine weekend with him in the Home Counties. Murphy's story did, however, confirm for Monica that Patsy was no longer a competitor for Larkin's attention, and reinforced his assurances to her that he was drifting towards middle-aged monogamy, or so she thought. While they were staying at the Murphy's house Larkin wrote a letter and secretly posted it to Maeve: 'I can't forget you, even if I had any inclination to . . . Accept a big kiss and some spectral maulings – are you wearing tights? Or stockings?' (4 September 1969).

August 1969. Outside Richard Murphy's renovated cottage in Co. Galway. Murphy is on the left, Monica on the right. At the front is Charles Monteith of Faber and at the rear is Emily Murphy, daughter from Murphy's marriage to Patsy Strang, now dissolved.

Chapter 21
Back to Oxford

The following year Larkin wrote to Barbara Pym of another imminent exercise in retrospection.

> I am hoping to go to All Souls for 6 months in the autumn – a 'Visiting Fellow' . . . I have dreams of reliving my youth – of doing the things I never did – going to Bach choir concerts – the Playhouse – having coffee at Elliston's – walking to those places I've never seen, like *Bagley Wood* and all that Scholar (Gipsy/Gypsey) jazz. Bet I don't. (3 February 1970)

The visit would enable him to complete a project begun three years earlier: editing the successor to Yeats's *Oxford Book of Modern Verse*. He was released by Hull on sabbatical leave and was resident in All Souls College throughout the 1970–1 academic year. In May 1971 he updated Pym. He had studiously avoided everything that he had promised to revisit: all 'was just as boring as ever'.

He lived in Beechwood House, a college-owned property, in the village of Iffley about one and a half miles from the centre of Oxford. It was a comfortable Georgian manor with some Victorian additions, and painted a rather garish light pink. From his first-floor rooms Larkin could see the nearby Thames and soon he adopted a routine of walking along the riverbank into central Oxford, taking a light breakfast in the All Souls Common Room and then dividing his time between the adjacent Bodleian Library, which held copyright editions of all the volumes of verse he needed to consult, and his office in college itself.

He would take lunch in the King's Arms, a short stroll from the Bodleian. Following his afternoon endeavours he might go again to the King's Arms for a light supper and some drinks or, with weary reluctance, dine in college with the other Fellows. This last was a convention of collegiality which he loathed but could not completely avoid. He found the conversation and company of the Fellows unendurably tedious and sought relief in very generous pre-prandial gin and tonics. The historian A.L. Rowse would later inform Andrew Motion that Larkin was 'falling over backwards to be a philistine . . . an undergraduate attitude perpetuated into adult life'. The

humourless pomposity of the comment is appropriate in that it was exactly the response he wanted to provoke. In his letters to Monica, Larkin presents Rowse as an infuriating sexual predator: 'Rowse is back. *Within twenty seconds* he was FEELING MY ARSE (demonstrating the frisking routine at airports) and asking me to read his poems. Oh God! Every Eden has its snake.'

Even when he had revisited the city in the early 1960s the smoke-blackened walls of the colleges were much as he remembered them from his undergraduate years. Now, the sandstone glowed proudly, following an intensive steam-cleaning project. But some things endured. It was as though he had gone back in time with the proviso that he became a member of a coterie that he, Amis and the rest of 'The Seven' had routinely treated with a mixture of derision and contempt, the dons, or as he put it in his poem for Monica on the All Souls experience, 'The arselicker who stays.'

In November he met Martin Amis, son of his now estranged old friend, and in the third year of his English degree at Exeter College. Larkin wrote to Monica: 'he looked and behaved like Mick Jagger . . . Am wondering whether to have him in to All Souls: stiff cocks wd upset the table.' He did so, twice, and made a point of ensuring that his exchanges with his young companion could be overheard by the likes of Rowse and the Warden, John Sparrow, including his comment to Martin that academia reminded him of the clergy of the eighteenth century, the refuge of second sons of the gentry: not eligible to inherit and too thick to do anything else.

Despite his claim that Oxford kindled no sense of nostalgia or affection the visit did coincide with the restoration of a friendship that had begun in the city thirty years before. His encounter with the Jagger-like Martin Amis had occurred in the Randolph Hotel in the company of Kingsley Amis and his second wife Elizabeth Jane Howard, known as Jane in private life. The four had met for drinks and a meal following a reading that Amis had given in Balliol. Amis and Larkin continued to correspond irregularly and without much enthusiasm for a further two years until in 1972 Larkin agreed to stay for a few days at Lemmons, Amis's late Georgian manor house in North London. The nominal reason for the visit involved a rather morbid coincidence. Larkin had always admired C. Day Lewis's work, had corresponded with him regularly during the 1960s and had secured him a one-year post as writer in residence at Hull. Jane Howard had had an affair with Lewis in the late 1950s but thereafter remained on affable terms with the writer and his wife Jill. She visited the couple at their home in Greenwich in early 1972 to interview the poet for a newspaper article and found both of them in a pitiable state. Day Lewis was terminally ill and Jill unable to cope, so she arranged that same week for them to move into one of the many spare bedrooms at Lemmons. Amis, again prompted by Jane, wrote to Larkin. '[Day Lewis] would love to see you. If you're in London you could pop up here without much difficulty.' Larkin agreed but wrote to Monica, 'Don't care for the prospect much.'

Afterwards they exchanged letters and it appeared that the previous ten years of inexplicable silence had suddenly been erased. Amis slipped joyously into the idiom

of their past. 'By the living God, cully, that was a fine old time, as far as I remember,' and he goaded Larkin for being responsible for a copy of *Men Only* hidden under a copy of *The Times*: 'Who put it there hey?' Larkin seemed happy to revisit old habits: 'Shall I never learn not to drink in excess? . . . I must say our old friend Al Cohol has wiped away my memory of what I said I'd do.' For Monica, however, he had already reported more honestly on the visit: 'not v. good. In practice he turns it into a drink/jazz old pal visit, whereas I can't help feeling a lower key would have been kinder,' by which he meant 'kinder' to Day Lewis, who would die six weeks later.

There would be further visits to Lemmons and to the more central Gardnor House where Amis and Jane moved in 1975. Jane Howard: 'When Philip came I would leave them alone to play their games . . . They seemed like adolescents, spending hours secreted in his [Amis's] study with jazz records and a bottle of whisky. On their own, talking. About what, I do not know, Kingsley never told me.'

Some of the poems in *High Windows* (1974) were composed as early as 1962 but the most frequently quoted are those which seem to reflect on Britain's emergence from decades of buttoned-up sanctimony into a new dawn of joyous hedonism. In truth the title 'High Windows' poem, 'Annus Mirabilis' and 'This Be The Verse' should be seen as pure distillations of irony. Each addresses the theme of sex and each ridicules its own candour. Larkin writes of 'Kids . . . fucking', of 'sexual intercourse' as now being virtually an obligation, but he does so as one who sees this sense of unprecedented openness as a collective delusion. He had seen it all before, and had found that deception, involving one's partner or the public ordinance to behave properly, was what made sex interesting. The famous opening stanza of 'Annus Mirabilis',

> Sexual Intercourse began
> In nineteen sixty-three
> (which was rather late for me) –
> Between the end of the *Chatterley* ban
> And the Beatles' first L.P.

is sardonically autobiographical. In November 1960 Conquest had written to tell Larkin of why Amis failed to appear at the Old Bailey to add his voice to pleas by other authors for the unbanning of the novel: 'he was at the time participating in an adulterous rendezvous. Pity he didn't make it, breathing heavily, smeared in lipstick and fly buttons mostly undone to testify that Lady C was a sacred monogamous work.'

It is no accident that during the period between these two dates Larkin decided to give up his role as spectator on Amis's career as serial philanderer and begin a faintly parochial one of his own.

The reviews were largely generous, with a hint of puzzlement. Some commentators were drawn to Larkin's apparent preoccupation with the sexual protocols of the previous decade, poems that as a rule implied that he was speaking

for a generation who now felt rather left out. Mixed in with the 'public' poems were verses much harder to categorise, at once thematically oblique yet compelling. With 'Friday Night in the Royal Station Hotel', 'The Building', 'The Explosion', 'The Card Players', each seems to have little in common with any of the others, but for a dextrous touch of genius, from the same hand. But Larkin was not showing off his versatility; rather, he had little more to say about anything. It was the most popular volume of previously unpublished verse to go into print since the war with almost 24,000 copies sold in the twelve months following its publication date.

Larkin was already being spoken of as Betjeman's successor and not merely as Poet Laureate. He was thought the embodiment of those, now in middle-age, formed by the plain-spoken mood of the late 1940s and early 1950s, but his appeal was broader than that. Christopher Hitchens recalled:

> We . . . Martin [Amis], James [Fenton], Julian Barnes, Ian McEwan saw quite a lot of Kingsley's set, Bob Conquest included, in the 1970s. They were the Speccie [*Spectator*] people. We worked at or wrote for the NS [*New Statesman*] mostly. We got on well enough, with some intergenerational banter, but at the same time we wanted to put a distance between ourselves and the post-war set, left versus right, us versus them mainly. But Larkin stood above it all, he closed the gap. Even though he was, physically, somewhere else. After *High Windows* everyone saw him as the finest poet writing in English. Even James, proselytising Trotskyite, thought him unimprovable.

OPPOSITE Beechwood House, Iffley, 1970.
To Monica: 'Quite a nice house, though not large.
I have rooms (2) over the front door. House is
painted pink – foully ugly. There's a lavatory next
door but I'm not strategically placed for baths'
(16 September). '[More] remarkable features of
the day were buying a pair of lemon braces and
walking back to Iffley along the towpath: this is quite
possible, and very nice – you start from Folly Bridge'
(19 September).

ABOVE Left, the sundial, designed by Christopher
Wren, above the All Souls Codrington Library,
and, right, the dome of the Radcliffe Camera,
photographed by Larkin from the Great Quadrangle
of All Souls. To Monica, 17 September 1970: 'My
proudest moment is when, under the eyes of
loitering Yanks and coachloads of Frogs, I take
out my Fellows' key and open the door in the wall
opposite the Radcliffe and disappear in to the
splendour of North Quadrangle. Vanity, all is vanity.'

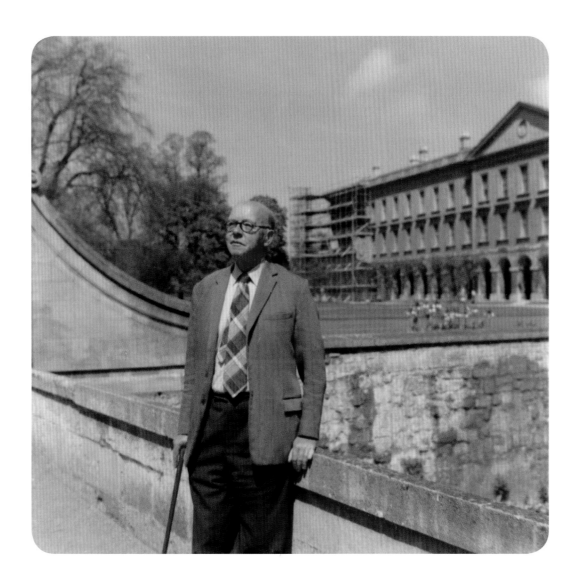

OPPOSITE, TOP Larkin's All Souls office, 1970. To Monica: 'College room nicer than this [Beechwood House], really – Parker chair, antique desk. In a sort of built annex' [actually a part of the College that resembles a small eighteenth-century manor house, facing the High on one side and a pleasant garden – from which the second photograph was taken – on the other].

ABOVE Charles Monteith, also an All Souls fellow, brought Larkin some relief with his weekend visits from London, sometimes taking him for lunch in Magdalen where he had retained connections since his undergraduate years.

Chapter 22

Cemetery Road

In March 1974, three months before the publication of *High Windows*, Larkin began work on what would be his last major poem. The sub-genre of the aubade carries with it a mood of optimism, generally the sense of anticipation felt by lovers when they separate in the morning. Larkin, with typically morbid irony, chose the term as his title. After he has spent the night 'half drunk', and 'waking at four' he stares past the 'curtain edges'. He laid the first two stanzas aside and did not complete the final draft until almost three years later. Larkin never rushed his poems but there is evidence that he was delaying the conclusion of this one because it was a fait accompli. Through the curtains he sees only one thing:

> . . . what's really there:
> Unresting death, a whole day nearer now,
> Making all thought impossible but how
> And where and when I shall myself die.

The years between 1974 and 1978 saw the death of Larkin as a poet. During the same period he seemed to be contemplating what would remain of him as an individual after that. As he puts it in 'Aubade':

> Most things may never happen: this one will,
> And realisation of it rages out
> In furnace fear when we are caught without
> People or drink.

Shortly after composing this passage he wrote to Amis: 'Poetry, that rare bird, has flown out of the window and now sings on some alien shore. In other words I just drink these days . . . I wake at four and lie worrying till seven. Loneliness. Death. Law

Spring Bank Cemetery, Hull: one of Larkin's favourite locations.

suits. Talent gone. Law suits. Loneliness. Talent gone. Death. I really am not happy these days.'

Two months before *High Windows* appeared the University of Hull announced to Larkin that it intended to sell its properties in Pearson Park. He had no choice but to look for alternative accommodation. He had lived in his flat there for almost two decades, the only long-term resident.

Hull, despite the blitz, had a reasonable stock of Victorian and Edwardian houses, with a few Georgian terraces close to the centre, but most were drab and unmodernised. He purchased 105 Newland Park; architecturally the kind of nullity-by-compromise that made up the estates of detached houses aimed at the new middle classes of the 1960s and early 1970s. He wrote to Anthony Thwaite: 'I've been v. upset [since the move] in most senses: I feel like a tortoise that has been taken out of one shell and put in another.' He was never happy in the house. He rather half-heartedly attempted to improve the interior with William Morris-style carpets and wallpaper prior to Monica permanently joining him there in 1983 following her crippling bouts of shingles, but while Newland Park was larger and better appointed than anywhere he had previously lived, he grew to hate it. Only two poems relate to it, and then obliquely. 'The Mower' was prompted by his accidental killing of a hedgehog when mowing the lawn but something much more unsettling inspired 'Love Again'. After a Senior Common Room party in November 1974 he invited Maeve to take last drinks and inspect his new house. Their relationship began again. Little more than three months later in March 1975 he began an affair with his long-term secretary Betty Mackereth.

'Love Again' is addressed mainly, though not exclusively, to Maeve, who he suspected was considering a relationship with someone else. It is a bizarre piece of work, his characteristic blend of muted elegance shot through with the grotesque. Much of it shows us another side to Larkin's lonely night-time presence in 'Aubade'.

> Love again: wanking at ten past three
> (Surely he's taken her home by now?) . . .
>
> Someone else feeling her breasts and cunt,
> Someone else drowned in that lash-wide stare . . .

The poem shows discernible features of Larkin at his greatest – it is beautifully crafted – but it is also as if we are listening to an ugly echo of what was once his voice.

It is notable that the only photographs he took of Newland Park were incidental to its presence, and his sense of how it felt to live there.

Previously he had shown a particular interest in the interiors of the flats he had rented since his undergraduate years. He enjoyed capturing on film a trace of how he had shaped the spaces in which he lived and wrote, and vice versa – a shaft of light

from a bay window, the arrangement of private mementos and framed photographs on tables.

It was not merely that this place afforded him no comfort; rather he sensed in its newness something transitory and ominous. When he moved in he felt that he would never move again at least until an ambulance or an undertaker took him away.

The recollections that habitually enabled him to connect the present with the past were becoming ossified, as those who embodied them disappeared from this world. The most significant departure occurred on 17 November 1977 when Eva died in a nursing home. For more than ten years she had suffered from a form of dementia but Larkin had continued to write to her, despatching on average three letters a week. Since the death of Sydney, he addressed her as 'Dearest Old Creature'. She never showed much interest in literature but nor did he patronise her. The tone of his letters, over forty years, was gossipy, distracted, amused and seemingly sincere. She had watched him grow up, talked with him of his ambitions and disappointments and he treated her as his emotional alter ego, a figure for whom he felt both attachment and impatience.

The day after Eva's death he met Anthony Thwaite in All Souls, Oxford and Larkin, a lifelong atheist, asked Thwaite, low-church Anglican, if he would come with him to the college chapel. Larkin did not know if he would pray but being there was important to the memory of Eva. 'I think my mother would have liked that,' he said. A week later he returned to 'Aubade', his tribute to death, and completed the final stanza. It was published shortly afterwards.

In October 1978 he was informed that the BBC planned to record Harold Pinter reading 'Aubade' on an evening arts programme. This was screened on 30 October and prompted a flurry of letters to Larkin on its subject, unlocking a cabinet of nationwide fascination and gainsaying the general belief that death was something only to be feared, lamented or bravely encountered. A generation earlier, the official consensus – albeit probably false – was that Britain drew upon its largely Christian, largely Anglican, heritage as the principal coping strategy. Now, it seemed, everyone wanted to write about it, to bombard Larkin with an array of personalised, often ruthlessly eccentric, accounts of what they felt and how they had prepared themselves. W.G. Runciman, the Cambridge sociologist, sent Larkin a long and scrupulously researched account of how modern rationalists, psychologists and anthropologists had attempted to pin down the precise nature of our fear of death, treating it in much the same manner that similar professional analysts might deal with arachnophobia or insomnia. Larkin was by parts amused and depressed. He replied to Runciman politely enough but bridled at Runciman's patronising presentation of our dread of death as some kind of neurotic condition. No, there is 'something one is *always* afraid of . . . It certainly doesn't feel like egocentricity.' It was as though his long-cultivated, wry interest in churchyards had transformed itself, vengefully.

By the end of 1977 he had all but ended the brief resurgence of his relationship with Maeve. They exchanged letters but in response to her tentative enquiries on what the future held for both of them he prevaricated relentlessly. In March 1978 *Larkinland*, a celebration of his work and interests, was moved from the site of its inception on the South Bank, London, to the university in Hull. The reception was attended only by those with invitations and while Maeve received one it was followed shortly afterwards by a note from Larkin stating that she should be accompanied by friends and colleagues: any indication that they were, or had been, partners was not, he thought, appropriate. Yet his affair with Betty continued in an erratic manner, tapering out during the early 1980s and concluding when Monica moved into Newland Park in 1983.

There is reason to believe that Larkin's earlier decision to relaunch his relationship with Maeve and transform his friendship with Betty into a carnal, intimate affair was prompted by something other than passion. He was gazing towards a future without any expectation of change, let alone improvement, and aside from his gloomy sense of death as his next significant moment the thing that had animated him since his late twenties, poetry, had now departed, seemingly for good. Could he, albeit briefly, roll back time to the mid-1950s and early 1960s, when his commitments to one woman were compromised not simply by lust but by a desire for gratuitous stealth? He enjoyed in those years the same sense of disingenuousness in his personal life that had made his poems so exceptional: transparency cut through with a suspicion of insincerity or ventriloquism. He even attempted poems that were addressed directly to Betty (notably 'Morning lost . . .'; 'We met at the end . . .'). Short lines, brief stanzas and compressed syntax tell of a man set upon achieving something, at least initially, yet feeling as he composes each verse an unendurable pressure from which he wishes to release himself as soon as possible.

He would drive out with Betty across East Yorkshire and the Dales, often along the same routes he had taken with Maeve or more regularly with Monica. His photographs give another indication of how his past was being exchanged for a moribund present. The few prints of Larkin and Betty that survive are eerily similar to those he took of Monica and Maeve, sometimes with the woman singularly juxtaposed against the landscape, sometimes with himself and his female companion facing the timed camera. By the end of the 1970s he had almost given up taking photographs at all and 1979 saw the final entries by both Larkin and Monica in their holiday diaries.

The diaries do, however, conclude with an idiosyncratic coda, composed exclusively by Larkin. It is a sequence of meticulously prepared score-cards, in the manner of the *Wisden Cricketers' Almanac*. In this instance the players are made up of all the women with whom he had been closely involved, though not necessarily sexually, from Ruth onwards. Their 'figures', at least in terms of runs scored, wickets taken and so on, involve a code that would test the ingenuity of Alan Turing. This, however, is the point: the statistics in *Wisden* are meaningless without the private memory they

stir for a particular reader, causing them to revisit the image of an afternoon at a county ground or even Lord's, perhaps twenty, thirty years before. Larkin enjoyed photographs of the female form, especially those he had taken of women he knew. By the time he began his scorecards, featuring these same women, the pictures were filed away and he would take no more. It is another example of Larkin building a bittersweet memorial to his irretrievable past.

In July 1984 he and Monica attended John Betjeman's memorial service in Westminster Abbey. Larkin was photographed by several newspapers principally because it was thought he would soon be asked to become Poet Laureate and much amused speculation centred upon how a man whose most famous line was 'They fuck you up, your mum and dad' would deal with votive pieces on royal births, marriages and deaths. Mrs Thatcher offered him the post but he turned it down. Ted Hughes accepted it.

He wrote to Amis shortly after Hughes was appointed Laureate:

Sorry about letting Ted in. Mrs T [Thatcher] was very nice about it. I just couldn't face the 50 letters a day, series of 24 programmes with live audiences on ITV, and British representative at the international poetry festival at Belgrade . . . However, I agree that the thought of being the cause of Ted's being buried in Westminster Abbey is hard to live with.

A few months later he remarked, again to Amis, on how Hughes's early official verses were serving a worthy objective by '*Compelling* chaps to realise he's no bloody good'. The wry tone belies a grim fact that now underpinned their correspondence. By early March 1985 he had been advised that his regular 'cardio spasms', his radical loss of appetite, increased amnesia, difficulty in swallowing and persistent pain in his lower abdomen might have a single cause. On 11 June he was operated upon. Cancer, suspected, was confirmed and his oesophagus removed, but it was found that aggressive growths had spread to other parts of his upper body. These were, he and Monica were told, inoperable. He left hospital after two weeks and spent the next five weeks in Newland Park drafting letters to old friends and fans. On 28 November he collapsed at home and was rushed to hospital where he died in the early hours of 2 December.

ABOVE In spring 1979 he accidentally killed a hedgehog when mowing the long grass. He was filled with sadness and remorse, evidenced in one of his last emotionally sincere poems, 'The Mower'.

OPPOSITE The colour print of Larkin and Betty, in a Yorkshire country churchyard, was taken in the late 1970s during their affair, more than twenty years after the one of Monica in Spring Bank.

No, give me my in-tray,
My loaf-haired secretary,
My shall-I-keep-the-call-in-Sir:
What else can I answer,
When the lights come on at four
At the end of another year?

'Toads Revisited'

Larkin had never felt exhilarated by anything, but by his thirties he had come to treat the routines of his life with grumpy contentment. By the 1970s even these had begun to bore him. In 1971 stage two of the new library at Hull had been completed and was receiving recognition as an exemplar of how libraries should be designed and integrated with academic institutions. In 1970 it won the Civic Trust Award and in 1971 the Yorkshire Region Architecture Award from the Royal Institute of British Architects. For fifteen years Larkin had played an integral role in how the design of the buildings would suit the practical demands of a large library catering seven days a week in term time to academics, undergraduates and researchers. He was respected for his achievements throughout the UK by fellow librarians and while quietly proud of what he had done he was now depressed. The buildings stood as a monument to his endeavours but by the early 1970s he had come to treat them as a crypt. He would continue to work in his rather grand office, deal with the demands of the University Grants Committee and pretend to sleep during meetings involving Senior Management Staff at Hull. He enquired about early retirement, knowing that he could never deal with the prospect: he complained continuously about his profession but he knew that his dreary acceptance of what he had become underpinned the mood of his writing. He could not have one without the other.

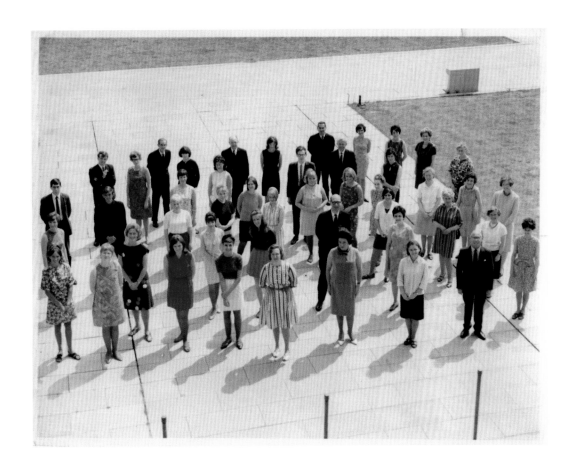

Larkin and his Brynmor Jones Library staff
photographed, as he requested, from a high window
in the building, six months after his final and most
successful volume of poems *High Windows* was
published in 1974.

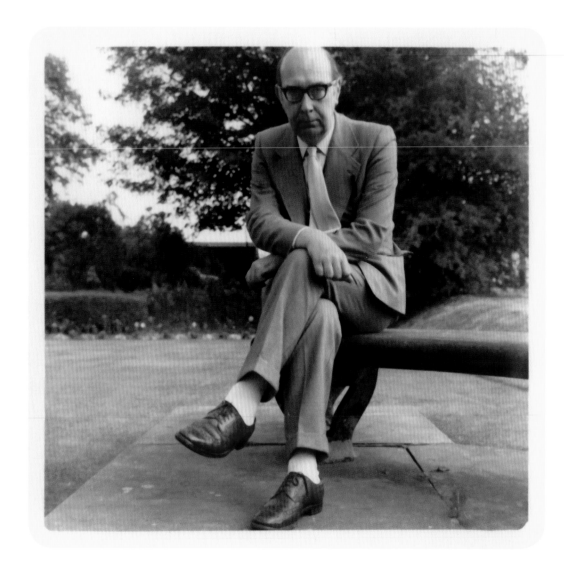

Taken by Monica in the grounds of the Elms Hotel, Abberley, a converted
Queen Anne house in Worcestershire where they had gone to celebrate
Larkin's fifty-fourth birthday. Three days later he wrote to Anthony
Thwaite: 'Absolutely nothing happens in my life except routine work and
thinking from time to time I've got lung cancer.'

Eva Larkin, 1967. Larkin wrote to Monica less than a year after taking
the photograph: 'Sometimes I wonder if I'm fond of my mother at all . . .
I know she's old and hates living alone . . . that she's extremely kind and
considerate and conscientious; that she never thinks badly of anyone or
says anything malicious about them; that she is my mother after all . . .
But once let me get home and I become snappy, ungrateful, ungracious,
wounding, inconsiderate and even abusive . . . muttering obscenities
because I know she can't hear them.'

It cannot be coincidental that as he ran out of things to say in verse so
he became less interested in the photographic image. Some late prints
survive, notably one of Monica filed next to one of his mother taken
shortly before her death. Monica's poses are similar to Eva's of twenty-
five years earlier – by a bookcase, lit by the sun from an adjacent window
– and each has a weary stoical air.

Index

Entries in *italics* refer to captions.

Acknowledgements

Particular thanks are due to Simon Wilson and his staff at the Hull History Centre, who have worked tirelessly and meticulously to provide images and unpublished text for this book: as archivists they are beyond compare.

I am grateful also to the Estate of Philip Larkin for their permission to use his photographs and to Faber and Faber for permission to quote from his work.

Mark Haworth-Booth has taken the time to provide an excellent Foreword; his contribution is much appreciated.

Dennis Low, Graham Chesters and James Booth have each at various points made useful observations and suggestions – thank you all.

Andrew Dunn is a fine publisher and an astute, dedicated editor.

Finally, and once again: without Dr Amy Burns this book could not have been completed.